PRAISE FOR
Women from the Ankle Down

"A fleet-footed social history." —Liesl Schillinger, *New York Times*

"A lively look at the history of stilettos, sneakers, and sundry other leather- and rubber-soled objects of swoon.... Chatty yet authoritative."
—Olivia Barker, *USA Today*

"If you could glimpse the passing parade of the last hundred years or so from behind a slightly raised curtain, you'd have a pretty good idea of what's going on in this richly anecdotal history of shoes."
—Amanda Lovell, *More*

"Every woman who loves her shoes should read this book—hell—every man who loves women's shoes should read this book.... Informative, interesting, and just plain fun."
—*New York Journal of Books*

"[Bergstein's] entertaining book wears its research as lightly as a pair of strappy sandals."
—Tricia Springstubb, *Cleveland Plain Dealer*

"Fun." —Susannah Cahalan, *New York Post*

"With humor, zest, and bull's-eye knowledge of fashion, Rachelle Bergstein has given us far more than the ultimate shoe story. She has given us the history of American style in delectable microcosm. Touring the world's most glamorous locations from Hollywood to Bonito, Italy (hometown of Salvatore Ferragamo), in Vans, stilettos, and very big boots, *Women from the Ankle Down* is—with all due respect to Nancy Sinatra—gonna walk all over you."
—Sam Wasson, author of *Fifth Avenue, 5 A.M.: Audrey Hepburn,*
Breakfast at Tiffany's, and the Dawn of the Modern Woman

"At last someone has dared to probe one of the most mystifying phenomena in our culture: what's the deal with women and shoes? Rachelle Bergstein starts from the ground up and tells us—with wit and brio—a lot about society from an unusual and original perspective."

—Ron Rosenbaum, author *The Shakespeare Wars* and
How the End Begins: The Road to a Nuclear World War III

"As a woman who walks, I've often wondered why I don't wear more sensible shoes. Now I know. Rachelle Bergstein has written a compulsively readable history: it won't keep you from buying an absurdly uncomfortable and expensive pair, but it will make you understand why you're doing it."

—Ruth Reichl, author of *Garlic and Sapphires*

"The evolution of women's shoes since World War II becomes the story of women's self-empowerment in this engaging, toe-to-heel study by editorial consultant Bergstein. . . . Bergstein . . . provides mini-bios and fascinating informational tidbits. . . . From flats à la Audrey Hepburn, Keds, and white go-go boots, to Tommy-era platforms and Jane Fonda's Reebok Freestyles, to *Sex and the City*'s pricey Manolo Blahniks and Jimmy Choo's, Bergstein ably runs the gamut of styles over the decades."

—*Publishers Weekly*

"An illuminating study of the history of women's shoes in the twentieth century. . . . Bergstein examines the fascinating and surprisingly complex relationship between women and their shoes. . . . Wickedly provocative."

—*Kirkus Reviews*

"An entertaining journey through the social history of shoes and the people who have worn them. . . . Well-written and well-referenced. . . . Recommended to all fashion followers as well as those who enjoy the ankle-down approach to studying our high-end material culture."

—Holly Hebert, *Library Journal*

"Engaging. . . . A charmingly interwoven story of the past one hundred years, detailing a bit of the psychology behind different styles as well as the fame that drives the fates of a variety of soles and heels."

—Barbara Jacobs, *Booklist*

Women from the Ankle Down

Women

from the

Ankle
Down

THE STORY OF SHOES
AND HOW THEY
DEFINE US

Rachelle Bergstein

HARPER PERENNIAL

NEW YORK • LONDON • TORONTO • SYDNEY

HARPER ● PERENNIAL

A hardcover edition of this book was published in 2012 by HarperCollins Publishers.

HarperCollins books may be purchased for educational, business, or sales
promotional use. For information, please e-mail the Special Markets Department
at SPsales@harpercollins.com.

Grateful acknowledgment is made for permission to reproduce from the following:
"These Boots Are Made for Walkin'" written by Lee Hazlewood. Copyright © 1965–1993
Criterion Music Corporation. All rights reserved. Used by permission. International copyright
secured.

All illustrations © Nami Matsuo Scott

FIRST HARPER PERENNIAL EDITION PUBLISHED 2013.

Designed by Jennifer Daddio / Bookmark Design & Media Inc.

Library of Congress Cataloging-in-Publication Data is available upon request.

ISBN 978-0-06-196968-3 (pbk.)

13 14 15 16 17 OV/RRD 10 9 8 7 6 5 4 3 2 1

For

MARCIA BERGSTEIN

and

PAULINE T. GARINO

The original style icons

In loving memory

CONTENTS

· · · · · · · · · · ·

PREFACE

.

They were the new Loeffler Randall snakeskin booties—stunning with their black, white, and gray mottled texture; the curved toe; the sloping arch that led up to a sky-high medium-width heel. Pamela, in her own words, was "stalking" them. "The moment they go on sale," she said on a drizzly Sunday morning, in between bites of eggs Benedict, "they're mine." She recalled the yellow gold hardware, reflected in subtle splashes of color on the snakeskin. "Full price, they're seven hundred and ninety-five dollars," Pamela continued. The gears were turning. "Which is basically my rent. But"—her face took on the impishness of a naughty child—"sometimes I can justify it, you know? Rent covers my apartment for only a month. But the Loeffler Randalls," she rhapsodized, taking another, satisfying bite, "those I'll have *forever*."

Even as she was speaking, Pamela knew that her logic was by no means unassailable, but you had to appreciate how hard she was trying. Beautiful shoes seem to elicit this kind of creative thinking; a few months earlier, Kristen—a budding fashion and accessories designer—was sipping a two-dollar iced coffee that she could barely afford because work, for an artist living in New York City, is so erratic. "I'm thinking of investing in a pair of Christian Louboutins," she said, watching a stylish girl, decked out for spring, pass by the sidewalk café. "Maybe not new, but I've been checking out barely worn pairs on eBay." It turns out, authentic Louboutins sold for a third of the retail price at online auction, giving Kristen access to pumps that would have otherwise lingered well beyond her budget. In truth, they were beyond her budget either way, but she was considering their value in other, nonmonetary terms. "When I go out, I want people to see those red soles," she confessed. "I'm tired of not being taken seriously."

The idea of shoes—as an investment, as social currency—isn't new and dates back to the theaters of ancient Greece, where characters of high rank wore elevated shoes; to the seventeenth-century courts of Louis XIV, where it was decreed that only men of high power could wear loafers with red, square heels; to the nineteenth-century Sioux, who allowed only chiefs to wear certain elaborate beading patterns on the soles of their soft leather moccasins. But what is relatively new is the incredible variety of socially acceptable shoes available to women today. Walking into a twenty-first-century shoe store is an exercise in decisiveness and restraint. Take in the wide array of materials available to footwear manufacturers and thus to modern-day customers—smooth matte and shiny patent leathers; pliable rubber; all sorts of artificial leather substitutes like plastic, polyurethane, polyester, and PVC; and on the opposite end of the spectrum, shoes

made from natural fabrics like canvas, raffia, rope, and cork. As the music pumps and the salespeople hustle, a woman looking to buy new shoes can decide if she wants to pay top dollar for perfectly crafted specimens shipped straight from Italy, or if she needs to be budget conscious and stick to less sumptuous ones manufactured in China. Ultimately she'll have to figure out if she's in the mood for classic high-heeled pumps, delicate strappy sandals, vertiginous platforms, modest ballet flats, practical oxfords and brogues, knee-high boots, high-ankle booties, wedges, Mary Janes, low-tech sneakers, or high-impact athletic shoes . . . not to mention the colors, cuts, and embellishments that make each pair feel exceptional. The possibilities are wonderful, dizzying, and it's no wonder that buyers get caught up in the frenzy and leave the store sheepishly clutching more pairs than they initially intended. (Or, if they're shopping online, the result is an engorged credit card bill and a friendlier relationship with the delivery guy.)

This diversity is the hallmark of the contemporary shoe scene—which is all the more remarkable given that it wasn't until the mid-nineteenth century that custom shoemakers, who still dominated the footwear industry, decided to differentiate between the left and right foot in their patterns. At that time, only wealthy women had the pleasure of a diverse and sizable shoe collection. The rest invested in all-purpose pairs that could be passed down within families from child to growing child. This changed at the dawn of the twentieth century, when shoe factories with efficient assembly lines began to replace the old-fashioned cobbler. Factories could make shoes in a fraction of the time it took for a cobbler to lay out the leather, cut the pattern, and stitch it together by hand. Modernization was bad news for the gentle artisans who counted on making shoes for their livelihoods but good news for buyers, who could

then afford cheaper factory-made footwear—the country's first step toward fast fashion.

Today, the average woman often owns upward of ten, twenty, fifty pairs of shoes, some of which have very little practical use and languish in the back of the closet until just the right occasion arises. This is thanks, in part, not only to factories but also to industrial leaders like DuPont, which introduced low-cost artificial materials into the market in the early 1960s. On the heels of the cookie-cutter 1950s, youthful consumers were willing to experiment with style, and they tested out new, outrageous designs like the *cuissarde*—a sexy thigh-high boot—with aplomb. Then, in the 1980s, another important development: sneaker companies, eager to promote their technologically innovative product, courted sports stars to appear as spokesmodels, and the age of the celebrity endorsement was born. Finally, progress came full circle when, during the late 1980s and early 1990s, the reign of the fairy-tale cobbler with his handmade, bespoke shoes returned. These glamorous, high-quality shoes could be purchased for a considerable price, and expressions of status— always subtly enmeshed with the worlds of footwear and fashion— became as conspicuous as the ruby red soles of a pair of Christian Louboutins.

These days, when women pick out their shoes, they find themselves, consciously or not, negotiating between the choices that have already been made for them by the fashion elite—the group of powerful designers, editors, and stylists who determine which shoes to show on the runways, and then to feature on the pages of popular magazines—and the prerogatives of personal style. As most women understand, lacing up a pair of Doc Martens or Converse Chuck Taylors sends a different message than shuffling through a restaurant in Crocs or strutting down the sidewalk in a pair of Jimmy Choos.

It's up to each individual to decide who she wants to be in any given moment, and what information she'd like her footwear to convey. Shoes have evolved to take on unique personalities and to communicate with the world in precise nonverbal language. If you ask a woman why she loves shoes she'll tell you that they're beautiful, that they make her feel good, that they have the ability to transform an outfit from simple jeans and a T-shirt into something showstopping and spectacular. These are just a handful of reasons why, at the height of this recent recession, footwear sales continued to rise while overall retail profits plummeted.

This moment in footwear is exciting, not just because the shoes themselves are inspired, accessible, and unprecedentedly celebrated but also because it hints at something bigger, and more profound, that took place during the twentieth century. The story of shoes in the past hundred-plus years is the story of women, told from the ankle down. It mirrors a trend that began with the well-heeled suffragettes in the 1910s, exploded in the 1960s with the women's liberation movement, and continued into the 1980s as women fought for high-level jobs and equal pay. It culminated in the 2000s when women embraced their personal agency. Pop culture introduced us to Carrie Bradshaw: a successful, financially independent single woman who refused to settle for Mr. Wrong and felt entitled to treat herself to expensive shoes. Women have fought for—and undoubtedly have won—greater freedom and mobility. This narrative is crucial to understanding the evolution of contemporary footwear; as women demanded more options in their day-to-day lives, different kinds of shoes became available. As culture embraced and then rejected and then reinterpreted new, feminine strides, footwear styles emerged that reflected these advances and allowed women to express their various points of view. Pop-culture snapshots captured these shifts,

and It Girls—those aspirational paragons of beauty and style—offer hints about what, at each historical moment, was being valued.

At the beginning of the second decade of the new millennium, heel heights have started to fall after the teetering five-inch platform heel—introduced at the moment when the financial world crumbled—ruled the footwear stage. Whether this is a reflection of the economy or simply the cyclical fashion world's version of the mantra *what goes up must come down*, it's two sides of the same coin: shoes, like works of art, are inextricably bound to the world in which they're produced, and yet they also rest agelessly outside of it, like bursts of beauty that defy the mundane. Unlike in the 1940s and 1950s, when one or two footwear styles dominated, the latter half of the twentieth century ushered in the age of multiplicity. To be a shoe-loving woman during this time was to enjoy an unprecedented array of options, from platforms to kitten heels, warlike wedges to wispy sandals. It's to be a jock one day if you're so inclined, a dominatrix the next. And isn't that the greatest pleasure of the twenty-first-century woman? It's having the room to choose—your shoes, your goals, your life.

Women from the Ankle Down

I

.

Ferragamo
and the
Wartime Wedge

(1900–1938)

1907: Bonito, Italy

Bonito was a small village about one hundred kilometers (60 miles) east of Naples that ended in a cul-de-sac and had just one road going in and out. It was home to 4,500 residents—mostly poor farmers, tradesmen, and a few gentry—including the large Ferragamo family, who farmed their ten-acre property and sold all of the crops that they did not consume themselves. They lived across the street from a small church as well as the town cobbler's modest shop. Salvatore Ferragamo, then nine years old, most afternoons could be found perched on a chair outside the window, watching intently as Luigi Festa

slid his hands over tanned leather skins; then he'd painstakingly cut a pattern, shaping it around a wooden foot-shaped last* and stitch the pieces together, careful to keep his actions precise. As Salvatore followed each step, his heart beating and his toes flexing, the practice of shoemaking echoed deeply inside him, as if he had learned it already in a previous life.

Making shoes was considered low-class work even by a poor family, and Salvatore, the eleventh of fourteen Ferragamo children, knew he was expected to earn his keep. He told his father what he wanted to do. But much to his disappointment, his father admonished him: *No, Salvatore, shoemaking isn't for respectable people.* So Salvatore dutifully apprenticed with a tailor, then a barber, then a carpenter—but at each job, he showed little interest or aptitude. One Saturday evening, his mother, Mariantonia, rushed home in a panic. She needed two pairs of white shoes for her six-year-old daughter's First Holy Communion the next day, one pair for Giuseppina and another for the elder Rosina, who would serve as her attendant. Normally, hand-me-downs would have sufficed, but the Ferragamo girls had used and reused their white shoes so many times that they were too worn out to wear to church. All day Mariantonia had knocked on her neighbors' doors, looking for shoes to borrow, but many of the townsfolk had Communion-aged girls of their own and nothing on hand to lend. Mariantonia cried over dinner, grappling with the shame of sending her daughter to receive the Eucharist in shabby

* A wooden or metal mold used by shoemakers to mimic the anatomy of a human foot. The shape of the last also dictates the type of shoe to be made: one with a high arch, for instance, is used to accommodate the slope of a high-heeled shoe. Today's lasts are most often made from highly durable plastics that can withstand the demands of factory production.

shoes or worse, dark ones that would stand out amid the line of girls dressed all in white.

Without saying a word, Salvatore scurried to Festa's shop and asked the cobbler for a length of inexpensive white canvas, two child-size lasts, and tools, and then hid them in the nine-room, three-story house until everyone in his family was finally asleep. He tiptoed back downstairs and carefully laid everything out on a bench, imitating Festa. A sense of anticipation rushed over him: without hesitation, he let his hands, and instincts, take over. Somehow, Salvatore knew how to make shoes, and as he handled the materials that trustworthy part of him—the reliable inner compass that had pointed him toward his vocation—vibrated.

The next morning, Mariantonia woke up to find four small pairs of pristine white shoes, and on the church steps, she gushed over her young son. By nightfall, his father had no choice but to relent: to Salvatore's delight, he gave him permission to go to work for Luigi Festa.

Ferragamo was thrilled, but Festa, whom he had so long admired, wanted first to use him as a babysitter for his two children, and then, when Salvatore resisted, he let his young helper rush to fill orders while he smoked, played cards, and drank wine with his friends. Two years later, Salvatore's father suddenly died from an infection that settled in after a routine operation. Only eleven, Salvatore announced to his mother that he would leave their village and go to Naples, where he could further study his craft. Mariantonia initially balked, but soon Salvatore was on his way west to the coast with five lire in his pocket. Once there, he immediately sought out one of the most successful shoemakers in Naples and asked for a job. After just two weeks, Salvatore had learned so much more about shoemaking than he had with Festa, but when he requested his wages, the cobbler pointed to mistakes he had made while practicing and refused to pay. Even at this

young age, Salvatore could not abide this kind of injustice and the next morning walked to the nearby town of Cervinara where his uncle Alessandro lived. His request was simple: would his uncle loan him twenty lire to open his own shop back home in Bonito?

What Ferragamo didn't appreciate was that even Milan was hardly a fashion—let alone a footwear—capital yet. That title belonged only to New York and Paris, and the two cities competed like haughty grande dames, with the City of Light fighting to maintain its reign as the premier purveyor of covetable couture. Shoe styles and colors were limited—the dominant palette was black, brown, and white— and emphasized propriety: a woman might wear low-heeled pumps with tongues to cover the tops of her feet outdoors, semiandrogynous spectators and oxfords, or buttoned or lace-up Edwardian boots, which squeezed the foot like a corset to emphasize narrowness. Slip-ons with embroidery or beading were appropriate only for the bou-doir: a strictly observed rule. Poor families bought handmade shoes that were expected to weather a lifetime, and the notion of choosing particular shoes to match an occasion, mood, or outfit was the pur-view of only the most privileged citizens. Skirts lingered well below the ankle anyway, so a woman looking to compete with her neigh-bor's shoes might only catch a glimpse of toe, or at most, a tightly laced vamp,* before her dress obstructed her view.

Yet women's manners and interests in both cities were slowly

* The vamp, or upper, is the top part of the shoe that holds it onto the foot. For ex-ample, a traditional oxford's vamp consists of two panels tied together by laces, and another piece that slides over the toes (creating the "toe box"). With a sandal, on the other hand, the vamp can be as skimpy as a few lean straps.

shifting. At the turn of the century in Paris, when young ladies began bicycling and playing other sports, hemlines rose to allow greater freedom of movement. In response, shoemakers created taller boots to protect the stockings from errant spokes and mud. Feeling liberated, some women even swapped skirts for loose-fitting pants called bloomers—still, if a woman was caught in bloomers and not in the company of her bicycle, then she very likely would be sent home to change. More than a decade later, when the economic pressures of World War I caused hemlines to hike up higher still—shorter skirts required less fabric—shoemakers again followed suit, with boots that reached farther and farther up the leg, until practicality prevailed upon the fashion elite to permit everyday women to show a short length of exposed stocking.

As World War I spread throughout Europe and crippled its economic progress, the United States led in adapting to mass production. In the case of shoes, cobbling went from an artisanal craft to a booming and competitive industry. Now, with scantier skirts that automatically raised awareness of what a woman wore on her feet by putting them on display, women could afford to own more of these less expensive shoes manufactured by machines rather than by skilled laborers. Companies were suddenly able to turn out different colors and styles seasonally, display and sell them in department stores, and women could shop and experience instant gratification, rather than wait for a cobbler to fill an order. The fashion magazine, unlike its predecessor the fashion journal, relied on income from advertisers instead of just reader subscriptions, giving burgeoning shoe companies the chance to brand themselves. The result: the female consumer circa 1918 no longer had to trust the advice of her (usually) stooped local shoemaker but rather could spot a style she liked in a fashion editorial, or on another woman walking down the

street, and then go straight to the store and buy it. For the first time, she might even take her cues from the movies; the nascent film industry cultivated comely stars and projected its fashion plates on ten-foot-high screens. America, with its increasing prevalence of cars, movie theaters, and household radios, inspired an incipient consumer culture, and women, whether at home or employed, were courted aggressively.

But back in Bonito in 1912, the world had not yet changed, and the role of the shoemaker remained secure. With Uncle Alessandro's twenty lire in hand, Salvatore took over a small, windowless space in his mother's house, between the village's main street and the family's kitchen. The quality of his work quickly overcame the limitations of his humble storefront as word spread across the village about Mariantonia Ferragamo's enterprising fourteen-year-old son and his beautiful, well-made shoes. He began to attract customers from outside Bonito as well, and soon Salvatore was running a successful business with six assistants and a loyal base of well-off clients. Working dawn to dusk and making twenty to twenty-five pairs per week, Salvatore was able to pay back his uncle and even to start saving for the future. Then his older brother Alfonso visited Italy from his new home in America, bringing news.

Alfonso admired the craftsmanship of Salvatore's shoes and had become something of an expert himself: in Boston, he had taken a job at the Queen Quality Shoe Company. But when he learned the meager price his younger brother's creations commanded, he advised him: "Why do you waste your time working here in Bonito? Here you make a pair of shoes and get so little for them. In America, a pair of custom-made shoes would pay you much more if you cared to work that way,

though as a matter of fact in America nobody works by hand anymore." Alfonso described the factories where soles could be stitched to uppers, and heels were composed by stacking layer upon layer of leather—all in a matter of minutes. The machines did all the work, completing tasks that would take a solitary cobbler hours or even days bent over the table, his eyes strained against dwindling daylight. Salvatore listened, aghast. He grasped that as long as he stayed in Bonito, the scope of his success would be narrow, but *machine-made* shoes? He wasn't interested. The very idea was a travesty: an insult to the craft that he considered a pillar of his soul. As Alfonso packed his bags to return to Boston, he tried again to coax his younger brother, but Salvatore refused to listen. He was happy in his small corner of the world, he insisted, with his old-fashioned tools and custom designs.

Alfonso didn't let up. He returned to America and wrote letters about how happy Salvatore could be living with him and two of their other brothers, who had also resettled across the ocean. It didn't take long to change Salvatore's mind; his innate ambition was tempted by Alfonso's words even as he tried to convince himself he was satisfied living in Bonito. Once again, he packed his suitcase and headed west to Naples, this time to the port, where he'd board a cramped ship in a third-class cabin, headed for New York. Just before the SS *Stampalia* pulled away from the dock, Salvatore purchased a gabardine coat with a fur collar, so that he wouldn't be mistaken for "a provincial" in his new country. His eyes were focused firmly on the future, not the past; when he arrived in New York harbor without as much as a rudimentary grasp of English, he took in the tall buildings, the looming metal structures, and knew instantly that he belonged.

A few months earlier, Alfonso, Girolamo, and Secondino had left Boston for Santa Barbara, California, but after a train ride from New York to Massachusetts, Salvatore was greeted by his sisters and his

brother-in-law who, like Alfonso had, worked for the Queen Quality Shoe Company. Just two days later, he arranged to give Salvatore a tour of the factory, where he was promised he could pick his favorite section and begin a job there right away. Appreciative, and eager to explore the mysterious world of machine-made shoes, Salvatore entered and then watched in horror as pairs in every state of semi-fabrication sputtered down the assembly line: "This was an inferno, a bedlam of rattles and clatters and whizzing machines and hurrying, scurrying people. I stood dazed; I walked about dazed, watching the thousands of pieces of shoes going in at one end of the assembly line and pouring out at the other on endless belts, rows upon rows of finished shoes, hundreds of them, thousands of them." Even as he could admit that the products were decently constructed, he also understood that the factory had leached every bit of artistry out of the process, treating shoes as no different from the tools that were used to make them. Feeling miserable, he refused a job, at the risk of insulting his brother-in-law. Still, Salvatore trusted his gut; he listened to that internal voice that told him he could be successful making handmade footwear, even at a moment when snorting American machines were poised to replace him.

He wrote Alfonso in Santa Barbara, who was excited about the prospect of the younger Ferragamo brother joining them out west. California, with its hot desert air and spiny palm trees, was an attractive place to settle, especially because the United States government had offered free land to anyone who was willing to cultivate it. California was also the seat of the burgeoning film industry, where pioneering directors like Cecil B. DeMille were staging full-scale westerns filled with brave cowboys and savage Indians, which were hugely popular with audiences. When Salvatore arrived, the older Ferragamo brothers were only slightly annoyed by his refusal to

adapt to the realities of modern shoemaking, and ultimately, they accommodated him, agreeing to pool their money and open a small Santa Barbara shoe repair shop. They found a two-room storefront at 1033 State Street; there, they could bring in money by fixing broken and worn-out shoes, and the now sixteen-year-old Salvatore—the only talented designer of the bunch—could make new ones for the studios, specializing in pairs of comfortable, attractive, and period-appropriate cowboy boots. In 1914 the shop opened its doors and almost immediately proved to be lucrative, as Salvatore filled a gap in Hollywood and won the right people over; "the West would have been conquered earlier if they had had boots like these," DeMille remarked when he saw his work.

Surrounded by his family and creatively satisfied, Salvatore grew into a dapper, caramel-skinned artist with Bogart-esque rugged good looks, and spoke English with a thick Italian accent that charmed his patrons. In just seven short years, he had come so far from Luigi Festa's village shop, but ever since he was a little boy, one aspect of the craft had nagged him. In order to create a custom shoe, the cobbler takes a series of measurements from the client's foot, and then cuts, shapes, and stitches according to the numbers. Salvatore had learned the particulars from Festa and then again from the best shoemaker in Naples, yet some of his customers still complained that their feet hurt, which led him to wonder if the practice *itself* was flawed; perhaps there was some gap in his knowledge of the body that was getting in the way. He recognized that shoes served a very specific function and thus needed to be comfortable; he also believed, with every fiber of his being, that a woman needn't sacrifice beauty or glamour in order to be kind to her feet. That said, having catered to women in both Italy and America, he had seen firsthand the kind of damage ill-fitting shoes could do—so many older *signori* sought

him out, requesting custom work to relieve pressure on their blunt
little hammer toes, their sadly fallen arches, their stubborn corns,
and irreversible bunions, looking for respite from chronic pain and
discomfort. Many women blamed their genes, but Salvatore sus-
pected otherwise. He swore that he would never inflict this kind of
harm, and just to be sure, he enrolled at the University of Southern
California to study anatomy.

While a student, Salvatore was able to use his shop like a labora-
tory, testing his theories about the foot, weight distribution, and the
graceful human skeleton. A period of trial and error, during which
some women sang his praises while others criticized him, left him
frustrated, and his brothers urged him to give up the quest for per-
fection. But eventually he was rewarded for his single-mindedness
with a breakthrough. He—along with everyone else—was making
shoes wrong. It was indisputable. Except now, he was the only one
who knew how to fix it.

Like his mentors, Salvatore had been laboring under the false
impression that the foot should be measured while flat. This led to
shoes that supported the ball and the heel—which seemed to make
sense, given that the arch never touches the ground. But what Sal-
vatore realized—to his utter astonishment—was that walking bare-
foot, and walking in shoes, are physically two different functions.
In other words: shoes *change* the way we walk. Thrilled by this rev-
elation, Salvatore remodeled his lasts and tossed out the others that
couldn't be altered. The secret, he realized, was arch support. Sud-
denly women were telling him that he had made them the most com-
fortable shoes they'd ever worn in their lives.

Soon after Salvatore graduated from USC, the city of Santa Bar-
bara changed its tax rates, chasing the film industry a hundred miles
south to Hollywood. The business that had been the Ferragamos'

bread and butter disappeared. Salvatore tried commuting to Los Angeles, but the travel exhausted him, and he told his brothers he wanted to move the shop. They resisted, arguing that the repair jobs would keep the business afloat and relocating would mean starting from scratch with an entirely new clientele. For months, the brothers argued until Salvatore packed a car himself and in 1923 opened the Hollywood Boot Shop on the corner of Hollywood and Las Palmas boulevards. The film industry kept him busy; he filled commissions for epic movies like *The Ten Commandments* and delighted in the range of delicate Greco-Roman sandals he was asked to create. But the store also became a destination spot for cinema starlets, for whom the exotic and charming shoemaker would gladly design one-of-a-kind shoes, stretching the boundaries of his imagination for a class of women who all wanted to look cutting-edge and stand out from their fellow actresses. Before long, Ferragamo had satisfied his dream of opening a bustling shoe store that mixed art, podiatric science, and commerce—without the help of factories.

Outside of the worlds of footwear and film, women's roles had very recently changed, and it had only a little bit to do with industrialization. Women wanted to gain a stronger position within their households, but more than anything, they wanted to get outside and *vote*: to ensure that their voices had the same legal weight, breadth, and value as men's. While Ferragamo studied the foot, the suffragettes campaigned tirelessly, pounding the pavement in ornamented wide-brim hats, blouses with puffed sleeves, long, trim-waisted skirts, and medium-heeled boots—albeit ones that didn't, like the buttoned and laced-up designs still in fashion, pinch the foot into submission. Deliberately, they kept their appearances femi-

nine, anticipating the criticism that by demanding rights they were trying to supplant their husbands. This was the first time American women, as a community, had mobilized, and they celebrated in 1920 when the Nineteenth Amendment, granting women the right to vote, was ratified. Amid this triumph, the country's perspective was shifting; 1920 census data revealed that more than half of the country's population, roughly fifty-four million people, lived in cities, rather than in rural communities—meaning that in the United States, tight-knit villages like Bonito, along with their small-town values, were disappearing. The census produced another surprising statistic: two-thirds of the population was thirty-five or younger, with the median age set at a jejune twenty-five, which meant that overarching values were in flux and being reshaped by a youthful, more sophisticated majority with unprecedented access to one another and the world around them.

Just after the suffragettes won the vote, flappers and jazz babies caused fathers to whip out their shotguns as they danced into the night, bobbed their hair, and sampled prohibition liquor. The flappers didn't believe in marriage. They believed in dancing the Charleston into the early-morning hours, flirting with men, and laughing through the silence in the streets of New York. These women were younger than the suffragettes—in their late teens and early twenties when women won the right to vote—and came of age at a time when World War I had changed everything. Stylewise, thin was in. In response to wartime food depletion, the government had issued a comprehensive public awareness campaign about nutrition. As girls, the flappers grew up reading books for teens starring slim, attractive characters who always proved more successful than their overweight friends. Cigarette ads promised that smoking would help them maintain their figures, and they faithfully added a steady stream of nicotine into their diets. (Be-

sides, smoking was a good way to meet handsome men. Dangle a fresh cigarette between your painted lips and the gentlemen will always rush to light it.)

Flappers were intentionally provocative. Cosmetics had long been considered the trappings of floozies and prostitutes, but in response to the growing sense of national health consciousness, many more women started using makeup to cover up acne and other facial impurities, which were now regarded as signs of poor personal hygiene. Flappers, however, gravitated toward eyeliner and lipstick, using them to seductively highlight their features under dim nightclub lighting. The new national emphasis on a slender body, combined with government efforts to educate women about menstruation and procreation, caused birthrates to plummet by 33 percent between 1900 and 1929. Popular fashions catered to the flapper, who counted ease of motion for dancing among her highest sartorial priorities. As a result, shorter hemlines allowed for kicking and jumping, and showed off the flapper's skinny legs. The flapper liked putting her body on display—sometimes she even brushed rouge on her knees to imply sexual acts. However, her brand of sexuality was decidedly different from anything that came before it. Instead of wearing corsets that accentuated her breasts and small waist, she wore shift dresses with undefined bodices and low-slung waistlines that de-emphasized her hips. The flapper wanted to look coquettish, but her clothing, in its deliberate youthfulness, also confirmed that she yearned to be more than just the sum of her reproductive parts.

And as for the shoes—shorter skirts and dresses meant that footwear could be in the spotlight. Flappers liked high heels (again for their suggestiveness), and decorative shoe clips, which were affixed to the vamp like a brooch on a jacket, became a trendy way to personalize footwear. In order for women to participate in athletic dances,

secure fastenings became popular, both in the form of a girlish Mary Jane—named for the shoes worn by the sister in the popular 1902 comic strip *Buster Brown*—and the more mature T-strap, which bisected the foot vertically rather than horizontally. Conservative critics of underground Jazz Age culture pointed toward the flapper's high heels as a symbol of her impropriety, and some dissenters even went so far as to entreat the shoe companies to stop producing them. At a gathering of three hundred women who met to hear a speech from an "abolitionist" surgeon, he "went on record as being wishful to send to the penitentiary all manufacturers of high heels on the ground of mayhem and mutilation." As Mama's tightly laced or buttoned Edwardian boot went out of style, flappers gravitated toward a looser-fitting pull-on boot inspired by the Russian *valenki*—warm, floppy felt boots worn indoors or used to line waterproof shoes.* In fact, while some sources attribute the term "flapper" to the birdlike way these women's arms moved when they danced, others suggest that it refers to the sound these floppy boots made when, left casually unbuckled, they hit against the leg.

The flappers were willing to play Russian roulette with their reputations (that perennial, catchall term used to scare young women into behaving "decently"). But on Sunday, March 20, 1927, an incident took place that put flappers and their values on trial. Party girl Ruth Snyder was discovered in her Queens Village home in a lace

* Caroline Cox, author of *Vintage Shoes*, relates an etymological tidbit: "In 1922, a young woman in Chicago had been photographed in a speakeasy mischievously concealing a flask of illegal liquor down the side of one boot—a perfect illustration of the practice of 'bootlegging,' a term that dates back to the nineteenth century. Bootleggers were those who hid whiskey in their boot tops when going to trade with Native Americans, and it became a byword for criminals involved in the illegal transportation of alcohol across state lines."

shortie nightgown with her feet bound and a loosened gag by her side. A neighbor, alerted by Snyder's frantic nine-year-old daughter Lorraine that Ruth had been hurt, roused the stunned woman, and then searched the house, only to find Albert Snyder murdered in the couple's bed. The neighbor called the police, who quickly discovered holes in Ruth's story that the house had been burgled. A medical examination showed no physical evidence of the blow to the head that Ruth claimed had knocked her out cold, not to mention that Ruth, now a widow, seemed suspiciously unemotional about her husband's death. Police also found at the crime scene an entry for H. Judd Gray in Ruth Snyder's address book and canceled checks made out to Gray. When questioned about this man, Ruth Snyder fumbled.

H. Judd Gray was Ruth's lover, and together they had plotted her husband's murder to collect on his life insurance policy. Once the police called Gray in and his alibi unraveled, the couple turned on each other shamelessly. The case went to a tabloid-ready trial, quickly becoming a national news story for the way it spoke to mounting fears about the Jazz Age's effect on motherhood, with Snyder as the grisly embodiment of family life shattered by female sexuality. Almost immediately, she became the national bogeywoman. Known in the papers as "Granite Woman," "Ice Queen," "Ruthless Ruth," and the "Viking Vampire," she lost in the court of public opinion, where she gained a reputation as a nymphomaniac and a predator. The official judiciary was equally damning. William Millard, an attorney and a longtime friend of the Gray family, spoke in court on behalf of his pal: "[Ruth Snyder] . . . like a poisonous serpent, drew Judd Gray into her glistening coils and there was no escape. . . . This woman, this peculiar venomous species of humanity, was abnormal, possessed of an all-consuming, all-absorbing sexual passion, animal lust, which seemingly was never satisfied."

Snyder, as a woman who cuckolded her husband and appeared to prioritize partying over family, was easy to convict on a moral scale. In the end, both Snyder and Gray were sentenced to death for the murder of Albert Snyder, but only Ruth was subjected to one final, hideous indignity. On January 13, 1928, the day of her execution, the *New York Daily News* ran a shocking and macabre cover photo of Ruth Snyder strapped to the electric chair.

Permissive flapper culture was fruitful for fashion, but ultimately, freewheeling women in dancing shoes proved too hot for the average citizen to handle. Snyder's trial had lasting implications, indicting the carefree Jazz Age before it too was put to death a year later on October 29, 1929: Black Tuesday.

Ferragamo narrowly avoided the Great Depression; in 1927, despite an impressive array of high-profile clients, he locked the doors to the Hollywood Boot Shop and said good-bye to Los Angeles. His brothers, still living in Santa Barbara, thought he was crazy. What they didn't understand was that once again, Salvatore's internal compass had twitched, and there was no stopping him. He had an idea so extraordinary, he was willing to put his name on the line to test it, and in the battle of man versus machine, Salvatore was convinced his next step would be an unprecedented victory.

Over the past few years in Hollywood, Ferragamo had begrudgingly begun to sell some—though not just—machine-made footwear. The decision had been pragmatic; running an exclusively handmade shop put him under constant pressure to keep ahead of his orders and made it difficult to compete with footwear companies that enlisted the help of factories. Aware that his own stubbornness was getting in the way of his success, and armed with his recent discov-

eries about the foot, he allowed himself to wonder if he could achieve an equivalent level of comfort in shoes that were produced more efficiently. He had to admit, the machine-made versions looked passable, and because he was able to supply the manufacturers with his special, arch-friendly lasts, they satisfied the majority of his customers. Yet Salvatore himself was never completely comfortable with the arrangement, and he moved his orders from factory to factory, always in search of quality that met his standards. He felt caught: he required the output and speed of mass production to keep up in the American marketplace, but the results disappointed him. Did it matter, as long as his clients were pleased with machine-made shoes? But the shoemaker was not content—he was the one who had to put his name on the product, and he was haunted by visions of imperfect stitching.

Then it hit him: why couldn't he absorb the lessons of industrialization but still do things his own way? That was the answer—he would apply the factory model to handmade shoes. In Italy, where labor was cheaper than in America and shoemaking a more widespread artisanal craft, he would hire other cobblers to work for him, and create an assembly line in which every stage of the process would be touched by human hands. He brought the idea to Alfonso, Girolamo, and Secondino, who rejected it, but Salvatore was accustomed to advancing without them, and he secured investors. He incorporated and sent out press releases that announced his decision to return home, in order to bring mass-produced—yet entirely handmade—Italian shoes to fashionable American women. The orders poured in.

He returned home to Italy with high hopes and an enthusiastic welcome from his friends and family in Bonito, as well as from the press, who reported on the return of old-country Salvatore, who had

made good in the land of promise. Unfortunately, the Italian shoe-makers weren't won over as easily as his stateside investors had been. First, he arrived in Naples, where the local workmen laughed Ferragamo farther south. Then he tried Rome, Milan, Turin, Venice, and Padua with no luck; eventually, he settled in Florence, all but bribing the best shoemakers to come work for him by offering the highest wages around. With sixty men in his employ and money running out, Salvatore designed an eighteen-shoe collection, which he loved, despite the stresses of impatient investors who wrote letter after letter demanding evidence of his progress. Finally, the samples were ready and it was time to set up distribution in the States. Salvatore sailed back to New York and booked a room at the luxurious Hotel Roosevelt, just a few blocks north of Grand Central Terminal, where he displayed his newest designs for review by the city's top department store buyers.

George Miller of the I. Miller department store arrived first. He circled the shoes in silence while Salvatore permitted himself to wonder if his collection was so breathtaking that Mr. Miller found himself at a loss for words. Finally, he managed to speak: "Do you want me to tell you exactly what I think about your shoes and all these models?"

Salvatore awaited the stream of compliments.

"You have nothing, nothing! Forget about all this. Take my advice and go back to Hollywood and do the work you have been doing so well. You've got nothing, absolutely nothing."

It was as if all of Salvatore's insecurities were voiced in one swift, dismissive appraisal. Somehow he managed to thank George Miller for his honesty, then sat, dumbfounded, as he contemplated his options. He examined the eighteen pairs of shoes. Had he veered so far off course—become so obsessed with his mission—

that he could no longer tell the difference between inspiration and "nothing"? Perhaps. But just to be sure, he placed an emergency call to Manuel Gerton of Saks Fifth Avenue and braced himself for his assessment.

Gerton was in a rush, but just as George Miller had done, he picked up the samples, examined them, and finally turned his gaze to Salvatore to offer his verdict. Instantly, Salvatore could see that his eyes were alight. "This is the work that belongs to you! You have done something new, Salvatore. You have done something no one has ever done. You keep these shoes away from everyone. I want them." Gerton sat on the floor, ignoring his other appointments. By the evening, he'd ordered pair after pair, with specific modifications—an assignment that would keep the ecstatic shoemaker busy and funnel several thousands of dollars back into his company.

Ferragamos were the first Italian shoes ever to be exported and sold internationally—he put Italy on the footwear map. His business model proved successful; when the older, staid cobblers refused to adapt to his methods, he replaced them with young apprentices who could be trained to make footwear the Salvatore way. However, the Great Depression affected his stateside business, and his American investors pushed him to sacrifice quality for quantity. In 1933, Salvatore faced bankruptcy and, for the first time since he was a teenager toiling in Bonito, turned his focus to Italian domestic sales. Then, another blow: Mussolini's power-hungry conquests cut a second, more debilitating slice into his revenue stream. After Italy's dictator unilaterally invaded Ethiopia in 1935—a fanatical play for power that presaged World War II like the tremor before an earthquake—the League of Nations responded by imposing sanctions on the small European country. Salvatore recalled that "in one stroke my growing export trade was killed. Consignments of shoes awaiting ship-

ment were never loaded; orders on their way through the factory had to be canceled and orders booked not yet put in hand, worth many thousands of lire, were wiped out." To make matters worse, as the war gained traction, materials like leather, rubber, and steel—the staples of a shoemaker's toolbox—disappeared from the market, repurposed for combat use. Imports were hard to come by, owing to the difficulty of transporting goods from hostile countries. Salvatore was desperate; his supplies were so limited that he considered trying to make shoes from glass. He refused to watch his hard-earned business sink for the second time.

Tinkering in his workshop early one Sunday morning, he slipped out to buy a box of chocolates for Mariantonia, who had a sweet tooth. As he unwrapped a candy, he examined the transparent paper foil, manipulating it to test its pliability. He twisted it around his finger, gauging its strength. Salvatore was accustomed to decorating soft leather with silver and gold to catch the early-evening light, and he imagined using this foil similarly, skipping the kidskin altogether. He purchased sheets of transparent paper, experimented with layering them and braiding them, and found, much to his delight, he could make attractive uppers using this material. Eureka: the problem of embellished sandals in wartime was solved, but Salvatore's second great challenge—to figure out how to make an elevated shoe without the steel required to reinforce a high heel and keep it from breaking—continued to vex him. He found that low-quality substitute steel snapped under the lightest pressure, which would never do, and so as long as sanctions were in place, traditional high heels were out of the question. This led to a second breakthrough: "I asked myself: Why not fill in the space between the heel and the ball of the foot? Excited, the line of such a heel clear in my mind, I sat and experimented with pieces of Sardinian cork, pushing and gluing and

fixing and trimming until the entire space between the sole and the heel was blocked solid."

The solid platform shape wasn't new; it dated back to ancient Greece, when actors wore wedged sandals to indicate characters of great importance, but it had long since gone out of style in favor of the delicate high heel. The idea of building a sole from cork had also been lost to antiquity. To advertise his new invention, Salvatore relied on a tried-and-true subset of consumers: wealthy, fashionable women. Excited about the style, he called one of his best customers to the Florence shop.

"I have an entirely new type of heel for you to wear," Salvatore announced to the Duchessa Visconte di Madrone. "I wanted you to be the first lady in the world to wear it."

"Signor Ferragamo!" she exclaimed when he produced the prototype. "You don't mean to tell me *you* designed that horrible thing?"

In spite of her resistance, he managed to convince her to wear a pair to church one Sunday morning, and much to her surprise, the duchess found them incredibly comfortable. She then shared this revelation with all of her high-society friends. Sure enough, cork-bottomed wedges—"lifties" or "wedgies" in the United States— became enormously popular, in large part because they were easy for women to walk in. By 1938 Alice Hughes, writing in her "A Woman's New York" column for the *Washington Post* about upcoming footwear fashions, noted that "one big house tells me of white summer shoes with 'peek heels,' 'platform soles,' 'punch-work pigskin,' and 'wheat-linen wedgies.' Meaning simply draped toes, open heels, perforated leathers, raised soles, and off-white shades. Whatever became of the good-old American language, anyway?" Yankee women, not yet feeling the same strains from the war as their European counterparts were, enjoyed the novelty and even whimsy of the wedged shoe, imi-

tating the outrageous Brazilian entertainer Carmen Miranda, who always wore platforms to augment her tiny five-foot frame. Miranda commissioned over-the-top versions, studded, laced, and even decorated with plastic fruit to play up her *hot-hot-hot* South American heritage. By 1939, Ferragamo estimated that 86 percent of women's shoes manufactured in the United States were wedgies, though he received disproportionately little financial reward from his shoes. Although he patented the cork-bottomed wedge in many countries— including the United States—the style caught on so quickly that he could not possibly take legal action against every single manufacturer that knocked it off. Throughout his career, Ferragamo's designs were invariably copied, but the coolheaded cobbler regarded imitations as incentive to go back to the drawing board, pushing the limits of his creativity to see what new kinds of shoes he could conjure that would, once again, be mimicked by less talented shoemakers.

2

· · · · · · · · · · ·

MGM, the
Great Depression,
and Pulling
Yourself Up
by Your
Ruby Slippers

(1936–1939)

1936: Hollywood, California

In his quest for international success, Salvatore Ferragamo left Tinseltown behind him, but as the years passed the film industry's popularity only grew. Soon after Judy Garland was signed to MGM, Louis B. Mayer wasn't convinced he wanted to keep her on the payroll. As the studios were trying to make sense of that uncomfortable age gap between cute child star and full-fledged adult, the studio

had signed two adolescent girls with grown-up voices: Garland and Deanna Durbin. Judy (born Frances Gumm) received her contract first, and only two months later, she was disappointed to learn that there would be another young female singer joining her on the lot. Deanna (born Edna Mae Durbin) was hired to play a younger version of German opera star Ernestine Schumann-Heink, and while Judy had no problem with Deanna per se, she couldn't understand why the studio would take on a second teenage singer when they were having so much trouble figuring out what to do with just one. At thirteen (Judy) and fourteen (Deanna), both girls were stuck in the "awkward age," when actors are no longer adorable moppets in the style of Shirley Temple—whose success with 20th Century-Fox since the ripe age of six had the other studios scrambling to find their own lucrative answers to her. Judy had performed with her family's vaudeville act for so long that her first steps were all but tap-danced; however, she hadn't made it to Hollywood in time to take full advantage of her appeal as a wunderkind.

At least their voices were different. Deanna—a cherub-faced soprano—sang classical opera while Judy was scrappier, singing all-American pop-jazz vocals better suited to her rich alto range. MGM tried to take advantage of their unique talents, pairing the girls in shorts such as *Every Sunday* in which their styles were intended to complement each other. Unfortunately, Louis Mayer was unimpressed and issued a decree that flummoxed his staff:

Fire the fat one, he commanded.

Physically, Judy and Deanna weren't so dissimilar, though Deanna, with her athletic build and slightly slimmer waist, was probably the girl Mayer wanted to keep. If Ernestine Schumann-Heink hadn't pulled out of her own biopic and left the project stalled, Judy Garland might have been booked on the next flight back to Grand

Rapids, Minnesota, where she would have spent her life singing torch songs about what could have been. As it happened, Deanna was cut, and she left to become an A-lister for Universal. Soon Deanna was carrying films, and Judy sobbed about her floundering career while Mayer wondered if they'd let the wrong girl go.

Ironically, Deanna's good fortune proved to be a boon for Judy. "Adolescents Get Chance in Pictures," the *Hartford Courant* reported in February 1937. "[The] success of Deanna Durbin gives youngsters who have outgrown child roles new hope." Mickey Rooney—an MGM contract player—was the first child star to effectively transition past the dreaded age of thirteen, and he starred in a series of movies about Andy Hardy, a teenage boy getting into comedic scrapes as he learned his place in the world. In *Thoroughbreds Don't Cry*, Judy joined the cast as a younger girl holding a torch for Andy, and she reprised the role in three of the sixteen Hardy movies. The Rooney-Garland pairing became popular, but the studio still wasn't quite sure what to do with her. Judy yearned to play more mature characters, comparing herself unfavorably with her peer Lana Turner, who also appeared opposite Mickey Rooney but as a love interest admired for her sex appeal.

There was no doubt Judy could sing, and her comedic timing had been primed in vaudeville—the girl knew how to tickle an audience. Unfortunately, she wasn't sensual like a starlet, though her body wasn't childlike either, and her weight consistently rankled the MGM brass. It was challenging to sell her as a romantic lead; Judy's wide eyes, diminutive height, and wise-beyond-her-years acting style gave her a puckish quality better suited to the role of the little sister. Then, after Disney struck gold with its animated full-length feature *Snow White*, shot all in arresting Technicolor, MGM acquired a property that had been bounced from studio to studio as producers struggled to conceptualize it on-screen.

The Wonderful Wizard of Oz was a children's fantasy novel written by L. Frank Baum, starring an ageless heroine named Dorothy Gale who was depicted in the book's pen-and-ink illustrations as a girl of roughly eight to ten years old. Though she was already fifteen by the time the film was casting, Judy's name came up for the part; vocally, she was a sure thing, and perhaps the impishness that left her wedged uncomfortably between childhood and adulthood would be an asset in a part that required both flashes of homegrown wisdom and naïveté. Unfortunately, not everyone at MGM believed in Judy, and the studio put out feelers to gauge the possibility of borrowing Shirley Temple—at ten, an established A-list box office draw—from Fox. Execs also floated the idea of hiring Deanna Durbin, but Mayer was still sore about losing her and refused to help advance her career with a competitor on his own dime. When word came back that Fox wouldn't loan out Temple, Judy Garland got the part of Dorothy—by default. Whether or not everyone at MGM agreed that she was the ideal lead actress for the film, at least she was a contract player, meaning that any individual recognition she received for her work would ultimately translate into money in the studio's pocket.

The screenplay proved just as troublesome as the casting, and South African screenwriter Noel Langley—one of a handful of writers offered the challenge of translating Baum's unusual story for the big screen—took a deep drag on his cigarette and examined page twenty-six of his script, attempting to see it with fresh eyes. Langley, a twenty-six-year-old who'd published his own successful children's book in 1937, was expected to do well with fantasy material. He scrutinized the scene: It was the moment when the Wicked Witch of the West (abbreviated as "West Witch" on the page) first appears on

camera, the moment when Dorothy, a simple farm girl from Kansas, realizes that her house has dropped on the witch's sister. Dorothy insists it was an accident, but the West Witch won't be mollified. "You kill my dearest friend and severest critic and then pass it off as an accident, do you?" she would sneer menacingly. No. Too wordy. Langley crossed out "dearest friend and severest critic," and wrote "twin witch" it its place. He read it again. Did they need to be twins? "Sisterwitch" sounded better—"you kill my sisterwitch." He'd go with that. Satisfied, Langley moved down the scene to a camera direction: *C.U. [close-up] silver shoes.*

L. Frank Baum described Dorothy's shoes as silver, in a schema that some scholars believe was an allegorical attack on the gold standard: the principle, criticized by William Jennings Bryan and the Populist Party at the time of the novel's conception, that all U.S. paper money should correspond to a reserve of gold in the federal Treasury. But thirty-eight years after *The Wonderful Wizard of Oz*'s publication, MGM was less concerned with faithfulness to the original story or with forwarding any kind of obsolete political agenda than it was with protecting what would become a three-million-dollar investment. With a quick pen stroke, Langley made an historic, and unilateral, decision. Aware that the studio would be filming in Technicolor, he unceremoniously crossed out the word *silver*, recasting the shoes as ruby. *Ruby* sounded more precious, and red would look better on-screen, in brilliant contrast against the yellow brick road. In that moment, the silver shoes from L. Frank Baum's classic book were forever changed, subject to a Hollywood makeover.

The management at MGM thought Judy needed more than a pair of fancy shoes to overcome her imperfections, and they weren't shy

about telling her so. She was a midwestern girl with a stocky build, and that sort of plain-Jane look didn't cut it in Hollywood. From her early years at the studio, Judy was subjected to a starvation diet, with the canteen under strict orders never to serve her anything but clear soup and cottage cheese. She was also given diet pills, which girls popped like candy on the studio lots, except that they made the already hyper teenager feel edgy. What Judy—and her mother, who approved of her daughter taking them—didn't know was that diet pills contained amphetamines, the active ingredient used to curb hunger. As a result, they kept Judy from sleeping, so she was prescribed barbiturates as well.

Once she was cast as Dorothy, Judy found she was pressured not only to perform well but also to be attractive: the implication was that audiences would have a harder time rooting for a fat, homely girl who just wants to go back to Kansas. The MGM costume designers considered her hopeless, and even her costar Ray Bolger, who played the Scarecrow, noted that "she wasn't pretty—she was plump." Judy, already insecure about her looks, endured nonstop scrutiny as the studio tweaked her appearance. They capped her teeth to change her smile and tested putty on her nose to give the tip, which was naturally blunt, more definition. When crash dieting failed to give Judy the desired hourglass shape, wardrobe tried out corsets that would make her waist look clipped, like Vivien Leigh's. The only problem was that they sucked in her abdomen so tightly she couldn't breathe—which would have been a surmountable setback, except that if she couldn't breathe, she couldn't sing. Judy put up with the slights because she was desperate to perform.

The Wizard of Oz went through four directors, but the first one—Richard Thorpe—made, along with the wardrobe and makeup teams, strong, particular choices about Dorothy's look. On August 27, 1938,

Judy shot her first costume tests for the film, trying on both red and blond wigs and modeling heavy, highly mature facial makeup. MGM initially approved the blond hairstyle, which cascaded down past her bust so that she looked less like a farm girl and more like the California version of one: a glamour-puss in Kansas trying to blend in by slumming it in a blue gingham smock. As with any story that requires building a fantasy world, the production team took a while to pinpoint the overall appearance of the film, toying, for instance, with the idea of making the Wicked Witch beautiful because *Snow White*'s evil queen was so elegant yet terrifying. Ultimately they opted for a more traditional vision of the witch (green face, pointy hat), and director George Cukor was hired to replace Thorpe after producer Mervyn LeRoy saw the dailies and was unimpressed. Cukor was obligated to start filming on *Gone with the Wind* in two weeks, but after watching the footage himself, he was disgusted to see that his predecessor had failed to capture the childlike sensibility of the original novel. To his eye, problem number one was Dorothy's styling, and between October 26 and November 3, Cukor and others tweaked Judy's costume yet again, experimenting with different blond wigs and then giving up on them altogether, choosing to use Judy's natural dark hair and set it in pigtail braids. They had her scrub her face almost clean, allowing her round, honest eyes to sparkle, working toward the ultimate impression that she was a teenage girl playing younger, rather than a juvenile trying to pass for a silver screen starlet.

As Cukor fine-tuned Dorothy's appearance, *Oz*'s costume designer worked on her ruby slippers, which unlike most shoes used in films would be subject to multiple close-ups over the course of the narrative. The foppishly handsome Adrian—aka Gilbert Adrian, aka

Adrian Adolph Greenberg, whose de-ethnicizing name changes were par for the course in Hollywood and, with Hitler's concurrent rise to power, demanded no exhaustive speculation—joined MGM in 1928, showcasing his opulent, glamorous style on previous films like *Camille* (1936) and *Marie Antoinette* (1938). He was accustomed to designing for sophisticated clients like Jean Harlow and Greta Garbo, and *Oz* wasn't exactly his métier, though he enjoyed the creative challenge of fashioning hundreds of tiny, unique costumes required for the opening Technicolor sequence in Munchkinland. Adrian was less inspired when it came to Dorothy's shoes, but he experimented with some more outlandish designs, like the "Arabian Test Pair": a draft version of the ruby slippers with elfishly curled toes. Producers ultimately settled on a standard round-toed pump with a low, French (curved) heel, similar to popular comfort styles advertised in women's magazines at the time for six or seven dollars a pair. The pumps were made of white silk, lined with white kid leather, and supplied by the Innes shoe company in Pasadena, California, before they were dyed red and decorated with a crepe georgette overlay covered in sequins—Adrian also tested out rows of bugle beads on the early models. Because a series of pairs of shoes would be needed for the shoot—in sizes ranging from 4½ to 6B, depending on whether they'd be used for close-ups or dance numbers—they were put together both in-house at the MGM wardrobe department and at Western Costume in Burbank, where cobbler Joe Napoli operated a permanent shoemaking salon. During Thorpe's tenure, the vamp of the slippers was unadorned, but even Dorothy's shoes were scrutinized during Cukor's makeover, and the bows that appear on all final versions of the pumps were added at the last minute, also to underscore the youthful spirit of the female protagonist.

Cukor understood that preserving the innocence of the story—

its sense of wonder and majesty—was vital to the film's success. In the years following the Great Depression, national tastes had swung from sophisticated to sentimental (as film journalist Aljean Harmetz put it), and in response, Hollywood started moving away from movies that celebrated slinky sexuality and glamour, and instead turned out pictures—like the ones starring Shirley Temple and Mickey Rooney— that focused on the home, life lessons, and family. The stock market crash of 1929 prompted an era of conservatism, when the best things in life had to be free because everything else was inaccessible, and then the looming threat of World War II, already spreading through Europe like hideous déjà vu, made most citizens want to nestle up safely in their beds. On August 25, 1939, when the film debuted, Dorothy's mission to return home to Kansas folded seamlessly into America's dominant ethos of self-preservation. After Mussolini invaded Ethiopia and Hitler expanded the breadth of the Third Reich, a poll called "What America Thinks About the War," in the September 25, 1939, issue of *Life* magazine, revealed the scope of countrywide denial. *Who do you want to win the war?* the magazine asked. Predictably, 83 percent of readers sided with the Allies. And yet when asked what the United States should do, only 3 percent polled voted to join in the fight.

"Home"—the destination toward which the slippers helped Dorothy, and therefore the audience, arrive—was a safe retreat, even if it did look like Kansas. In March 1938, the *Chicago Daily Tribune* cheerily declared gray the color of spring, offering unintended insight into the mind-sets of both fashion designers and consumers. Thanks to Ferragamo's wedgie, the high heel was becoming less common, not only because it wasn't *en vogue* but also because at a time of financial uncertainty and political unrest, comfortable shoes were appealing. It wasn't just that the ruby slippers looked exceptional on film (though,

thanks to Langley and Adrian, they did), but also that the message inherent in the story resonated deeply with *The Wizard of Oz*'s audiences. Though World War II hadn't yet slithered onto American soil, it was eerily familiar; this was a country of immigrants and exiles, many of whom were expelled from their motherlands by the first massive wars that made home a distant, haunting memory. Even if America was the land of plenty—a promise that was beginning to feel deceptive too, since the Great Depression leached this real-life Oz of its riches—it couldn't compete with childhood, family, and a piercing sense of homesickness that shaped following generations. That nostalgia in turn informed America's isolationism: citizens, whether native born or immigrants, felt deeply protective of the lives they'd built. And what better beacon was there for the American public to turn toward than a pair of glittering, magical shoes; at a time when luxury was unattainable, the ruby slippers were both covetable and comforting, in that they reiterated a profound and timely conviction. Though temporarily lured by the opulence of the Emerald City, the young heroine ultimately prefers dusty, unglamorous Kansas, where hard work is rewarded and familial bonds trump a life of leisure. Dorothy is able to appreciate what she had only once she lost it, a revelation close to the hearts of Depression-era audiences. And though she ultimately slays the witch to save herself, Dorothy's mission was never to rescue Oz from its demons. Rather, she wants to recline in a familiar bed; no matter how dull and uninspiring her home life, only the devil you know is worth the battle.

After the ruby slippers made their sparkling debut, red replaced gray as the new It color: "Seldom has a color caught on like this one. Red, with a dozen new names—gunfire red, flag red, fireman's red,

Robin Hood red, rowdy red, red flannel, bonfire red, roaring red and bullfight red—promises to blaze through the winter." When Dorothy clicked her heels together three times, audiences fell in love with her for her absolute goodness. Embedded in the family-friendly story about a pair of miraculous red shoes was an appealing and persuasive fable; sixteen-year-old Dorothy Gale, aching with wanderlust, receives the slippers as a token of gratitude. Glinda, the Good Witch of the North, assures her that they'll also protect her from the dead witch's vengeful sister, the Wicked Witch of the West. Throughout the film, the shoes appear to have little power and, though beautiful, serve as an encumbrance more than anything else. The witch wants the slippers, but they can't be removed from Dorothy's feet: a predicament the bloodthirsty villainess is more than willing to rectify. It's not until the end of the film, when Dorothy has found the inner strength to stand up to the wizard and vanquish the witch, that Glinda reveals the slippers' true potential; with just three clicks of her heels, Dorothy can fulfill her heart's desire, which is to return home to Kansas. *The Wizard of Oz* is a classic tale of self-actualization, with the shoes serving as a stunningly visual metaphor—strength comes from within.

The story, in a succinct and dramatic way, reinforced an idea about shoes that finds its source in older fairy tales: they will help us to achieve our dreams. The slippers can turn Frances Gumm into Judy Garland and a clumsy farm girl into a heroine; shoes can transport us from one place to another, but they can also transform us into wondrous versions of our most imperfect selves. Just like Dorothy's ruby red pumps, Cinderella's glass slipper restores her to her rightful position in the world. Once Cinderella slips that sparkling, delicate shoe on her tiny foot, her true identity—as a poor chambermaid but also a warm-hearted, gorgeous young woman who has captured

the imagination of a prince—is revealed. Elizabeth Semmelhack, cultural historian and senior curator of the Bata Shoe Museum in Toronto, Canada, believes shoes are so central to cultural narratives for two reasons: one, because after a certain point of human development, nearly everyone wore them, and two, because unlike other clothing or other accessories, they have to fit perfectly. She cites Charles Perrault's 1697 version of *Cinderella, or the Little Glass Slipper*, in which the shoe fits her "as if cast from wax." This, Semmelhack argues, hints at why the slipper is so effective at distinguishing the kind-hearted servant girl from her evil stepsisters; glass doesn't stretch, so without the matching foot the shoe is useless, thus rendering it the ideal judge of identity and—in the story's case—character.[*]

Many cultures have a version of the Cinderella story, in which a shoe helps to elevate a kind and beautiful girl to a superior social stratum. In the Korean version, a peasant girl named Peach Blossom loses her straw sandal, only for a handsome magistrate to find it and fall in love with her upon the shoe's return. Egyptian youths rooted for Rhodopis, a Greek slave girl whose gilded sandal is stolen by a bird, which then deposits it in the pharaoh's court. Pharaoh is so intrigued by the delicate shoe that he decrees—just as in the French story—that the tiny-footed owner shall be his bride. When Rhodopis fits the shoe, she and pharaoh are married, and she never has to suffer the burden of hard labor again. Perrault's take on the story has Cinderella born of a good family, but through the misfortune of her mother's death and her father's ill-advised remarriage, she is

[*] For this reason, Ms. Semmelhack also believes that the rumor that Perrault's glass slipper was originally made from *vair* or fur, and that a mistranslation changed it to glass, is an "urban legend."

stripped of the advantages of her class and forced to work as a maid for her stepmother and her two hideous stepsisters. Cinderella is so virtuous that she never complains and thus is rewarded by her generous fairy godmother, who arranges for the girl to wear a beautiful disguise when she meets her prince. Eventually an abandoned glass slipper sends her on the path toward happily ever after.

Before she marries the prince, Cinderella's strength shows in her ability to endure, but other stories have less deserving protagonists punished for their social ambition, exhibiting the dark side of every morality tale. In Perrault's story, Cinderella instantly forgives her tormentors, and the suggestion is that her soul is too pure even to hold a well-deserved grudge. When the German brothers Grimm adapted the story in the early 1800s, they made more of "Aschenputtel's" noble birth and were not nearly as kind to the usurping stepsisters. When word makes its way across the countryside that the prince is armed with an itty-bitty shoe, the evil stepmother commands her daughters to cut off their heels and toes to make it fit. The prince—not so bright, apparently—gets one sister, then the other, halfway home before noticing the glass slipper pooling with blood. When our heroine finally gets the chance to slip on her shoe, her status is restored, and thus the tale reinforces the inevitability and dominance of the social order.

This theme is even more pronounced in "The Red Shoes," a dark 1849 fairy tale written by Hans Christian Andersen. Noel Langley might not have known it, but his quick decision to change Dorothy's slippers from silver to ruby visually aligned them with a demonic pair of shoes sent to teach an uppity young girl a lesson. Traditionally, red shoes are affiliated with nobility: in the sixteenth century, red was one of the most expensive dyes because it had to be imported from Mexico, and in the seventeenth century in Paris, Louis XIV

ordained that only members of his court were allowed to wear red-heeled shoes. In "The Red Shoes," orphaned peasant girl Karen is lucky to be adopted by a rich woman, but rather than appreciate her good fortune, she grows up vain and entitled. She isn't happy just to be wealthy—she wants to be *royal*. After spying a real princess in a pair of red shoes, Karen tricks her near-blind mother into buying her a pair. She cherishes the red shoes far more than she cares for the woman who paid for them, wearing them to church despite the strict dress code, and ultimately abandoning her family to go dancing when her mother falls ill. Then comes the inescapable cosmic retribution: Once she starts dancing, she can't stop, and the red shoes won't come off, taking on a life of their own and spinning Karen into exhaustion. She can't attend her mother's funeral, and ultimately she is forced to have her feet cut off by the local executioner. But the red shoes still torment her, dancing at the threshold of the church when she tries, now hobbling on crutches and wooden feet, to repent. In the end, Karen takes a job as a maid and finds God within her heart. At once, she is shepherded to heaven.

Like Cinderella's stepsisters, Karen is punished for her ill-advised aspirations toward status and for failing to appreciate all that she's been given. Andersen also promoted this message in "The Little Mermaid," in which a young woman leaves her perfectly comfortable underwater home in pursuit of a human prince, only to find that he loves a princess (naturally) and that her decision—to trade her tail for legs, even if it meant that each time her feet touched the ground it would feel like she was walking on broken glass—left her miserable. Magical shoes can be tricky, and whether they deliver a reward or a curse seems to depend almost entirely on the soul of the person who wears them. As far as the viewers knew, the ruby slippers, in the witch's hands, could have turned ruthless, penalizing

her for her nefarious designs on Oz. Though Cinderella's glass slippers elevate her classwise while Dorothy's ruby ones restore her to a modest home, what the two girls have in common is a sense of humility and decency, an unwavering ability to make the best of challenging circumstances.

Dorothy is particularly special because Oz's riches do not tempt her; instead, her brush with fantasy turns a daydreamer into a realist who understands that Kansas is the best she can possibly hope for. Concise fairy tales, which speak volumes about cultural values, tend not to reward immoral strivers: those restless villains scheming to get their hands on the world's most glistening possibilities by any means necessary.

3

· · · · · · · · · ·

Back to the
Drawing Board

(1937–1943)

Even before they officially tossed their weight into World War II, Americans hated Hitler. Like the Wicked Witch of the West, he was a usurper who destabilized the fragile international community and felt entitled to take what wasn't his; just days after *The Wizard of Oz*'s premiere, a satirical cartoon titled "In the Not-So-Merry Land of Oz" popped up in the Utica *Observer-Dispatch*, depicting Hitler as a pointy-hat-wearing, broom-wielding thug, and Dorothy and her companions as the Allies. As the Axis countries bulldozed their way across the globe, the role for

men to play—as tough guys and heroes—was clear. For women, how-ever, their place in the war effort was less easily defined. At the end of 1939, when England unleashed 1,500,000 women into the work-force, Americans were still negotiating the space for femininity in a world so hostile and dark. Should women find a way to participate like their British counterparts, or should they be innocent, wide-eyed bystanders? Beautiful muses in spindly high heels? Or some-thing else entirely—like paragons of compassion—in skintight, red-hot boots?

While Judy Garland was winning over audiences with her natural sense of wonder and virtue, Lana Turner—her peer and sometimes rival—was a tabloid sensation, as famous for her performances as she was for her tempestuous love life. During the reign of the studio system, all publicity was (in theory) good publicity, but it was also run through the sanitizing filter of the Hollywood star machine. For instance, there was the story of Lana's beloved father's early death, back when she was Julia Jean Turner and just ten years old. According to the press, he died of a sudden heart attack that left mother and daughter solemn but also prepared to fend for them-selves. Years later, Lana herself would admit that her father was a bootlegger and a gambler, who got himself killed after a mobbed-up card game and was robbed of the sock where he'd always stashed his winnings. Then there was the legend of Lana being discovered at a soda fountain at age fifteen, which became not only the peg of every early article written about her but also a piece of Tinseltown lore that would prove that Los Angeles was the city of dreams. Lana was drinking a chocolate malt at a soda fountain when a journal-ist approached her and asked, "How would you like to be in the

movies?" Though she was young, Lana knew a line when she heard one, except this time W. R. Wilkerson (founder of the *Hollywood Reporter*) turned out to be the real deal. Turner would later confirm that the story was mostly true, though publicity left out the part where she was cutting her class at Hollywood High, and she was drinking a Coke, not a chocolate malt, because a Coke cost only a nickel and that was all she could afford.

Wilkerson introduced Turner to talent agent Zeppo Marx, who in turn introduced her to producer and director Mervyn LeRoy, after a stop with Warner's casting director, who didn't bother with idle chatter but instead instructed the terrified teen to lift her skirt and show him her thighs. LeRoy liked Turner, and after changing her name he cast her in a small but pivotal part in 1937's *They Won't Forget*, in which a southern girl (Turner) is raped and murdered and the town sets out to solve the crime. Lana was styled in a black pencil skirt, a tight-fitting sweater, a skinny black belt around her waist, and a scarf tied around her neck, all intended to accentuate her zaftig figure. With an off-center beret, with eyes and lips that dominated her round face, Lana's appeal was obvious: she was a teenage girl, caught somewhere in between schoolgirl innocence and womanly sex appeal. When she attended the film's screening with her mother, that adolescent self-consciousness quickly occluded the initial thrill of seeing herself on-screen. As her character appeared in the frame, Lana saw "a Thing," with bouncing breasts and undulating hips. A few men in the audience whistled. Humiliated, she slipped out of the theater as soon as the lights came up, all too aware of the impression that her body—not her acting— had made.

Lana became "The Sweater Girl," a nickname that alluded to the size of her breasts, and this persona went on to inspire a girl-next-

door style of pinup that showed all-American babes in various states of tantalizing seminudity.

Babes in states of tantalizing seminudity were Alberto Vargas's specialty. When Vargas's friends in Hollywood learned that he drew pictures of sexy women in his spare time, they teased him: *"Who do you think you are, George Petty?"* Vargas thought, I should be so lucky. Petty made almost $1,000 per cartoon drawing curvy, vivacious girls—always with their toes pointed to extend the leg—wearing everything from sexy high heels to ballet shoes to cowboy boots, for national publication in *Esquire* magazine. Meanwhile Vargas was stuck doing suggestive portraits of starlets for the movie studios. The work tested his technical artistry but not his imagination. Every night he came home and painted fantasy girls, inspired by his wife, Anna Mae Clift, who had been his first model back in New York when she was a dancer for the Ziegfeld Follies. For years, Anna Mae tried to give him the eye while she posed for him. For years, the mild-mannered, Peruvian-born artist kept his distance, referring to her only as "Miss Clift" as she stood before him undressed.

But Vargas wasn't a coward. Eventually he got the girl, and when his buddies chided him about his hobby, he pushed back: *I'm better than Petty. I could easily take his job if I wanted it.*

That confidence was tested a year later, after Alberto had been blackballed for joining his fellow artists in a unionization walkout. Desperate for income, Anna Mae encouraged him to travel back to New York—the heart of the advertising industry—to see what kind of freelance work he could find. Around the same time, Petty's demands to *Esquire* had become untenable. His pictures were popular,

but the publisher found him moody and entitled, consistently taking advantage of his position with the magazine.

Alberto didn't know he was headed to *Esquire* when he closed the crosshatched steel door in front of him and pressed the button in the elevator. A friend had arranged a meeting with "Mr. Kaufman"; even after hearing rumors that *Esquire* was looking to replace Petty, he refused to send them pictures, afraid that years of bravado and nourishing daydreams would be shot down in one heartbreaking rejection. When he opened the door to the *Esquire* offices, Alberto realized where he'd been sent. He showed his portfolio to Kaufman and the New York chief Sidney Carroll, who were quickly on the phone to the main branch in Chicago, announcing that they'd found an artist who could—as Vargas had long suspected—"out-Petty Petty."

A quick trip to the Midwest and a handshake with the publisher later, Alberto had a three-year binding magazine contract in front of him, guaranteeing him seventy-five dollars a week and 50 percent of all profits from sales of his work. David Smart, *Esquire*'s president, suggested a minor concession: would the talent be willing to drop the *s* from his last name, changing it to Varga? Like "Petty Girl," "Varga girl" had a certain je ne sais quoi, and Smart could imagine his readers saying it. Alberto, thrilled to secure his dream job (along with a weekly paycheck), gladly agreed.

Vargas couldn't have chosen a more serendipitous time to become the nation's most high-profile nudie artist. The first Varga Girl appeared in *Esquire* in October 1940; the attack on Pearl Harbor, which shocked America out of its isolationist slumber, took place just over a year later, on December 7, 1941. Suddenly servicemen were being shipped overseas in droves, separated from the wives, girlfriends, and lovers who had, among other things, kept their beds warm. The studios, aware that army life could lead to some long, lonely nights,

responded quickly. They mass-produced photos of shapely contract players like Lana Turner, Jane Russell, and Betty Grable in revealing costumes and flirtatious poses, boosting American morale by giving soldiers something to pin up in their lockers. Vargas, however, was able to plumb the depths of his fantasy life, drawing gorgeous girls whose proportions weren't limited by the reality of actual women's bodies, and whose poses weren't inhibited by what real actresses and models were willing to do. For his first 1941 calendar, he created young, lithe women with pin-tucked waists and supple breasts. There were brunettes, blondes, and redheads; some wore lingerie, some were topless, and nearly all of them wore either high heels, or had their toes pointed and their bare feet arched in a way that suggested the shape of a sloped shoe.

Though the Varga Girls were impossibly attractive, the shoes in particular gave them that girl-next-door quality that assured admirers that they were meant to be real women, and not just fantasies—a practice that began as early as the 1800s in pornographic images. And the more that high-heeled shoes were used in hypersexualized images, the more sexualized the shoes themselves became. This made them a crucial accessory of female sexuality (or, at the very least, an accessory of the male vision of female sexuality) and reinforced the sense that high-heeled shoes were inherently sexy. As the line of reasoning goes, high heels are alluring for a few reasons. Physically, they shift a woman's weight so that her breasts and buttocks are emphasized, and her hips move from side to side when she walks. A woman's foot flexes during orgasm, and when the slope of a shoe forces the foot into an attenuated position, it recalls the arch that happens naturally in lovemaking. Because the elevated shoe only appears in men's fashion every once in a blue century or so, the high-heeled shoe is a decidedly gendered object, which, like linge-

rie, gives it that naughty, off-limits appeal. Finally, the curves that are inborn in the design of a high heel mimic the shape of a woman's body, which renders it a genuinely evocative image. And then there's Freud; according to the doctor of the unconscious, high-heeled shoes are polymorphously perverse for their suggestion of both male and female genitalia.* For women, high-heeled shoes provide phallic replacement—the answer to penis envy, that old thorn in our feminine sides—yet the shoe is entered by the foot, which also suggests (to Freud, anyway) a vagina. But whether or not the Varga Girls radiated with psychoanalytic underpinnings, they certainly resonated with dogfaces† and civilians alike. A January 11, 1941, "Talk of the Town" column for the *New Yorker* tried to figure out why: "The Varga Calendar . . . may be just the thing we need right now. A little concentration and perhaps we can visualize each month as a separate and lovely encounter with a beautiful stranger, the whole year a harmless and joyous trip through the old seraglio. . . . August, the invasion month, is a cutie lying prone on a beach, covered slightly by a transparent hat. October, when the sky may be full of bombers, is a slip of a girl bared from toe to hip, shooting an arrow. November, when the mists may be rolling over the Channel, perhaps as a shroud, will be a blonde in a dress as tight as the skin over the knuckles of your fist.

* He might have been right. In the 1940s and 1950s, a Canadian neurosurgeon named Wilder Penfield set out to map the surface of the human brain. After conducting a series of experiments, he concluded that not only do certain highly sensitive body parts, like the lips and the fingers, correspond to disproportionately large areas of gray matter, but also that the brain's map of the body is not always consistent with its physical layout. Examining Penfield's results, neuroscientist V. S. Ramachandran noted with some interest that, according to our brains, the genitals are located below the foot (via Valerie Steele's *Shoes: A Lexicon of Style*, pp. 113–14).

† World War II slang for infantrymen.

What may be the end of the world will be marked by a nice thigh, the beginning of chaos by the lift of a pretty hip."

Indeed, reports from the front lines were grim. Stories reached the States via newspaper and newsreel: Hitler marched farther into the USSR. With the Vichy government's concession, Japan seized French Indochina. As shots were fired all across Europe and the American presence in the war escalated, a psychologist named William Moulton Marston envisioned a woman who wouldn't just bat her eyelashes, or lie prone in a flimsy negligee as the powers of evil pressed forward. Instead, she would save the world with her nonviolent mix of strength, compassion, and goodness. She would be wonderful. She would be Wonder Woman.

It was the era of the superhero. Superman made his debut in 1938, followed by Batman in 1939, along with a legion of handsome, valiant characters to whom posterity has been less kind. Racked with fear over real-life international leaders like Hitler, Stalin, and Mussolini, who could easily go head-to-head with the most sadistic cartoon villains, readers were primed to lose themselves in colorful stories where good always triumphed over evil. For Marston, the figure of the magnificent champion of human kindness could only be improved by changing his gender. It was an innovative idea: the landscape for heroines at the time either relegated them to sidekick status, or treated them like a separate genre ("like westerns or space opera," one expert explained). As Marston told comics historian Coulton Waugh, "Frankly, Wonder Woman is psychological propaganda for the new type of woman who should, I believe, rule the world. There isn't love enough in the male organism to run this planet peacefully. . . . What woman

lacks is the dominance or self-assertive power to put over and enforce her love desires. I have given Wonder Woman this dominant force but have kept her loving, tender, maternal, and feminine in every other way."

She first appeared in issue number eight of All American's *All Star Comics* in 1941 and received her own comic book in 1942 as the first female character considered strong enough to carry her own series. Marston intended her to be a feminist role model. As he famously told *The American Scholar* in 1943, "Not even girls want to be girls so long as our feminine archetype lacks force, strength, and power. Not wanting to be girls, they don't want to be tender, submissive, peace-loving as good women are. Women's strong qualities have become despised because of their weakness. The obvious remedy is to create a feminine character with all the strength of Superman plus all the allure of a good and beautiful woman." Marston was a bit of an eccentric: A Harvard-educated PhD with only an enthusiast's knowledge of comics, he nonetheless began drawing them in his spare time. He also had two wives; he lived with Elizabeth Marston and Olive Byrne in a polyamorous relationship. Explains Byrne Marston, William and Olive's son: "It was an arrangement where they lived together fairly harmoniously. Each woman had two children, and my brother and I were formally adopted by Elizabeth and Bill somewhere along the line." He believes his biological mother provided the physical prototype for Wonder Woman. "I think physically she resembled Wonder Woman more than did Elizabeth, who was short, and nice, but not that type of woman at all. . . . [Olive Byrne] had black hair and blue eyes. And she was slender. And she had those big silver Indian bracelets and they were heavy. She had one on each wrist and she wore them for many, many years." Wonder Woman's indestructible bracelets, her golden lasso of truth, and her

invisible airplane made up her arsenal of nonviolent weapons used to thwart even the most menacing ne'er-do-wells. Marston groomed Wonder Woman as a mouthpiece for peace and diplomacy. "Bullets never solved a human problem yet," she counseled her boyfriend Steve Trevor as he raised a gun to Cheetah, her feline foe.

Her costume was intended as a direct reference to Superman's, with a corresponding nod to the all-American Stars and Stripes. Her shorts—first depicted as blowsy culottes in the war years and then later revised as a pair of sexier briefs—were blue with white stars, and the prototypical Wonder Woman wore red high-heeled boots with a white stripe down the front. John Wells, DC Comics historian and coauthor of *The Essential Wonder Woman Encyclopedia*, relates this tidbit about Wonder Woman's footwear: "The original Wonder Woman concept sketches of artist H. G. Peter surfaced a few years ago. In those images the character wore high-heeled sandals. 'The shoes look like a stenographer's,' Peter wrote on the page. The change to boots probably originated with William Moulton Marston although his reasoning is likely lost to history. It's certainly possible that he was hoping to emulate the boots that were common of characters like Superman, Batman, Hawkman, Green Lantern, and other characters." One thing's clear: the boots weren't inspired by everyday fashions. For daytime, most women still wore wedgies or medium-high-heeled lace-up oxfords; for evening, the same women wore T-strap sandals or flirtatious slingbacks. They wore boots only if it was raining, and then they were utilitarian rubber galoshes that slipped over the shoes to keep them dry.

Alterations to Wonder Woman's outfit varied by time period and artist, but differences (both significant and insignificant) in her shoes included stripes or no stripes, heels or no heels, and the ap-

pearance of a white fold-over "duck bill" at the top of her boots in the late 1940s.

The more that World War II loomed over American citizens, the further away the Great Depression felt—yet just as the economy improved, the war also forced the government to ration items that consumers, finally feeling the weight of money in their pockets again, might have wanted to buy. On Sunday, February 7, 1943, one day before the crucial American victory at Guadalcanal, the War Production Board announced at 2:30 p.m. that shoe rationing would go into effect at 3:00 p.m., giving store owners one "freeze" day to sort their footwear into rationed ("shoes made in whole or in part of leather, and all rubber-soled shoes") and unrationed ("soft and hard-soled house slippers and infants' soft-soled shoes; ballet slippers; ordinary waterproof footwear") items. Sundries like coffee, gasoline, and sugar were already regulated, but shoes were the first wearable articles, and in order to prevent hoarders from accumulating stock in the time it would take to print up a new coupon book, the government designated Stamp no. 17 for shoes, good for one pair per person per household between February 9 and June 15.

The initial ration, called Ration Order 17, was three pairs of shoes per person per year. It was considered a preventative, rather than emergency, measure; since manufacturers still had an excess of product, the law was intended to make sure shoes were distributed among citizens appropriately and fairly. Research showed that the average American bought only 3.7 pairs of shoes per year in the last five years, but sales had increased so dramatically in 1942 that the threat of a shortage was imminent. "Only one possible alternative to rationing was announced," the Associated Press explained

on February 8. "That was to compel manufacturers to produce shoes that would be so unattractive that people would not buy them unless absolutely needed." As it was, the ration stipulated not only how many shoes consumers could buy but also what kinds of shoes the footwear industry was permitted to make going forward. With one-third of the sole leather supply allocated to the army, any sort of perceived wastefulness or frippery was immediately forbidden. For men, this meant that the leather used in sports sneakers and formal shoes would have to be replaced with an alternative material, and that the rationed leather shoes they bought with Stamp no. 17 should be carefully preserved. For women, however, the shoe ration instantly outlawed flourishes that had become the quintessence of a varied shoe collection. As the Associated Press reported, "The number of colors will be reduced from six to four—black, white, town brown, and army russet. Gold and silver and all two-tone shoes will be prohibited. . . . Heel heights in women's shoes will be shortened so as not to exceed two and five-eighths inches in height. Leather boots will be limited to ten inches in height. Leather platforms on women's shoes will be cut down." As for decorative embellishments, "straps, fancy tongues, non-functional trimmings, extra stitching, leather bows, etc. will be dropped." The law also prevented shoe companies from producing only high-priced shoes, so that buyers of all walks of life would be able to afford new footwear. Even the lucrative film studios were affected. In a *Hartford Courant* article dated March 7, 1943, just a month after shoe rationing officially began, a Paramount costumer confessed, "We stopped supplying our stars with shoes three years ago. . . . In a close-up, you don't see a person's feet anyway. . . . We used to have a rack of shoes for each star. But now they are strictly on their own." Stars were expected to provide shoes from their own closets,

and as wardrobe mistress Edith Head explained, "I will design my dresses to the shoes owned by the star."

It's no wonder that W. W. Stephenson, vice president of the National Shoe Manufacturers' Association, delivered a solemn speech to his peers. Standing before the male shoe industry representatives charged with the task of producing wearable shoes for "milady"—as the female customer was designated in trade parlance—he outlined the various indignities the wartime shoe business suffered, and concluded grimly: "Whether we like it or not, we must regard Washington as the seat of the shoe industry in America today." He continued: "The shoe and leather industry has been subjected to about every known form of government control. . . . M–217 [first enacted in September 1942] says how much you can make, how you can make it, and how you shall distribute it to your customers. GMPR [Government Maximum Price Regulation] sets your prices and stipulates your terms of sale. Ration Order 17 establishes how consumers will buy and use your goods. The War Manpower Commission says whom you may employ, and the National War Labor Board tells you how much you may pay your employees." Stephenson closed this list of fiscal indignities with a dry joke: "This explains why shoe and leather people exhibit such leisurely, carefree expressions, and why they are completely relieved of all managerial problems."

Initially everyday women used their ration coupons to buy the shoes they wanted, rather than needed, as if that impractical pair of shoes sitting untouched on the shelf would be a signpost of better days to come. On February 9, 1943—the first day of the "thaw," when shoe shopping was permitted under the new restrictions—stores were bombarded with eager buyers, and "ration tickets were turned in right and left for frivolous, bold colored leather sandals, spike heeled suede dress shoes, and high style pumps of all kinds." Even

so, as the war progressed women found they had fewer and fewer reasons to dress up. As men shipped overseas in incredible numbers, they left behind scores of women who were then told it was their patriotic duty to keep the country solvent by doing typically masculine jobs like factory work and agriculture. Six million women joined the workforce during the war, which meant that the need for delicate slingback sandals disappeared, and instead women shopped for durable, heavy-bottomed shoes appropriate for cold weather and physical labor.

New jobs automatically meant a new style of dress. In peacetime, a woman hardly ever wore slacks, but suddenly she was buying enough pairs to slip them on for work every morning. She carpooled to the factory in flat, practical shoes and passed the days with other women just like her: married, in some cases the temporary head of the household, and tensely awaiting her husband's return. Many women on the line were her peers, but some were at least ten years older, and while a fair share hadn't worked before the war, those women of lesser means admitted that the new circumstances on the home front translated to better job opportunities and bigger paychecks. Hollywood, as a powerful source of propaganda, was called upon to set a positive example for viewers. After making unrealistic choices in a recent war film, Columbia Pictures' hairstylist received a letter from a defense plant requesting that "when styling the hair of an actress who represents a defense worker on screen, confine yourself to something simple and safe. Women are reporting to work in the shops with long, flowing bobs, piled-up curls, and the other dying hairdos copied from the screen which seriously menace their safety." So, when Lana Turner cut her hair into a short "Victory Bob," which involved long, flat curls tucked on either side of the jawline, MGM took it as an opportunity both to inspire regular women to do the

same and promote one of its biggest stars. Stop the presses: "Lana
Turner Tries a V-Style Haircut," one newspaper headline read.

Even from a distance of four thousand miles, soldiers were only
superficially encouraging of their wives' new careers; a 1943 "Gallup
poll found [that] only 30 percent of husbands gave unqualified sup-
port to the idea of their wives working in industrial war jobs." That
same year, Norman Rockwell's portrait of feminist icon Rosie the
Riveter, sitting against the backdrop of an unfurled American flag,
appeared in the *Saturday Evening Post*. This redheaded woman wore
denim coveralls, had thick, brawny thighs and arms, held a sand-
wich in one hand and cradled a substantial rivet gun in her lap. She
looked mannish, and a little bit smug—hardly the kind of woman a
soldier would dream of bringing home to Mom. Not long after, an-
other version of Rosie appeared, this one from the War Production
Co-ordinating Committee. Reconceived, the new Rosie looked much
more like a Varga Girl, or even Wonder Woman in disguise: she had
penetrating eyes with thick, soft lashes, pouty lips, and curled hair
under a kicky red bandanna. Rockwell's Rosie wore thick red socks
and clunky, masculine brown penny loafers, and while Rosie redux's
feet were outside of the frame, she looked like she'd be more at home
in a cute pair of lace-up sneakers.

In other words, the woman who went to work was expected to
maintain her femininity, even if she was dabbling in welding or
firefighting for a spell. And somewhere in the chasm between the
two Rosies—one intimidating and masculine, the other helpful and
pretty—the femme fatale, a frightening hybrid woman, emerged on
film.

4

.

The
Femme Fatale
and the
Original
Power Pump

(1944–1948)

The femme fatale exhibited a funny kind of freedom. Where most women around her were subservient, submissive—Marston's Wonder Woman without the earth-shaking core of power—she figured out how to slip across class and gender lines by honing in on man's fundamental weakness: his desire to get laid. Disguised in feminine finery—high heels, jewelry, hats, and gloves—the vamp used her appearance as smoke and mirrors to distract from the fact that she was ruthless. Her motivation was always money, but that money bought her independence, which is the true ambition of any wild creature. And wild she was: The 1940s femme fatale was the ultimate wolf in sheep's clothing. The shoes, peeking out, were her freshly polished fangs.

...

At a time when all frivolous shoes were still strictly controlled under Ration Order 17, Phyllis Dietrichson, played viciously by a blond-wigged Barbara Stanwyck, showed up in movie theaters, chilling audiences with her dangerously good looks and delicious double-speak. *Double Indemnity* was based on a 1935 novella of the same name by pulp fiction writer James M. Cain; it told the story of the cocky (yet hapless) insurance salesman Walter Neff, ensnared by icy housewife Phyllis Dietrichson, who with Neff's help schemes to kill her wealthy husband and collect on the life insurance policy.* Walter rings Phyllis's doorbell expecting to speak to her husband, but instead he's greeted by an attractive woman wrapped in a towel after a "sunbath." As he waits for her in the living room, Phyllis races down a flight of stairs, her fluttering feet shod in medium-high white satin pumps with a flirtatious pom-pom on the vamp. The soon-to-be-lovers sit, and Walter compliments her—"that's a honey of an anklet," he says coolly—as Phyllis tempts him with an ankle's worth of exposed flesh.

The anklet came straight from Cain's story. But despite director Billy Wilder's own explanation that he "wanted to photograph [Stanwyck] coming down the steps with the anklet," which he later described as "the equipment of a woman . . . that is married to this kind of [rich] man," visually, the shoes stole the show, bright against the film's grainy, atmospheric lighting. These pumps, capricious and ultrafeminine, told viewers everything they needed to know about Dietrichson. They were so instantly eloquent that they set a

* Sound familiar? Cain was inspired by the details of the Ruth Snyder case.

longstanding film precedent: shoes as a mode of introduction. As a woman who looked like a pinup but schemed like a man, Dietrichson was the stuff of nightmares. And every good nightmare needs a well-constructed harbinger—in this case, a disarming pair of high heels, as sexy but potentially dangerous as the gorgeous girl slinking around in them.

The shot was especially effective because by the time the war was ending, women looked at shoes—not to mention one another—in a very different way, and with men coming back from the war, once well defined gender roles were mutually contaminated. Women, in the absence of men, became strong and self-sufficient, while men, overseas, experienced real fear and vulnerability, which they then felt obligated to downplay. The femme fatale, in her exquisite pumps, perfectly crystallized the fears of the postwar viewer. She was capricious and greedy—thus her willingness to kill for money. She'd stop at nothing to get her mark into bed, which no doubt enraged female audiences, who were conditioned to regard other women as competition, now that the population of viable men had been culled. For the men fortunate enough to return home, the wives and girlfriends they found waiting for them didn't behave the way they remembered. They may have slipped into dresses to celebrate the soldiers' arrival, but it was hard to ignore that they now had jumpsuits hanging in their closets, and they knew how to assemble car engines or operate forklifts.

Dietrichson was the preeminent femme fatale: the unapologetically murderous woman in "the first true film noir." The script was so controversial that it took Hollywood's Production Code Administration eight years to approve it, but *Double Indemnity* became an enormous success, garnering seven Oscar nominations and spawning a series of moody, black-and-white mystery films that entertained the

American public in the years after World War II and featured variations on the theme of Phyllis Dietrichson.

A few years after Lana Turner's debut in *They Won't Forget*, Anita Loos, author of the novel *Gentlemen Prefer Blondes*, which would ultimately become a 1953 Marilyn Monroe vehicle, publicly dubbed Lana "the vamp of today": "When she steps into the picture the audience relaxes. They see nothing to fear in this youngster with the good figure, self-possessed air, yet who at the same time is slightly naïve. It is only when the women in the audience hear their men raving about 'little Turner' that they begin to wonder whether she is so harmless. Then and there, Lana establishes herself as the new vamp type." At the time, Lana was happy to play the off-screen role of the out-of-control starlet and entitled media darling. She even felt free to admit that she didn't take her acting career all that seriously; the *Hartford Courant* reported in 1941 that "Lana confesses that until recently, she had no particular ambition, no aim, was not career-conscious. She just wanted to have as good a time as possible, get as much money as possible so she can buy as many things as possible." When Lana had to supply her own shoes for films, it wasn't a problem: "She buys shoes every time she goes shopping. How many pairs? 'Oh, gosh, I shouldn't say. It might make other girls around the country resent me. But, let's see—two pairs this week (business of counting on fingers) makes it about 137 now. But I only wear six or seven of 'em.'"

By the mid-1940s, Lana could buy anything she wanted with her $4,000 a week MGM contract salary, but overall, her priorities had significantly changed. At the age of twenty-five, she'd already lived through two failed marriages; the first, to playboy bandleader Artie Shaw, lasted only four months, and the second, to restaurateur

Joseph Crane, sparked a tabloid sensation when Lana discovered that his divorce to his previous wife had never been finalized. She kicked him to the curb—and then realized she was pregnant. Could she, such a high-profile woman, really give birth out of wedlock? Joseph and Lana tried to make it work, but in the end, she bravely embarked on a career as a single mother to their beautiful daughter, Cheryl. Lana found that being a mother changed her, and suddenly acting, like parenting, felt like a job she shouldn't take for granted. For the first time, she craved a challenge: a role that reflected the heartbreak and hardship she'd experienced and allowed her to call upon those deep wells of emotion. The Sweater Girl was all grown up, and she was ready to cast off the cardigan: "When I see that stuff about me and sweaters . . . I want to run and hide and put on a mother hubbard," she told a journalist testily. "I don't own a single sweater—except some loose fitting button-down-the-front kind." Then, in 1945, just as the war was ending, a script appeared that had the potential to transform Turner from gossip column mainstay into a respected actress. *The Postman Always Rings Twice* was a direct descendant of *Double Indemnity*: a noir, also based on a story by James M. Cain, it featured another frosty vixen who used her looks and guile to get ahead. Cora Smith, *Postman*'s leading lady, was the kind of woman who backed herself into a corner and then had to chew her way out. It was perfect—Lana was hungry for a role with teeth, a character whose appearance wasn't the whole story.

The Postman Always Rings Twice debuted on May 6, 1946. The Japanese had formally surrendered on September 2, 1945, and the end of shoe rationing followed soon after on October 31. Turner's first moment on-screen was breathtaking; Frank Chambers, played by John Garfield, arrives at the roadside diner that will become his new home and place of employment. He meets Nick Smith,

its aging owner, who entices the wayward caller to stay with the promise of a well-prepared hamburger. Smith readies the meat on the grill, then leaves to attend to a customer. Chambers notices a lipstick rolling across the floor, and the camera, from his point of view, traces its way to Smith's wife. Then the camera stops—jolted, as Chambers is, by a pair of white, open-toed pumps in the door-frame.* The lens trains on Lana's feet and legs just for a moment. It cuts to Chambers's stunned face and finally pulls back to reveal Cora, in a white two-piece bathing suit and matching turban, poised at the threshold. . . .

Although it's a hamburger the proprietor offers, Cora turns out to be the real meat dangling into the lion's mouth. Cora's shoes served as an invitation; they were able to lure Frank Chambers in, and in their ability to function as the "hook," they gave the femme fatale a jolt of power. By then, slinky heels had earned the salacious—and descriptive—nickname "Come Fuck Me" (or CMF, or just plain old "Fuck Me") shoes, a term actress Shelley Winters used with her gal-pal and roommate, an aspiring actress named Marilyn Monroe. In her memoir *Shelley, Also Known as Shirley*, she recalls going danc-ing with her husband, Captain Paul Miller, after he returned from his tour in the army: "Paul wanted to jitterbug . . . but first I had to take off my beautiful three-inch heels. These were a special kind of sandal—tied in front with a bow—that Marilyn and I used to 'borrow' from the studio. Giggling, we called them our 'fuck-me shoes.' They really were the sexiest shoes I've ever seen. Whenever we did pinup photos for the soldiers, we wore them."

Lana got what she wanted: reviewers called Cora Smith the best

* These shoes were designed by Ferragamo.

role of her career, and for a moment at least, talk turned to her talent—and away from her personal life and her bustline. At last she felt that she earned that $4,000 a week, rather than coasted on what turned out to be a particularly lucrative resemblance to Jean Harlow. She happily posed for photo ops with her young daughter, Cheryl, just in case there was any confusion between Cora Smith, the murderous vamp, and Lana Turner, the devoted mother. The film's success solidified grisly noir as a successful trend in Hollywood and immortalized Lana's introduction: the camera's slow pan up from feet to face.

Soon Hollywood had a new blonde to worship, and this actress was even more *femme* than Lana Turner, though—given that Turner would eventually be implicated in the murder of her lover Johnny Stompanato—she was quite a bit less *fatale*. Via her own storied love life, she paid her dues to the tabloids, but on-screen, she was sweet and agreeable and sensuously breathless—almost like a Varga Girl brought to life. While in the 1920s, the flappers' willful cavorting caused critics to speak out against high heels, in the postwar era the nation wholeheartedly embraced them. As one *Washington Post* article observed in 1945, real women in the age of the pinup were destined to come up short: "The pinup is the only feminine companion a man [in the service] has . . . and after a while a man comes to believe that all women are like his pinup girl. Imagine his disappointment when he comes home to discover that his wife or sweetheart does not measure up to his ideal. Pinup photographs are bad enough, but the Petty and Varga girls are worse. Women simply aren't constructed like that."

But Marilyn Monroe was. Norma Jeane Dougherty (née Norma

Jeane Mortenson, baptized Norma Jeane Baker) was an understated beauty—soft and accessible in a way that didn't even make her girlfriends jealous, and which made every man feel like he was the first one to notice. An auburn-haired, nineteen-year-old war wife, with apple cheeks and a broad nose, she lived with her in-laws in California and was working at a local aircraft plant the day photographers from the U.S. Army's First Motion Picture Unit arrived to document wartime women in action. Maybe it was Norma Jeane's fresh-faced good looks or a twinkle in her eye that proved she was comfortable in front of the camera, or perhaps it was the palpable sense that this fatherless, one-time orphanage charge had nothing to lose, but she was quickly singled out as exactly the kind of Rosie that people wanted to see. Just a year later, after appearing on over thirty men's magazine covers, the successful model divorced her husband and set out to conquer Hollywood as a thinner, platinum blond version of her small-town self.

In August 1946, Norma Jeane Dougherty became Marilyn Monroe, and in some ways her transformation mirrored the changes experienced by American women in the years following the end of World War II. She was a dutiful, take-it-as-it-comes wife turned into a national plaything, and even those women who welcomed their G.I. husbands home with open arms altered their lives and appearances to accommodate them. When "the men started to come home . . . we tried to be joyful in the way we looked," Barbara D'Agrosa says, a then-Queens, New York, resident who worked as a shopgirl at Macy's during the war, and who married her high school boyfriend when he returned from the service. Almost overnight, women's priorities collectively shifted from fulfilling a patriotic responsibility to their country to practicing more localized, traditionally feminine obligations like mothering children and tending to domestic life.

The women who'd worn pants, tied up their pin curls under bandan-
nas, and skittered through vast factories in flats found themselves
faced with an entirely different set of sartorial needs. A long era of
deprivation, in the late 1940s, gave way to an age of lustrous, restor-
ative prosperity that revolutionized—with the help of French coutu-
rier Christian Dior—the way that European and American women
dressed.

They called it the New Look. On the winter morning of February
12, 1947, just a year and a half since the war's official end, and roughly
a year after Marilyn Monroe signed her first contract with 20th
Century-Fox, the fashion upstart debuted his first in-house collec-
tion at his design studio in Paris. Though he hadn't yet made a name
for himself on the global stage, thirty-eight-year-old Christian Dior
created enough buzz when he partnered with a French cotton mag-
nate to launch his own label that fashionable Parisians gathered out-
side the five-story neoclassical corner building at 30 rue Montaigne
for an early look at his line. Among crowds of women in tailored
skirts, strong-shouldered jackets, hats, and gloves, young models
swished out onto the runway, wearing pieces from the collection the
designer called *Corolle*, meaning "flower petal." Onlookers sucked
in their breath; the clothes were achingly, almost controversially,
beautiful. Skirts, which in the past few years had crept up toward the
knee because of fabric rationing, now swung around in abundance.
Bolstered by tulle underskirts, they dropped well toward the calf and
in some cases skimmed the girls' ankles, requiring even more ma-
terial to craft their delicate pleats. Like blossoming, inverted roses,
the models glided forward wearing wasp-waisted jackets, accen-
tuated by corseted bodices that sucked in the frame while spilling
out sensually over the hips. Shoulder pads, which had remained in
style through the war years, were noticeably absent from Dior's gar-

ments, replaced by soft, rounded shoulders that unlike the prevailing trend, did nothing to recall the decidedly unfeminine V-shaped jackets worn by soldiers. "It is impossible to exaggerate the prettiness of 'The New Look,'" Susan Mary Alsop, an American socialite living in France, who soon after the show received pieces from the House of Dior to initiate brand recognition, reported home. "We are saved, becoming clothes are back."

Dior thumbed his nose at the wartime ethos of conservation and sobriety, shocking fashion's early adopters with a collection rooted in fantasy. Though department store designers scrambled to create ready-to-wear pieces inspired by the New Look, not everyone was as bullish as Ms. Alsop; critics dismissed the clothes as elitist, and Dior's long, billowing skirts, considered wasteful for the amount of fabric they required, inspired particular venom. "In Georgia, a group of outraged men formed the League of Broke Husbands, hoped to get '30,000 American husbands to hold that hemline,'" a September 1947 *Time* magazine article reported. "In Louisville, 1,265 Little Below the Knee Club members signed a manifesto against any change in the old knee-high style. And in Oildale, California, Mrs. Louise Horn gave a timely demonstration of the dangers lurking in the New Look. As she alighted from a bus, her new long, full skirt caught in the door. The bus started up and she had to run a block before the bus stopped and she was freed."

With so much lip service paid to the collection's skirts and dresses, the dainty high-heeled shoes Dior showed with 1947's New Look were less divisive, though they were certainly higher and more typically "feminine" than the wedgies women were still wearing at the time. It wasn't until 1953, when the designer joined forces with French shoemaker Roger Vivier, that stilettos, with their needle-thin heels, came to be associated with postwar style. Vivier, a Pari-

sian designer who began working in a shoe factory when he was just seventeen, was drawing high, slender-heeled shoes as early as the 1930s, even if he didn't yet have the materials to realize his footwear fantasies. They were similar to the arched, wispy pumps and sandals envisioned by pinup artists George Petty and Alberto Vargas, who, it turned out—along with creating a feminine ideal for the World War II era—were also working as de facto shoe designers.

5

The Stiletto

(1950-1954)

Invented in Europe and named for a type of dagger with a slender blade, the stiletto initially took its name from the narrow girth, rather than the height, of the heel. It was a design innovation bred from postwar plenty, both in the shoemakers' toolboxes—the stiletto required metal for reinforcement, which had been heavily rationed since the war started—and in the consumers' pockets. Unlike the solid, reliable wedge, the stiletto placed an enormous amount of pressure on the ball of a woman's foot, thus rendering it a less than

ideal walking shoe.* But after years of sacrifice and hardship, practicality and poverty, women were ready to embrace fashions that signified fresh ideals: sex appeal, status, and luxury. The stiletto was a new kind of shoe precisely because it was so clearly divorced from its function; in 1953, *Picture Post* magazine published a series of photographs called "The Hazards of the Stiletto Heel," in which model Jean Marsh demonstrated the perils of walking in these tricky shoes. In one picture, her heel was caught in a manhole cover; in another, she braced herself for a fall on an uneven sidewalk. Then she rested over a street drain, one shoe removed as she exhaustedly rubbed her ankle. Clearly, walking in heels was a skill, not an instinct—but one that the majority of women, in the postwar years, were willing to cultivate.

There was something appealing about this sleek, pointy shoe—it felt dangerous but also, somehow, deliciously smug. Like a car or a diamond ring, the stiletto was effective at classifying women by their economic rank and social value. If a woman couldn't manage to glide in the dainty, vertiginous shoes? Then she hadn't *earned* the right to wear them. If a woman couldn't afford the luxury of staying off her feet? Then la-di-da—stilettos weren't for her. The war years were a great equalizer, when upper-middle-class women worked alongside their blue-collar peers in an effort to keep the economy afloat. But afterward, fashion reinforced the class divide. Wearing an impractical pair of shoes implied that a woman had room in her life for caprice: the time, means, and desire to think beyond labor

* An October 2009 London *Times* sketch proving "why a woman in stilettos is more dangerous than an elephant" shows that the elephant exerts 125,000 newtons of pressure per foot, while a woman in a high, attenuated heel exerts a whopping 3,000,000 newtons of pressure.

and the mechanics of survival. High heels became a visual short-hand for which there was already historical precedent.

In Europe, from the fourteenth through the seventeenth centuries, a type of shoe came in and out of style that made stilettos look as breezy and sensible as loafers. Chopines, or *pianelle* (in Italy) or *zoccoli* (in Venice specifically) were slippers with soles that could extend up to twenty inches tall: a pair of clogs with platforms that reached toward the sky. Often worn by a woman of superior rank and considerable economic means, chopines unsurprisingly limited her range of motion, and in the most extreme cases required servants on either side to support the grande dame if she deigned to walk. While the advantages of these shoes were largely social—they created a visual impression consistent with the noblewoman's high status—they also, in some cases, protected the wearer's feet and garments from the trash and sewage that filled the streets. Yet practicality aside, this footwear was evidence of excess and was worn by those women who could afford human bookends.

Dating back further still, Chinese foot binding, which involves reshaping the structure of a young girl's bones before they ossify, wasn't considered a punishment at all, but in fact was a mark of distinction for women of a certain class. Beginning as far back as 960 BC, and outlawed as recently as 1912, this practice all but immobilized a woman but was necessary to ensure a posh marriage, which would then bring honor on her family. The bound foot was called the "lotus foot," and its epitome was the three-inch-long *jin lian*, or "golden lotus"—which, just like the chopine, signaled freedom from manual labor. Sexual politics factored into both of these fashions. In one account of the origins of foot binding, Emperor Li Houzhou, also known as Li Yu (AD 961–975), fell in love with a concubine who bound her own feet in order to perform a special lotus dance. Entranced, he

insisted she never leave his side, and he worshipped her curled toes forever. After that, the rumor that fragile, stunted feet were sexually attractive to men of high rank spread, and thus families of a certain echelon, who could afford not to use their daughters as laborers, began binding girls' feet as well. But in the alternate tale, dating back thousands of years, it was a self-conscious empress who started the trend. Born with a clubfoot, she was said to have forced all the ladies of the court to bind their feet so that her disfigurement would be less conspicuous. No matter—whether it stems from one man's sexual obsession or a powerful woman's vanity, foot binding originated within the upper classes but was then imitated by the lower ones, spreading to citizens who, unlike the gentry, couldn't afford to sacrifice workers. Therefore, peasant women with bound feet were still expected to toil in the fields wearing tiny "workboots" with treads on the soles.

Stilettos, while decidedly less extreme than Eastern lotus feet or Western chopines, contained echoes of these historical fashions for the way they asked women to prioritize style over mobility. After Vivier introduced his provocative shoes into the marketplace, a French demoiselle bought an embroidered pair from his boutique, only to return them the following day: "The beadwork [was] slightly torn, [and she complained] that the shoes were uncomfortable. After examining the soles, the manager responded—'But Madame, you *walked* in these shoes.'" Stilettos were meant to be decadent, not useful: a sign that women in the postwar years could kick up their feet and indulge. By the mid-1950s, average women were enjoying the return of frivolity, in some cases as a consolation for the fact that they'd been ejected from the workforce as swiftly as they'd been told it was an act of patriotism to enter it. Despite the skepticism and in some cases indignation it inspired, Dior's New Look proved groundbreaking as hemlines across the Western world dropped, skirts

puffed, and high heels narrowed. This in turn put women back on a pedestal and assisted in keeping them from their wartime jobs— nobody wears stilettos to build airplanes. Rosie the Riveter banished her clunky war wedges while spindly shoes, made of hand-dyed silk or lavish, supple leather, filled the pages of *Vogue*. Delicate high heels allowed women to reclaim their femininity without overstepping their husbands: a distinction as precise and potentially wobbly as the shoes themselves.

6

· · · · · · · · · · ·

The
Feminine
Balancing Act

(1953–1959)

September 15, 1954:
New York

It was just past 1:00 a.m. on Fifty-
second Street and Lexington Avenue,
but Marilyn Monroe wasn't tired. The
movie lights glared so brightly that
it hardly seemed like night at all, and the feeling outside was elec-
tric, fueled by the thousands of fans who had gathered to watch the
shoot. Fox's publicity department had tipped off the public that the
film version of *The Seven Year Itch*—already a hit play on Broadway—
was filming a pivotal scene on the real streets of New York, and the
frenzy that had been building ever since the world's biggest movie

star arrived in Manhattan exploded that night, right by the entrance to the subway. Her character, called only "The Girl," was to pause over the grate until a train passed, relishing the cool air that blew up her skirt from beneath her. Marilyn knew that countless people would be watching and so, in a last-minute move, slipped a second pair of underwear on over the first to make sure that the coy peep show planned didn't turn inadvertently X-rated. Marilyn wasn't usually modest, and any misgivings she'd had about wearing a skintight dress or even posing nude she'd tried, throughout her life, to shed, the way a child acts bravely around her older friends until she's the one leading *them* to sneak over the fence into the neighbor's yard. A year earlier, when Hugh Hefner published those old, amateur photos, the whole world had seen her in her birthday suit.* Still, she didn't want to have to worry tonight about what onlookers could or couldn't see, especially since a busybody pressman had invited her husband, Joe, to the city, to witness firsthand the flame his twenty-eight-year-old wife had ignited just by being her blond, larger-than-life self.

Joe DiMaggio: They'd been married just nine months, and Marilyn feared that they wanted different things. He'd committed himself to an actress, yet it was quickly becoming clear that Joe was an old-fashioned Italian boy who wanted his wife to cook for him, clean the house, and iron his Yankees uniform. Marilyn tried to do all that and more, but deep down she had to admit that doting on Joe wasn't nearly as satisfying as doing her own work. She craved that approval from the crowd: that overwhelming, indescribable feeling that they loved her, *worshipped* her, and that every man in a sample of

* In 1953, Hugh Hefner put Marilyn on the cover of the debut issue of *Playboy*, using nude photos from a 1949 modeling shoot for her playmate spread.

thousands wished he were lucky enough to be Joe DiMaggio just for a moment. This was the second time Marilyn tried being a wife, and though she savored the rush that led her to the altar, once again life after "I do" left something to be desired. What was wrong with her that she found being someone's wife so challenging, that she could balance over a crosshatched subway grate in teetering high-heeled sandals, but when it came to waking up every morning with the same man, her day-to-day existence just felt so tenuous?

But now Billy Wilder wanted to shoot, and it was up to Marilyn to be a professional. As costar Tom Ewell escorted her out into the street, Marilyn could hear the crowd swell, but more important, she could feel it, like a chilly shot of vodka that burned deep into her belly, and then spread down her spine and through her veins. Her wide, red-lipped smile was utterly authentic. By the time the first blast of air came up from the subway, she no longer cared if her dress flew over her head. The sounds—the hoots and hollers from faceless admirers—exhilarated Marilyn even as they drowned out the dialogue. It didn't matter that she had to say some lines so goofy that she wondered if she'd ever be hired to play a girl who had half a brain. It didn't matter that they'd have to reshoot on a closed soundstage, or that anyone who'd ever visited New York City knew that the air coming up from the train tracks isn't cool or refreshing at all, but hot like the winds of hell. It didn't matter—while the cameras were rolling, anyway—that out of the corner of her eye, she could see her husband, Joe, furious at her exhibitionism. Tonight she was Marilyn Monroe the silver screen goddess, and when you hired her, you got something fantastic.

The image of Marilyn Monroe in the billowing white halter dress, beaming over the subway grate, became one of the most recognizable

in Hollywood history. While the oft-reproduced full-body still didn't even appear in *The Seven Year Itch*—the Hays Office prohibited any shot from that evening in which Marilyn's dress floated above her knees—prints from the set abounded. Producers from Fox knew they were sitting on something so special that to promote the film, they hung a fifty-foot version of The Girl over Loew's State Theatre in New York, just in time for the June 1, 1955, premiere. And with Marilyn's perfect platinum-blond coif, the white dress that hugged her curves so sensually, and an expression on her face at once guilelessly joyful and almost obscenely pleasure filled, the shoes put the perfect punctuation mark on the outfit: a pair of white slingback skinny-heeled sandals—quintessential CFM shoes—designed by shoemaker to the stars Salvatore Ferragamo.

Since his tremendous success with the wedge, Salvatore's international business had only grown. With his wife and children he remained in Italy, but he traveled to the States frequently, and continued to make his mark, particularly when it came to designing shoes for Hollywood actresses. While Roger Vivier earned the nickname "the Fabergé of Footwear" by designing delicate sculptures— meant for admiring, *not* walking, as that misguided demoiselle learned—Salvatore pursued his interest in women's feet, confident he could learn plenty about a client just by examining her toes and the curve of her arches. He believed he could read women's feet the way others could scan their palms, or plumb their eyes, for information. Women, he determined, fell into three categories: Cinderellas, Venuses, and Aristocrats. Naturally, Cinderellas had the tiniest feet, wearing shoes smaller than a size 6. Cinderellas were the most feminine, who craved love as the singular source of happiness. Venuses (size 6) tended to be lovely and sophisticated, but underneath their polished exteriors they were simple girls who felt misunderstood,

while Aristocrats (size 7 and above) could be sensitive, sometimes moody, but were deeply empathetic. One day in Hollywood, a young woman walked into his salon, and after looking at her feet, he asked if she was an artist. She told him she was a secretary, but Salvatore assured her that she was fated for something greater: one day, she would be famous. That woman was Anita Loos, future screenwriter and author of *Gentlemen Prefer Blondes*.

Perhaps she remembered the soothsaying shoemaker when it came time to dress the film's blond starlet, or maybe Marilyn pursued him herself, aware that he designed shoes for all of the most stylish actresses like Rita Hayworth, Ava Gardner, and Gene Tierney. Once they met, it was nothing but mutual admiration: Salvatore and Marilyn formed a relationship that would lead to more than forty pairs of distinctive Ferragamos for the star. Their fittings are tempting to picture. Marilyn, in cropped black pants and a fitted sweater belted at the waist, enters his shop, which is spotless but smells strongly of treated leather. The artist, wearing impeccably polished shoes and a pin-striped bespoke suit, greets his guest, momentarily stunned not just by her beauty, but also by a special quality that sets her apart even from other comely actresses. Marilyn sits, and they make small talk, before Salvatore asks her, in a professional, unpretentious way, if he may remove her shoes. She giggles and looks away, then proffers her feet, pointing her toes like a child but then smiling and raising her eyebrows coyly, as if he'd asked something altogether less chivalrous. As he rests his weight on a footstool, Salvatore anticipates his favorite part of working with a new client: the moment when he gets a first look at the customer's bare soles. Marilyn sits patiently, fidgeting with a fingernail before making a fist. From a distance, the transaction could be misconstrued as erotic, except that Salvatore isn't thinking about Marilyn's body or her famous face at all, but of

the kind of shoe he can design that will perfectly capture all that and more: not only the persona but also the essence that makes her *her*.

"I don't know who invented the high heel," Marilyn Monroe once purred, "but all women owe him a lot." Ferragamo was her prince and fairy godmother all wrapped into one. He was the man who slipped the glamorous shoe onto her ready size 7AA foot, but also the benevolent artist who created it in the first place. For Marilyn, high-heeled shoes contributed significantly to her overall appearance and, according to one tabloid myth, were at least partially responsible for her trademark walk. The noir *Niagara* premiered in 1953 and featured Marilyn's character taking a 116-foot stroll toward Niagara Falls, "the longest walk in movie history," shot from behind. She's wearing a form-fitting black skirt and stilettos with crisscrossed ankle straps, and as she moves with quick, small steps into the horizon, her hips wiggle back and forth. The shot left audiences hot under their collars and gossip columnists scrambling to explain how the star's walk could be so sensual, so mesmerizingly rhythmic. Stilettos could have caused her hips to swing, or as those who helped to shape her early career claimed, it was a movement she'd perfected by way of hours and hours of practice. Though Marilyn insisted that she "learned to walk as a baby and [hadn't] had a lesson since," one writer claimed that her gait wasn't natural at all but could in fact be attributed to a trick. Marilyn, he said, intentionally had shoes made with one heel higher than the other, to create that rise and fall so flattering to her body. There was no smoking gun—no one was able to produce evidence of uneven pumps in her wardrobe—but it was often cited as a possible explanation for her undulating stride, considered so inexplicably divine that audiences yearned to find the secret truth behind it.

By 1954, when she was cast in *The Seven Year Itch*, Marilyn's per-

sona was so sharply honed that audiences had completely conflated her on-screen character with the actress herself. Having appeared as the gold-digging Lorelei Lee in 1953's *Gentlemen Prefer Blondes*, and then shining as the nearsighted Pola Debevoise in *How to Marry a Millionaire* that same year, Monroe was the obvious choice to play The Girl: a comically enticing model/actress who sublets an apartment upstairs from married Richard Sherman, conveniently living alone after his wife and young son have left town for the summer. Sherman, a book editor, is trying to avoid the vices his suddenly "single" peers enjoy—cigarettes, whiskey, and wild, wild women—and stave off the dreaded seven-year itch. The Girl, a bombshell as wily as she is helpless, personifies this temptation, flirting and strutting yet happy to keep the new friendship chaste.

The popularity of the ultimate blond bombshell in the squeaky-clean 1950s hinted at the collective desire for a less-guarded sexuality running just below the surface. The Girl, for all of her unindulged suggestiveness, was the consummate look-but-don't-touch fantasy. As The Girl, Monroe was stunning to look at and ultrafeminine—yet she was also oddly sexless. Although enticing and, presumably, available, The Girl is childlike and less independent than Sherman's classy, self-sufficient wife. Rather than a husband or even a boyfriend, she needs a father figure to install the air-conditioning and teach her that martinis don't come in nice, tall glasses. Ultimately, Sherman's affair is innocent, occurring via a series of hallucinations, and serving to remind him of the value of his family. The film version of *The Seven Year Itch* advises married men to see with their eyes, but not with their hands; The Girl-next-door could be "Marilyn Monroe"—as Sherman quips to the man who he imagines vies for his wife's affections—but she's still not worth the substantial risk to his home life.

Marilyn was certainly beautiful, but ironically, her home life was suffering at the hands of her own alter ego. The similarities between her and her *Seven Year Itch* character were marked; The Girl is a pristine canvas for Sherman's lewd imaginings, but she can't compete with the flesh-and-blood woman he married. That night outside the subway, after the crowds dispersed and Billy Wilder called, "Cut!" for the last time, Marilyn sidled up to her husband, Joe, who gave her the cold shoulder and wouldn't speak a word to her until they arrived back in their Manhattan hotel room. Then, behind the safety of closed doors, the fury: how could she mug for the camera like that, where was her respect for herself, for her body, for *him*? They divorced soon after amid rumors that Joe DiMaggio hit her that night. Marilyn must have felt gutted. The man's pinup fantasy appeared in the flesh, but just like the movie, his desire for a refined yet docile housewife invariably won out.

Because wartime fiscal conservatism bred a generation of eager consumers, for 1955, the year *The Seven Year Itch* premiered in theaters, footwear industry insiders predicted their best season yet. "For the past three years," William J. Ahern, editor of the *Coast Shoe Reporter*, wrote in his August 1955 editorial, "shoe production has been at an all-time high of approximately 525 million pairs annually, and at the rate production is going right now, 1955 will reach a new top, of about 600 million pairs." So much for three pairs of shoes per person per year. "Why does she buy more than eight pairs of shoes a year?" one ad for Carmelletes shoes asks in the January 1955 edition of *Footwear News*. "She loves high fashion. . . . Fashion moves merchandise more than any other force!"

Fashion moved merchandise—as did the feeling among women

that they were expected to look a certain way. The goal wasn't necessarily to look sexy for one's husband but appropriate; the wife was a reflection of her mate, and thus the rules of dress didn't favor self-expression either, but rather a rigid set of conventions aimed at crafting the cookie-cutter image of the ideal wife and mom. As the economy steadily grew there was a return to old-fashioned gender politics, in which men were viewed as rational and, on the other end of the spectrum, women as innately irrational, which placed additional pressure on them to be polished and put together, as an indication of the husband's newfound wealth and success. Under no circumstances was she to make it look effortful; "A lady never admits that her feet hurt," Marilyn, as Lorelei Lee in *Gentlemen Prefer Blondes*, advises her brunette partner-in-crimes-of-the-heart played by Jane Russell. After a while, the particulars of the new fashions were so ingrained that they seemed nothing but obvious. High heels, for the average 1950s woman, weren't sexually loaded or politically charged, so much as they were an expression of her femininity, a physical extension of her womanhood.

During these years, families expanded, houses grew, and the American Dream—in which a prosperous, capable man could provide for his lovely wife and darling children—proved alive and well. American men and women alike got everything they thought they wanted—while simultaneously erecting the walls of their own prison cells. Doris Day, the blue-eyed darling of squeaky-clean rom-coms, starred in *Pillow Talk* opposite Rock Hudson in 1959. The film opened with a shot of her medium-heeled violet mule sandal, which signaled to the audience that although she's happily single for the moment, deep down she's the kind of dame who wants to be admired. "If there's anything worse than a woman living alone, it's a woman saying she likes it," Day's character, the

independent Jan Morrow, is counseled by a friend early on. Meanwhile her romantic interest Brad Allen gets the corresponding earful from his thrice-married buddy about his playboy lifestyle: "A wife, a family, a house—a mature man wants those responsibilities." Like most films in its genre, *Pillow Talk* ends with a kiss and a promise, courting the viewer but not daring to venture past the altar to define what actual married life might look like.

For women, their initial enthusiasm about buying new clothes and looking pretty gave way to the suspicion that this was, in fact, an obligation, and that wearing heavy skirts, girdles, corsets, and uncomfortable shoes wasn't exactly a luxury but was, more accurately, a wifely duty. They received this message not just from their husbands (also, in their own ways, becoming slowly demoralized by the limited roles available to them) but also from other women, who penned articles in fashion magazines describing the art of being well dressed. Most famously, fashion designer Anne Fogarty published a 1959 how-to book called *Wife Dressing*, aimed not at Svengali husbands but at female readers interested in curating their wardrobes. "The first principle of wife-dressing is Complete Femininity," wrote Fogarty, a successful career woman who nonetheless maintained that she was most proud of her roles as wife and homemaker. "The most dangerous threat to successful wife-dressing is the triumphant cry, 'I'm married! The battle is won!' To paraphrase John Paul Jones: 'You have not yet begun to fight.' " Despite its questionable title and very limited ideas about wedded bliss, the book provided accessible advice about keeping a wardrobe manageable and current, making Fogarty a popular style guru to the 1950s housewife. Her firm belief that shoes should always be stylish and well maintained suggested the notion that clean footwear is a signpost of the upper crust: "Old Garbo movies may make you cry—but old shoes are only good for

hanging on the back of a bridal car or giving to the children for dress-up play. Nothing spoils an outfit more than time-worn shoes. . . . If you feel guilty about spending lots on shoes, spend a little less on each pair but replenish more frequently. Fashion is a living, changing part of your life."

.

Flats, or
Some Like It Not

(1957–1959)

Not everyone was such a big fan of the sti-letto. Just like Dior's voluptuous, bell-shaped skirts, tall, thin heels drew criticism even at the height of their popularity. The *New York Times* ran an article on May 28, 1955, warn-ing that "Posture Is Affected by Size of the Heels"; a Dr. Gerald Warner of Buffalo, New York, recommended that for the sake of their carriage, tall women should wear high heels, while short women should stick to low ones (questionable health advice that also managed to rob petite fashion fans of the chance for a little upward mobility). In a primer called *The Essential Eve: A Guide to Women's Perfection*, one medical professional advised: "Excessively

high heels will always be a source of danger to feet and eventually to health. Their habitual use causes the calf muscles to contract to such an extent that . . . it becomes almost impossible to walk." Warner eschewed a bit of practical wisdom—still de rigueur to this day—that heel enthusiasts should sometimes give their feet a break, opting for sneakers or flats in order to be kind to one's arches. "Above all," he said, "women should wear the same size heels consistently." Still, many women varied their heels as a practice. Saddle shoes and ballet flats were both popular styles, worn by the housewife during the day, to be swapped out for more flattering, feminine shoes when she heard her husband's car in the driveway. Flat shoes were also particularly trendy among teenage girls, still on the cusp of sexual maturity and thus less restrained by the sartorial standards meant to visually define womanhood. The bobby-soxer—named for the way she rolled her socks down over her low-heeled Mary Janes or her two-toned saddle shoes—was often a doll-faced junior high school–aged girl in a poodle skirt. She was allowed to pine for, say, blue-eyed crooner Frank Sinatra precisely because her feelings were regarded as immature and therefore innocent: a freedom not afforded to a girl past a certain age, who could appreciate the implications of her sexual identity.

Young girls in the 1950s were groomed from an early age to want to grow up to be like their mothers. A 1955 ad for Esquire Lanol-White shoe polish shows a blond toddler with a string around her finger, as a "reminder to stock up on" their product as she balances in ankle socks and Mom's white babydoll heels.* As they do today, merchandisers recognized in adolescents a generation of potential

* Shoes with a closed, round toe.

consumers who, if properly courted, would become loyal to their products for decades to come. One ad urging shoe manufacturers to advertise in *Seventeen* magazine relied on persuasive statistics collected from their own "College Freshman Survey": "Cinderellas need no coaching when your ad's in *Seventeen*, especially in August when 85% of *Seventeen*'s readers are shopping for back-to-school, off-to-college clothes. In fact, *Seventeen*'s readers alone spend $10,000,000 plus on shoes, buy 5.7 pairs each!" By stocking up on shoes and spending money—presumably earned at summertime or after-school jobs, or supplied courtesy of Daddy's wallet—girls were rehearsing for a time when they'd be the primary shoppers for their own households.

But as much as advertisers wanted children to believe that shopping was deeply satisfying to their mothers—it wasn't. To manage the stress of an unfulfilling routine, the stereotypical 1950s housewife took pills—downers, mostly—and smiled vacantly over her coffee cake, sleepwalking through Stepford days in order to silence the inner voice of dissent. But it wasn't stifled forever; some children who grew up in nuclear families headed by two passively, yet undeniably unhappy, people chose to reject that life for themselves, moving to urban centers and seeking out alternatives—via music, poetry, and literature—to marital obedience. For the beatniks, style was an obvious manifestation of their counterculture ideals, a way of not only self-identifying as a group but also of rejecting the structured, starchy fashions so *en vogue* for their parents. Men grew out their beards, wore loose, untucked shirts, took to workingman fabrics like denim and, of course, European-influenced fashions like off-center berets and dark glasses. Women wore pants and dark, neutral colors that suggested they were absolutely *not* blossoming flowers, let their hair hang loose, and opted for flat, comfortable shoes that

snubbed both America's heightened consumerism and their mothers' unappealing balancing acts. If "the girl with low / and sensible heels / is likely to pay / for her bed and meals"—as one *Saturday Evening Post* postscript warned—so be it. Beds and meals were bourgeois constructs anyway, far inferior to the pursuits of the mind.

Funny Face (1957), starring Audrey Hepburn as Jo Stockton, told the story of a mousy—and mouthy—Greenwich Village bookstore clerk turned reluctant It Girl model, after a demanding fashion magazine editor sends up a flare for a fresh face, and a photographer, played by Fred Astaire and based on industry legend Richard Avedon, identifies Jo as his muse. The plot was hardly beatnik-friendly; Jo stands by her philosophical beliefs and antifashion stance to a point but ultimately finds love with the older photographer after realizing that her academic idol is a cad. Jo remains a spark plug, but the gussied-up version of herself that appears in the last shot of the film in a New Look–influenced Hubert de Givenchy wedding gown is not quite faithful to the goals of the Beat Generation. She embraces her new life in the fashion world, and the audience (if they're feeling cynical) can see the trajectory of her future play out: wife, mother, a prescription for barbiturates.

Still, the beatniks get the last laugh. Far more memorable than the gowns Jo modeled in the midst of her transformation is the outfit she wears her first night in Paris, to visit a café peopled with fellow "empathicalists" (the intellectual movement to which she's passionately devoted). Audrey Hepburn, with her coltish figure and intelligent doe eyes, was an actress wildly unlike Marilyn Monroe. She was appealing for her brains, whereas Marilyn was all "brawn"; that Audrey was also gorgeous (and Marilyn reportedly smarter than

most assume) is unimportant, because she was the thinking man's ideal, while Marilyn, at times to her own disservice, got the audiences thinking with other body parts. Like Marilyn, Audrey also had a Cinderella-esque relationship with Salvatore Ferragamo, who created pairs of elegant, restrained, sensible shoes for her. Marilyn's shoe size put her at the cusp of Ferragamo's Venus, but Audrey was clearly an Aristocrat. At five foot seven, she was tall for a woman of her generation, with "long, slim" feet, which in Salvatore's own words were "in perfect proportion to her height. She is a true artist and a true aristocrat. Audrey is always natural and completely unaffected, whether she is acting or buying shoes or handbags." For *Funny Face*, he designed a pair of black suede slip-on loafers, to go with a Givenchy black turtleneck sweater and cropped black stovepipe pants. But when presented with the look's pièce de résistance—a pair of spotless white socks—typically coolheaded Audrey balked. With boat-feet like hers, which she made an effort to camouflage—along with her unsightly, bony collarbone—how could she wear an outfit that all but drew two gleaming arrows toward her clunkers? It was bad enough that the self-conscious actress, who didn't consider herself to be silver screen pretty, had to sing a duet with Fred Astaire about her "funny" face.

But on the question of the white socks, director Stanley Donen wouldn't back down, and Audrey was a professional. In a dimly lit café, accompanied by a percussive jazz band and two French-looking male dancers (one in horizontal stripes, *bien sur*), she performed a three-minute-long dance sequence, to decidedly—and delightfully—unsexy effect. Using her long, slender limbs to make charming, awkwardly birdlike shapes, Audrey at once proved the full uninhibitedness of the character, as well as her willingness to pull no punches when it came to doing what was right for the film. Even

Audrey was fond of her performance. After seeing the film for the first time, she wrote Stanley Donen a note: "You were right about the socks. Love, Audrey."

If Marilyn's signature shoe was the stiletto, Audrey's most definitely became the flat. Marilyn was the consummate sex kitten; Audrey made a career of playing women who undergo a Cinderella-like transformation, whether it was from gamine to princess (*Roman Holiday*, 1953), chauffeur's daughter to heartbreaker (*Sabrina*, 1954), simple farm girl to gal-about-town (*Breakfast at Tiffany's*, 1961), or cockney ragamuffin to lady (*My Fair Lady*, 1964). Aside from her natural elegance and camera-friendly good looks, her particular talent lay in treating those pretransformation characters with such delicate humanity that they were equally, if not more, charming than the versions they became on their way to happily ever after. Despite her aristocratic carriage, audiences almost preferred to see Audrey in a ponytail and flats, because hers was a relatable, mischievous presence, while Marilyn felt untouchable: the magnificent Hollywood goddess.

Soon after *Funny Face*, beatnik-inflected styles made it all the way into the vernacular of haute couture. In 1957, Yves Saint Laurent succeeded Christian Dior as the head of Dior's eponymous fashion house. As the assistant to the legendary middle-aged designer, Saint Laurent had been tapped by the master himself, but no one, not least his mild-mannered, bespectacled protégé, expected Dior to drop dead of a heart attack less than one year later while vacationing in Italy. For his first collection as head of the revered—yet financially challenged, after a few too many years of coasting on the New Look's success—fashion house in 1958, Saint Laurent unveiled a respectful variation on the New Look, featuring the trapeze dress: a high-necked, A-line, below-the-knee frock that was both innovative

yet perfectly attuned to his mentor's point of view. It put the House of Dior back in the black. However, just two years later Yves Saint Laurent stepped quite a bit further away from Dior with his "Beat Look": a collection of turtlenecks and biker jackets inspired by the beatniks he observed drinking and smoking at the cafés in Paris and London. It was an early instance of street style affecting the world of high fashion, rather than vice versa, but Saint Laurent's experiment, criticized by American *Vogue* as "designed for very young women . . . who are possessed of superb legs and slim, young, goddess figures," cost him his job.

These midcentury pop-culture moments helped to establish a definitive dichotomy between high heels and flats, encoding stilettos as sexy, flirtatious, and feminine, and flats as quirky, intellectual, and unrestrained.* Flats became the purview of the alternative youth culture, which prided itself on rejecting the styles of the privileged mainstream. And indeed, the stiletto, for all its positive sexual, social, and economic connotations, lacked the cachet of the underdog, which is precisely where flats got their inimitable cool. The 1950s were a historically rigid decade that took a particularly

* Like the high heels in 1940s film noir, these shoes are useful as visual cues on-screen, but they've also become loaded objects in everyday life that can lead to snap judgments. Take Clinton versus Palin in the 2008 presidential election: Hillary downplayed her femininity, canvassing for the Democratic nomination in pantsuits and sensible loafers. Sarah Palin, on the other hand, harnessed her gender as an asset—thus her knee-high stiletto motorcycle boots and red patent leather high heels—and a fundamental aspect of her public persona. Both women drew criticism for the way they handled the issue of their gender; Hillary ruffled feathers by "trying to be a man," while Sarah exasperated her detractors by exploiting her womanhood. No matter how many cracks we put in that glass ceiling, the question of whether femininity is an asset or a handicap remains hotly debated—even if we need, in this prolonged era of political correctness, to use the language of fashion in order to talk about it.

black-and-white view of women. One could either be a lonely intellectual like Jo Stockton, or a vapid sexpot like The Girl—though in truth, most women were beleaguered housewives like Mrs. Richard Sherman. The question of whether one could be *both* an Audrey and a Marilyn didn't emerge until the 1960s, when the sexuality of the stiletto and the practicality of the flat merged into a shoe that was made for flirting, butt kicking, and most important, walking.

From
Dolly Birds
to Birkenstocks

(1961–1966)

January 20, 1961:
Washington, D.C.

John and Jacqueline Kennedy were by
far the best-looking couple to ever in-
habit the White House. The morning of the inauguration the air was
absolutely bitter—the thermometer read twenty-two degrees Fahr-
enheit, but with the windchill, it felt like an unforgiving seven—but
the handsome forty-three-year-old president and his regal thirty-
one-year-old wife didn't let the weather impede their style as they
took their places before the crowd. The president-elect chose a tra-
ditional, almost throwback look: a dark overcoat and a silk top hat,
which he removed for his famous "Ask Not" speech. On the other

hand, the fresh-faced first lady wore an of-the-moment taupe Oleg Cassini wool dress with a matching three-quarter-length-sleeve overcoat, with a round, high collar and oversize wool buttons down the front. As her husband spoke of the "torch [being] passed to a new generation of Americans," she stood by him, the picture of youthful elegance, accessorized in a pillbox hat (designed by an up-and-coming milliner named Halston), pearl earrings, a fur muff, and low-heeled black pumps—which she'd later swap for a pair of form-fitting fur-trimmed black boots to march through the snow-covered streets for the inaugural parade.

That year, America found a new fashion icon. Jackie Kennedy wasn't a movie star, but she certainly had star quality, complete with a collection of oversize dark sunglasses. Like Audrey Hepburn, she was a natural brunette with an innate sense of poise, and from the moment she stepped out onto the campaign trail she debuted her signature style: a kind of elevated casual that looked fashion-forward but was still appropriate for her role as the president's wife. From her collection of Hermès scarves, which she wrapped effortlessly around her chin-length hair, to the Capezio flats she paired with everything from tailored skirt suits to brightly colored A-line dresses, to beatnik-friendly black turtlenecks with cropped white stovepipe pants, Jackie's personal style set the tone for the nation. The Kennedy presidency would be classy but cutting-edge. The young couple had their fingers on the country's collective pulse, responding to the beat for *change, change, change.*

While the American electorate picked a leader who reflected its positive energy and optimism, fashion's old guard was due for an overhaul. After losing his job at Dior and surviving a hellish stint in the

army, Yves Saint Laurent launched his own label in 1962. He was confident that he had been onto something with the Beat Look, even if it wasn't appreciated by his shortsighted peers, lost in the gossamer folds of haute couture.

Even from the posh address of 30 rue Montaigne, Saint Laurent could recognize a paradigm shift in his industry, a fundamental change in the way fashion was being consumed. Since the advent of couture, the tastemakers and trendsetters had always been the aristocracy, the class of men and women who could afford to update their wardrobes with cutting-edge pieces that were hand stitched to the specifications of top designers: the crème de la crème. The role of youth was to admire and covet the older generation's acquisitions until one day, when their economic profiles allowed, they joined their parents in the pursuit of luxury. Fashion has always been a tool of systematic social demarcation, but traditionally it catered to the seasoned consumer and regarded younger generations only as *potential* clients. In the late 1950s and early 1960s, however, the quality of that upward glance from teenagers to their parents changed significantly as the younger generation questioned whether older generations were setting a desirable example.

What this meant for style was a breakdown in the vertical system that presumed fashion trickled down generationally, and that kids wanted to dress like their elders. "People are talking about . . . Vietnam and the Negro Revolution . . . and Youthquake . . . the eruption of the young in every field," editor in chief Diana Vreeland wrote in American *Vogue* in 1965, coining a term that would go on to define the character of 1960s trends. Possessed by the thrill of newness—of new fabrics, materials, colors, and silhouettes—the youth culture dominated the fashion landscape, forcing designers to adapt to these shifts in cultural values. One of the preeminent designers to recognize and

ultimately benefit from the redistribution of trendsetting power was the British Mary Quant, a clothes lover who opened her first London boutique in 1955. If Dior's New Look defined the sartorial point of view of the 1950s, Quant's unstructured dresses, splashy prints, and lighthearted styling were an inspired fit for the ordinary girl she set out to target. In fact, part of Quant's democratic appeal was her lack of couture pedigree. A self-starter, she had no formal fashion training and even made the rookie mistake of buying fabric retail at Harrods, rather than wholesale like the in-the-know designers. "I have always wanted young people to have a fashion of their own," she once wrote. "To me adult appearance was very unattractive, alarming and terrifying, stilted, confined and ugly. It was something I knew I didn't want to grow into." One way Quant made this perspective manifest was by selling clothes that highlighted the legs rather than the breasts. The bosom, seat of maternal womanhood, went out of style, and in its place appeared straight hips and miles of girlish stick-thin legs. Prefigured by Audrey Hepburn, willowy London gamines like Twiggy and Jean Shrimpton became the new It Girls, gazing at the camera with big, wide-set eyes and pouty mouths.

The early 1960s became the era of the miniskirt,* which opened the door to fantastic new footwear possibilities. By mimicking what she saw the "dolly birds"† wearing on the streets of London, Quant helped to resurrect the boot, which in the age of the stiletto went

* An anecdotal story supplied in *American Style from A to Z* by Kelly Killoren Bensimon attributes the creation of the miniskirt to New York City socialite and fashion editor Nan Kempner, after she was scolded at an upscale restaurant for wearing pants. Supposedly she removed the offending garment on the spot and for the rest of the night wore her long blouse as a dress.

† British slang, which originated in the 1960s, for "pretty girls."

largely ignored. Twiggy was a convert—but admitted that prior to this boot renaissance, she and her friends would go "through whole winters with [their] legs frozen to the bone because you just wouldn't wear boots . . . nobody wore boots. Boots meant ankle boots, brown with a zip, the sort of thing old ladies wore." Quant paired miniskirts and dresses with shiny, pop art—inflected boots in a rainbow of colors, most notably in her 1963 "Wet" collection, which used cutting-edge waterproof materials like vinyl and PVC. Similarly, French designer André Courrèges, in his "Moon Girl" collection of 1964, showed wide, flat pull-on boots that not only looked thoroughly modern but also rejected the prevailing viewpoint that a woman needs to teeter in heels in order to look sexy and feminine. In fact, even in the highest fashion houses, vertiginous heels were going the way of the girdle. After founding his eponymous label, Yves Saint Laurent teamed with Dior's go-to shoe designer Roger Vivier to design a shoe to match the series of color-blocked shift dresses he planned to show, inspired by the geometric paintings of Piet Mondrian. The father of the stiletto unveiled a simple square-toed pump with a low heel and a large silver buckle on the vamp. Vivier's Pilgrim Pump was an instant hit, selling 200,000 pairs and reaching icon status via Jackie Kennedy, who wore them often, and Luis Buñuel's 1967 film *Belle de Jour*, starring Catherine Deneuve as a bored housewife turned high-class call girl.

Even high-end designers like Vivier reached for a shiny artificial leather called Corfam after DuPont debuted it at the 1963 Chicago Shoe Show. The availability of this and other new, inexpensive materials inspired more experimentation on the part of shoe designers, and a reciprocal willingness to test-drive styles on the part of the consumer. As man-made leather substitutes flooded the footwear market, an era of disposable fashion emerged, in which buyers willingly traded long-lasting, classic purchases for inexpensive, trendy

items that could be worn only as long as they remained at the fore-front of chic. Unlike their mothers who had lived through miser-able periods of rationing, this younger generation was more than willing to pay for products that held no promise of extensive wear. For instance, the knee-high go-go boot, which gained in popular-ity through the mid- to late 1960s, would have been significantly more expensive to manufacture if the only option had been to craft it entirely out of leather. Were this the case, the go-go boot would have remained accessible mostly to older, wealthy patrons, who aren't generally known for their willingness to sample unconven-tional trends. An experimental shoe made in durable leather is a good investment in one sense but proves riskier in terms of retain-ing its value in fashion currency. By using materials like Corfam and PVC, manufacturers enabled more adventurous, and less affluent, customers to try out the look. With its free-form shapes and eye-catching colors and prints, 1960s fashion was a huge departure from styles of the past and caught on in no small part because the lower price point made it more democratic. Thus innovative go-go boots became acceptable street wear for the mod: a new type of fashion-conscious, independent, sexually and politically liberal woman.

Around the same time, another kind of flat-soled shoe was slipping its way into street style: the sneaker. Natural rubber–soled shoes had been used by the aristocracy for recreation since the days of Henry VIII, but it wasn't until the American inventor Charles Good-year patented the process of vulcanization in 1839 that they entered into the mainstream. Vulcanization, in which heated rubber is combined with sulfur, helped manufacturers overcome some of the organic material's drawbacks: sticky, not particularly durable, and

sensitive to both hot and cold temperatures. Shoes with vulcanized rubber soles were then popularized by the U.S. Rubber Company in 1916, when it debuted a proprietary line of tennis shoes called Keds (a mix of "kids" and "peds"); an advertising executive at New York's N. W. Ayer & Son first described them as "sneakers" because the quiet, bouncy soles allowed wearers to "sneak up" on their friends. For decades, Keds dominated the market for tennis shoes, but in the 1960s, they were embraced as a casual alternative for fashionable gamines like Audrey Hepburn and fearless trendsetters like Jackie Kennedy. Keds weren't the only game in town; beatniks had gravitated toward the Converse Chuck Taylor All Star, which was another simple canvas shoe with laces and a white rubber sole, this one designed for basketball. It was introduced to the market in 1917, and like most sneakers, it was originally intended to appeal to athletes looking to improve their performance. In 1921, just a few years after he won the shoes notice by choosing to wear them on the court, basketball legend Charles "Chuck" Taylor officially joined the Converse team, signing one of the nation's preeminent sports celebrity endorsement deals. In the 1950s, this affordable, comfortable shoe found life off the court, thanks to the growing popularity of rock and roll, and in the early 1960s, the brand debuted a low-top, oxford-style version of the high-topped original to appeal to nonathlete clients who didn't require ankle support. Meanwhile, on the West Coast, slip-on Vans gained a following. A family company founded by Paul Van Doren in 1966 with two business partners, it specialized in washable canvas sneakers with a thick, flat vulcanized rubber sole. Vans also attracted the counterculture, in this case disciples of the Pacific Ocean and beach culture—surfers and skateboarders—who valued high-quality, no-frills footwear.

Sneakers were a fixture within youth culture and the under-

ground, but they were systematically pushing their way into the mainstream. By May 1962, sneaker sales had jumped from a modest 35 million pairs a year during the 1950s, to a stunning 150 million. The *New Yorker* noted "a revolution that seems to be taking place in footgear," while a U.S. Rubber representative announced in *Newsweek* that sneakers "are socially acceptable now. . . . They're like hot dogs, part of America." It wasn't until 1964, with Philip "Buck" Knight, a track star who sold running shoes out of the back of his car at college meets, that rubber-soled sneakers took a turn toward the high-tech. Knight and his coach William J. Bowerman imported "Tiger" brand shoes from Japan, which sold well with athletes until the pair had a falling-out with their Asian supplier. A few years later, Bowerman and Knight would decide to take matters into their own hands, and go on to found Nike.

For some women, ditching the high heels and hiking up their skirts was all it took to feel liberated, but for others, it was like putting a Band-Aid on a gushing wound. To Betty Friedan, whose *The Feminine Mystique* was published on February 19, 1963, the idea that women should be led by their consumerist impulses was inherently flawed and served to stifle their ambitions by distracting them with targeted advertising: "The buying of things drains away those needs which cannot really be satisfied by home and family—the housewives' need for something beyond themselves with which to identify. . . . The store will sell her more . . . if it will understand that the real need she is trying to fill by shopping is not anything she can buy there." Friedan's treatise gave voice and context to the limitations of traditional married life and put a name to a condition experienced by so many 1950s housewives, characterized by a gnawing, hollow

feeling that she'd been sold a bill of goods when she signed up to sacrifice herself to house and home. Women who loved their families, and took pleasure in taking care of their own, still suffered under the burden of disappointed expectations and the dull suspicion that one's lifetime contribution needn't be confined by a white picket fence surrounding a manicured yard.

In the 1960s the world was changing rapidly and, in some cases, abruptly. Friedan's book came at the perfect moment, dovetailing with a prowomen groundswell that was gaining in visibility and momentum. That same year a prominent activist named Gloria Steinem published an undercover exposé of Hugh Hefner's Playboy clubs, which launched her into the limelight as an outspoken leader within the women's movement. The moment for breathy, helpless femininity, à la Marilyn Monroe, was passing—and, in fact, Monroe had died the year before of a tragic overdose, plagued by rumors that she was having affairs with both the president and the attorney general, Kennedy's younger brother Bobby. The notion that JFK could have cheated on his radiant, stylish wife—even with Hollywood's number one sex bomb—shocked the nation, but that was nothing compared with the events of November 22, 1963, when a man who seemed untouchable was murdered in plain sight.

The world order was being upended, and while there would be many more unforeseen casualties, participants in the civil rights and feminist movements believed fervently in the power of change. If the suffragettes were considered the first wave of American feminism, this group, committed to the policies of reproductive rights and equal pay (as well as larger, nonlegislative issues of gender, family, and sexuality), represented the second. They rejected fashion wholesale as an insidious tool of the patriarchy: the stereotypical image of a hard-nosed Second Waver is a woman with messy, grown-out hair

and unshaven legs and armpits; she wears no makeup, burns her bra, and marches in Birkenstocks. Embraced by women's libbers for their comfort and practicality, these German, earthy, foot-friendly sandals were introduced to Americans in 1966 by German-born Margot Fraser, who fell in love with them on a trip back home. It took a health food store owner to recognize their charms; one shoe store proprietor rejected them as "hideous" before Fraser found them a place in the States. Caricatures aside, Second Wavers used their collective appearance to convey the story of gender emancipation from rigid beauty standards and laws that inscribed their status as second-class citizens. If the medium is the message, this message was written on the flesh.

Women weren't the only ones experimenting with their physical appearances. With the scent of permissiveness and rebellion in the air, young men felt freer to express themselves via clothing as well. After a decade of starched collars and pressed blazers, mods in London started wearing tight-fitting pants, longer (though not yet long) hairstyles, and jackets with eye-catching trim and skinny ties. Stateside, similarly adventurous male dressers were inspired by urban, African-American street style, which incorporated flamboyant, even feminine, accents like hats, necklaces, fur, and feathers. Masculine self-adornment was dubbed "peacocking" for the way it sought to attract attention, yet it had the surprising effect of emphasizing a guy's masculinity rather than detracting from it. Still, the Peacock Revolution—as this moment in fashion was dramatically christened—was a niche, largely metropolitan trend until a group of talented English mods appeared on the music scene.

In 1964, when they made their stateside debut, John, Paul,

George, and Ringo had already undergone at least one total make-over, prompted by Lennon after he enrolled in art school and encouraged the boys to trade their leather jackets and skinny jeans for tight polo sweaters, professorial tweed jackets with leather elbow patches, and winklepickers: ankle boots with a long, pointy toe. These shoes, worn by both male and female rock and rollers in England, featured broad but sizable heels known as Cuban heels, which are flat in front and tapered in the back, and are traditionally worn by male dancers. In 1961, on their way back from a nightclub tour in Hamburg, John and Paul had walked by the famous London shoe shop Anello & Davide, pausing to admire a pair of Chelsea boots—modified riding boots that hit the leg at low to midcalf—on display. They commissioned four pairs to be made but specified that they wanted them done with a lift: *et voilà*, the bespoke Beatle boot was born. The boys from Liverpool went international with their new look, touring as clean-cut kids with an edge. Like their simplistic, four-chord songwriting, this style didn't last too long for the group, but the boots were unique enough to cause imitators to line up in front of Anello & Davide to buy their own pairs, and to go down in fashion history as forever associated with the band.

The 1960s became a watershed moment in the democratization of footwear, when young, adventurous buyers—no longer looking to their parents for fashion advice—sought out stylish role models elsewhere. The music industry supplied rowdy voices of dissent, as well as cool, attractive stars whom their legions of fans rushed to emulate.

9

These Boots
Are Made
for the
Valkyrie

(1965-1969)

1965: Jersey City, New Jersey

What was Lee Hazlewood going to do about Nancy Sinatra? The moment he entered her family's stately New Jersey mansion, he realized he was in for a hard sell. He expected a quiet sit-down with the girl, and maybe her parents, but what were all of his music industry friends doing here? Was that garlic he smelled? *And for Pete's sake, how's it hanging, Bobby Darin, wasn't expecting to see you here, man.* Someone had done their research; the bar was stocked with Chivas Regal, which was Lee's drink. Soon enough

he had a tumbler of the good stuff in hand, was sniffing it under his broad brown mustache, and had nearly forgotten why he'd come.

It was a command visit, ordered by Mr. Sinatra himself. Lee hadn't been too optimistic about the meeting, but he knew, even if the invitation was secondhand, that no one said no to the Chairman of the Board—just ask Tommy Dorsey. Lee, a swaggering southern songwriter and producer, had enjoyed modest success in the business, deejaying a popular radio show in Arizona that put him on the map after he played a little-known Memphis-bred track that just happened to be recorded by the kid who turned out to be Elvis. Around the same time, he crossed paths with a talented teenage guitarist named Duane Eddy, and with Lee's help, Texas twang made its way to the recording industry's hub in Los Angeles. Lee got his kicks in the City of Angels for a while; then the so-called British invasion hit, and four dweeby mop tops, singing about the kinda love that goes hand in hand with soda pop, all but commandeered the airwaves.

That music just wasn't Lee's style. He was thinking about retiring at the ripe old age of thirty-six—going back to Texas or maybe bumming around Europe, but then the Sinatra girl's name came up, and he was penciling her in. Truth be told, Nancy was a cute little thing. Her mama was still pretty, and as far as Lee could tell, as sweet as pie, and Nancy had her father's big blue eyes, which were clearly worth their weight in record sales. Unfortunately, the Sinatra name hadn't done enough for dear Nancy's rising star. The old man's label, Reprise Records, who'd signed Nancy in 1961, was, sans a hit, just about ready to give up on her. Lee knew a thing or two about music, but he wasn't sure if he was the right man for the job.

Yet here he was at the Sinatra house, and nobody was talking about logistics. He could hang out with his buddies until the Chivas ran

dry, but then the front door opened and closed, and in walked Old Blue Eyes himself, passing through like he'd just put on a show and was waving to the regulars on his way to the car. Frank and Nancy Sr. had been divorced for years, and, in fact, Frank was coming up on wife number three (Mia Farrow with a pit stop at Ava Gardner—what a life). Yet he sauntered toward the kitchen like he still lived there, saying hi to Nancy and flashing that million-dollar smile.

Frank didn't emerge for another hour, during which time Lee Hazlewood wondered if he'd even get a chance to meet him. Suddenly, Frank Sinatra materialized, looking full and self-satisfied. He offered his hand.

"I'm glad you kids will be working together," he said without discussion, before taking off again.

Lee Hazlewood had recently written "These Boots Are Made for Walkin'" down in Texas, but he hadn't envisioned Nancy as the singer. In fact, he'd originally imagined the narrator to be a man: himself. As Hazlewood told French documentarian Thomas Levy, "I wrote it in 1965 cause my friends down in Texas—especially ladies, the girlfriends of my friends and the wives of my friends—says, why don't you ever write a song about love? And I says, OK, I'll write one, especially just for you." But the first time he performed it at a party— Lee, who never performed at parties, but couldn't resist showing off his new wicked little ditty—the churchgoing women in the room dispersed in disgust. "Boots" wasn't about love at all, but rather its less righteous counterpart: lust. The first verse (and one of only two verses, when Lee first wrote it) was particularly naughty, sung in a man's voice that's part honey, part gravel: "You keep sayin' you got somethin' for me / Somethin' you call love, but confess / You've been

a'messin' where you shouldn't've been messin' / Now someone else is gettin' all your best . . ."

Not quite a love song, but hardly a reason for Bible-belting indignation. Hazlewood said guess again: "In our part of Texas, 'messing'—*What were you doing last night, I was out messing*—was the four-lettered word, we didn't say the four-lettered word, we said messing." Translation: Lee took a request for a song about romance and instead delivered one about a woman who, quite literally, fucked around on him. But when Nancy heard it, among an informal showcase of Lee's songs she could potentially record, she knew it was the one. "He played me a bunch of songs, and my favorite one was about boots," she told CBS *Sunday Morning* in 2006. "I thought it was a hit record, I mean, first time I heard it. Because even on the guitar, that quarter tone [sings the opening notes] every time you hear that, you know what the song is."

Lee, however, had reservations. Aware of the words he would be putting into a pop princess's mouth, he let her in on the song's secret meaning. "They'll shoot us if we do this," he told her, no doubt recalling the reactions of his female friends down south. "Boots" was good for a laugh, but was it really ripe for the airwaves?

Nancy was undeterred: "It doesn't mean that in New Jersey! It doesn't mean that in California." Lee made a few phone calls, and sure enough, when he asked his northern friends about "messing," and what it implied, nobody understood it as code for you-know-what. So Lee wrote the song's third verse, and Nancy Sinatra and Lee Hazlewood set out to record "Boots."

Lee knew that in order to capture the essence of the song, he had to do something about Nancy's squeaky-clean image, which had failed

to help audiences see her as anything other than Frank's doll-faced daughter. Her voice, which was all but genetically guaranteed to be good, was also too high and cutesy for a song about stepping over a cheater and kicking up dirt. She was pushing herself to sing like an old-fashioned cheesecake pop star, fighting against her naturally lower register. He delivered an explicit direction: "Sing it like a fourteen-year-old girl who screws truck drivers."*

"I can do that," Nancy said.

She was ambitious. Already married and divorced by age twenty-five, she was ready to make a splash on the music scene. She knew that her father's name afforded her unusual opportunities—when she called her agent wanting to do her first film, he landed her the lead in *The Wild Angels* opposite Peter Fonda—but music was her first love, a passion that transcended her appetite for celebrity. "It was always about the music," Nancy remembered. "I never expected anything as big as ['Boots'] was, never. The music was all I knew." In 1965, her marriage to actor and singer Tommy Sands finished, she ditched the conservative brunette hair flip and buttoned-up pants suit that she wore for a 1965 performance of "So Long Babe" on *Hullabaloo*—a prime-time music variety series that ran from January 1965 to August 1966—and opted for a look better suited to her easy, flirtatious rapport with the camera.

Nancy dyed her hair, wore black false eyelashes all day, and slept in brown ones at night ("so I look gorgeous in the morning," she told reporter Natalie Gittelson for the October 1966 issue of *Harper's Bazaar*—an evocative statement suggesting that the unmarried star

* Hazlewood's instruction has also been reported as "sing it like a *sixteen*-year-old who *goes with* truck drivers"—a sanitized version for the press, perhaps?

might have someone around in those early hours to look gorgeous for). For a second, 1966 *Hullabaloo* performance, this time performing her new single, Nancy appeared onstage as a coiffed, frosted blonde, in a long-sleeved blousy, white peasant top and an A-line black miniskirt that ended above the knee but was not nearly as revealing as some of her future hemlines. Bopping against a backdrop of four larger-than-life Edwardian-style boots, and surrounded by a team of energetic female go-go dancers, Nancy tapped her feet in a pair of tall white boots, which would later appear in publicity stills of the star. These pictures—of a thinner, blond bombshell version of Nancy hugging her knees in a white, open-backed micro minidress, with carefully tousled and teased long hair and smoky bedroom eyes—are iconic in and of themselves. They followed a sultry album cover of Nancy lying on her side and resting her chin on her hand as she stared down the camera. Wearing a form-fitting gray long-sleeved shirt, a red miniskirt, black-and-white striped tights, and red fold-over pirate boots, she was the fresh-faced personification of the independent American mod, who worshipped fashion as a way to express one's own quirky, devil-may-care independence.

Though many fans attributed the makeover, which turned out to have a significant effect on her career, to Lee's savvy, Nancy counters that it was simply an organic evolution of her personal style. "I went to London when my first [Lee Hazlewood] record came out, which was 'So Long Babe.' I had been there before with my more bubblegum type music, and I had seen some of the fashions already, but then when I went back . . . I went right to Carnaby Street. I couldn't wait to get there, because I fell in love with the fashions." A three-block stretch of boutiques in the center of London, Carnaby Street was the location of Mary Quant's popular store, as well as ground zero for mods and hippies who enjoyed shopping for the newest disposable

styles almost as much as they liked posing in them. Nancy felt herself at home among the cigarette-smoking, New Wave–watching cool kids, inspired by the atmosphere of youthful vigor and determined self-expression.

It was Carnaby Street where she found many pairs of her famous boots—the majority of them were not, as many sources have since reported, designed by Beth Levine. "Some of the boots [came from Levine]," she remembers, "but I was getting boots mostly in London, and that's not Beth Levine, I think that's where the confusion came [in]." She goes on: "You know, Mary Quant, was my . . . fashion guru without knowing it, and that's where the look came from. Beth Levine came in later when I started having boots made . . . and then my official boot maker was [Pasquale] Di Fabrizio here in Los Angeles, and he made a lot of wonderful boots that I used onstage."* Her London-inspired style was right on trend; that same year, French sexpot Brigitte Bardot dismissed couture as "for grandmothers" and Yves Saint Laurent opened a *prêt-à-porter* (ready to wear) boutique on the Rive Gauche in Paris.

Lee Hazlewood might have been skeptical about working with twenty-five-year-old Nancy at first, but their collaboration would go on to make history. "Boots" hit number one on the U.S. and UK charts and topped in Australia, New Zealand, Brazil, Japan, Italy, and Belgium as well. As a concise tale of female empowerment that encouraged women to give a cheating man the boot should his lies become transparent, the song was a clear departure from the 1950s stand-by-your-man mentality (incidentally, "Stand by Your Man,"

* Nancy still owns some of her original 1960s footwear; "I actually have a pair of the red ones as lamps," she admits with a laugh.

recorded by country sensation Tammy Wynette in 1968, peaked on the charts at number nineteen). With her inspiring message and shapely legs, Nancy spawned a generation of sartorial look-alikes. Soon the demand for boots was so great that Saks Fifth Avenue, long a leader in footwear sales, devoted a corner of its shoe department to "Beth's Bootery," named for husband-and-wife shoemaking team Herbert and, yes, Beth Levine. By the end of 1966, Nancy was poised to earn half a million dollars (the equivalent of approximately 3.3 million dollars today). Lee Hazlewood, the man who had been hired to turn Frank Sinatra's daughter into a star, had done his job well beyond satisfaction. And boots, with their legacy as footwear for the powerful, spectacular, and brave, would shoe a generation of real-life Amazons.

In a way, boots' long, historical lineage as activewear had already made them a symbol of women's emancipation. At the end of the eighteenth century, women wore boots only for horseback riding until they were adopted for the sport of "pedestrianism" as well; as Jonathan Walford explains in *The Seductive Shoe*, "This was not a stroll, but rather a brisk activity that required good posture and stamina, what we would call hiking today, and was considered a suitable social exercise for young ladies." In the nineteenth century, women hiked up their skirts and wore boots to go bicycling, and ladies across the social stratosphere turned to knee-high shoes to protect their feet in bad weather. Boots offered women freedom—to ride horses or bikes, or to go outside even when the elements were inhospitable.

But Wonder Woman, as the quintessential booted heroine, shaped the nation's impression of the shoes as an accoutrement of power. In 1966, she celebrated her twenty-fifth birthday, meaning

that a young woman Nancy Sinatra's age never would have known the world without her. Though Wonder Woman is most commonly depicted wearing boots, her shoes varied through time and by artist: around 1950, her boots disappeared altogether and in their place emerged a pair of Greco-Roman flat sandals, with ballerina-like ribbons that crisscrossed their way up her calves. Like the original boots, these shoes fluctuated between flat and high heeled (1959), open- and closed-toed, and even showed up in gold once or twice. The sandals, with tweaks here and there, remained consistent until 1965 when, during a period of especially low readership, author "Robert Kanigher—the writer who'd succeeded Marston in the late 1940s—initiated a revamp of the series that attempted to replicate the 1942 look of the comic book." John Wells, author of *The Essential Wonder Woman Encyclopedia*, continues: "As part of that, Wonder Woman's boots were restored, although they were now solid red as opposed to the originals [which had a white stripe down the front]." The redesign was an effort to capitalize on the public's renewed interest in Golden Age comic books, but it failed to capture either the spirit of Marston's stories or the effortless camp required to pique the interest of aspiring collectors.

The world was more complicated in the mid- to late 1960s than it had been in 1942. World War II, although horrifying, united Americans as they sought to defeat the enemy: an *us* versus *them* mentality allowed citizens to see the world in black and white. On the other hand, after JFK's shocking assassination, and then a second one that claimed the life of liberal Bobby Kennedy as he tackled the campaign trail, the sense that evil was among us, rather than outside of us, started to sink in. Meanwhile, politics proved divisive as President Johnson, John Kennedy's successor, escalated the hugely contentious war in Vietnam, widening the chasm between

conservative supporters of the war who'd stop at nothing to stanch the international spread of communism, and the liberal youth who felt that payment in American blood was too high a price. In April 1967, the birth control pill appeared on the cover of *Time* magazine sparking, alongside the demands of the Second Wave, an ideological deadlock on the subject of reproductive rights. The civil rights movement, led by Martin Luther King Jr., gained significant traction, highlighting the cultural and generational gaps and then coming to a shocking halt when King was shot on the balcony of a Memphis motel.

It's no wonder that a Golden Age comic book struggled to stay relevant. In the summer of 1968, DC Comics published an ad that promised a "really big change . . . coming to Wonder Woman." It showed Diana Prince—the superheroine's human, Clark Kent–esque alter ego—wearing a bright orange mod tunic over a gray-and-black-striped bodysuit, her sleek black ponytail dangling toward the small of her back. The ad presaged the October 1968 issue of *Wonder Woman*, which debuted an *Avengers*-era Diana Prince in stylized street clothes and holding a paint can. "Forget the old . . . the New Wonder Woman is here!" the text read. Explains John Wells: "The Diana Prince makeover was explicitly inspired by Emma Peel* but the real impetus was the *Wonder Woman* comic's increasingly low sales. Convinced that the character had become utterly irrelevant to either male or female readers, writer Denny O'Neil and artist Mike Sekowsky did away with Wonder Woman's powers and costume and brought in a vibrant—if now terribly dated—splash of late 1960s

* A spy, martial arts expert, and gifted swordswoman, Peel was a mod-era badass in boots who could best her foes with wit and panache—but with no superpowers.

fashion and international intrigue." O'Neil and Sekowsky hoped to breathe new life into the *Wonder Woman* comic, but the dramatic makeover had unintended consequences. Stripped of her powers, the scope of Diana Prince's world shrank. Suddenly the character was less concerned with the machinations of good and evil than she was consumed by her complicated love life.

"The Diana Prince experiment ended with a well-intentioned but frankly painful story whose cover expressly declared it a 'Women's Lib issue,'" Wells recalls. "In essence, Diana was hired to be a fashion model for a Manhattan businessman and ignored complaints that he paid female salesclerks far less than men. Dismissing their concerns, she remarked, 'In most cases, I don't even like women.' Which may be the most remarkable statement made by Wonder Woman in her seven decades of existence." The lessons of the feminist movement hadn't yet affected the world of comics.[*] Diana Prince, while a trained martial artist, spent as much time battling foes as she did second-guessing her relationships. Ultimately it was Gloria Steinem who came to the rescue, successfully lobbying DC Comics to end Diana Prince's arc and rightfully restore a superhuman heroine— possessed of awesome powers—to the series.

The association between boots and women's inherent capabilities was established. If high heels signaled the presence of an ambitious woman who used her sexuality to get what she wanted, boots became an indication of a female character's physical and moral strength,

[*] But it would—in the late 1970s and early 1980s, comic books gave birth to venerable heroines like Phoenix (Dr. Jean Grey) in the X-Men.

her willingness to rise to the challenge—and to look good doing it. A femme fatale's chief talent is manipulation, while the valkyrie—a woman who faces the dragon and leaves it panting for breath—surprises her companions only by surpassing their modest expectations. Femininity, often regarded as a fundamental weakness, becomes her greatest asset, and she uses it for good, rather than evil. Boots, for their alluring gender ambiguity, symbolize this intersection of "male" strength and "female" compassion—with a dash of sexuality tossed in for extra measure.

In 1968, Jane Fonda played the intergalactic sexpot Barbarella, modeling a whacked-out space-age wardrobe designed by French visionaries Paco Rabanne and Jacques Fonteray that often involved little else but a pair of kinky boots and a bikini. She made *cuissardes* famous: skintight, thigh-high boots invented by André Courrèges, which Fonda wore as hybrid footwear-garters. Though she looked like a futuristic goddess, crowned with a mane of blond hair that, as Fonda later joked in her memoir *My Life So Far*, should have received its own billing, she was grappling with painful insecurities: "There I was, a young woman who hated her body and suffered from terrible bulimia, playing a scantily clad—sometimes naked—sexual heroine. Every morning I was sure that Vadim [Fonda's husband at the time and the film's director] would wake up and realize he had made a terrible mistake—'Oh my God! She's not Bardot!'" For Fonda, the list of her husband's previous partners—Catherine Deneuve, Brigitte Bardot—loomed large enough in her mind that she pushed herself to live up to their legacy. This meant tackling the Swinging Sixties with surprising literal mindedness, overcoming "bourgeois" emotions like jealousy and sharing her husband, and sometimes even her bed, with a string of anonymous lovers. On March 29, 1968, Fonda's erotic film and unconventional lifestyle landed her on the

cover of *Life* magazine. Decked out in full Barbarella garb, including a pair of slouchy black low-heeled boots, the headline read "Fonda's Little Girl Jane"—like Nancy Sinatra, Jane Fonda blossomed in the shadow of a dauntingly accomplished father. Still, a famous name didn't stifle Fonda's desire to topple the "Establishment": "To Jane, a nude scene in a movie—'within the artistic concept of the story,' she emphasizes—is all in a day's work. To achieve this point of view she has worked hard to cleanse her psyche of 'hang ups,' and it appears she has been, but for occasional lapses, successful. There are still outcroppings of prudery that annoy her."

Via *Barbarella*, Fonda became the symbol of a new kind of liberated woman who acknowledged her sexuality and didn't shy away from it, treating sex less like a delicate secret between husband and wife, and more like no big deal, a fact of life that distinguished the enlightened from the squares. By the late 1960s, monogamy, like stiletto heels, was looking terribly old-fashioned. In July 1969, *Harper's Bazaar* published a novella-length exposé titled "The Erotic Life of the American Wife" by Natalie Gittelson, in which she proposed, among other things, that cheating was not just for husbands anymore. "For the first time in modern history," she wrote, "the married woman has begun to regard herself frankly not only as sexual, but as a sensual creature, equal on both counts to her husband, entitled to the same privileges and prerogatives, sharing the same feelings and fantasies and accorded—by virtue of the same humanity—the same freedom of action." For suburban couples, who appeared on the surface to be about as revolutionary as Ward and June Cleaver, a furtive life of steamy affairs resided just below the surface. "Contrary to popular legend," Gittelson wrote, "the real threat to marriage is not the 'dangerous divorcee' of drugstore fiction. The little-discussed, all-American menace is Mrs. Peter Goodwife's neighbor, Mrs.

George Goodwife, who lives across the lawn or across town." *Mad Men*'s Betty Draper is taking a lover not just in retaliation for her husband's infidelities, but also to satisfy her own personal lust.

Jane Fonda fully embraced the new morality, in which monogamy—as Natalie Gittelson put it—"is no longer a moral dictum, but a matter of personal aesthetics and private taste." Though Fonda later attributed her loosey-goosey attitude toward marital fidelity to a dangerous blend of Roger Vadim's persuasive personality and her gnawing insecurities, there was a sense, in the 1960s, that boundaries were meant to be crossed, buttons were only there to be pushed. At first glance, *Barbarella* is little more than a campy sexploitation flick, but its world-saving heroine, with her capacity for transcendent love both emotionally *and* physically, survives as an over-the-top testament to the way the parameters of acceptable female behavior were moving. Just as fashion's ruling class failed to respond to the changes taking place on the street as quickly as outsiders like Mary Quant did, so too did the powers that be react, at times frustratingly slowly, to the evolving role of women in America. As Lisa Parks points out in *Swinging Single: Representing Sexuality in the 1960s*, *Barbarella* premiered at a time when the notion of a female astronaut was still verboten: "Scientists suggested that the extreme unpredictability of the female body, especially during menstruation, made women unfit for astronautic endeavors." Women could work in a limited capacity for NASA but couldn't train for blastoff, and the issue of women in space was heard before the House Science and Astronautics Committee in 1962, as well as debated in the popular media. Sally Ride wouldn't break the barrier until 1983. Interesting, then, to see a late-1960s woman in her best moon boots, whose body isn't a liability but an asset: the only weapon strong enough to restore intergalactic peace and equilibrium. The line, in this tumultuous decade, between the

abject and progressive was thin. The two were blurred such that Fonda herself "took decades" to appreciate why posterity has been indulgent toward *Barbarella*, like a mother trying to stifle her amusement at a young child's antics. Ultimately it would take time for true equality to take hold, and for men and women to occupy the same space.

10
.

Props,
Platforms,
and Porno

(1970–1974)

May 1970: Hollywood, California

After antitrust suits and increasing television sales left the film studios all but dissolved, MGM hosted a series of dreary nighttime auctions to liquidate its troves of accumulated props. The studio hired a team to sort through the seven soundstages' worth of junk they'd collected, some of it moldy, tattered, and covered with moth holes—anything left over would be unloaded at a flea market in San Francisco, where the Haight-Ashbury set paid twenty-five dollars and under for dresses worn by Elizabeth Taylor, Marilyn Monroe, and Greta Garbo. The market for Hollywood memorabilia had yet to

emerge, and the studio hoped only to unload an era's worth of costumes and set pieces, freeing up the budget allocated to storage.*
One spring evening, MGM's Stage 27 buzzed as auctioneer and liquidation specialist David Weisz commanded the podium with pieces from the classic film *The Wizard of Oz*. The night had been a success: these props proved surprisingly popular as eager bidders filled rows of red chairs, willing to pay unexpectedly generous prices for old movie items that could have easily ended up in the trash. Bert Lahr's lion costume fetched $2,400 (approximately $13,000 in today's dollars), and the witch's hat, the villain's pointy crown, sold for $450.

Then came the moment for the pièce de résistance: lot W–1048, Dorothy's ruby slippers. When they came up for auction, Kent Warner—a passionate, svelte blond costumer—was given the honor of presenting them on a velvet cushion of his own design, as a reward for discovering them in a cluttered corner among an assortment of lesser-known shoes. Unfortunately, these ruby slippers weren't as glamorous as anyone remembered; they were worn out and far less brilliant than the film stills implied. The supervisor in charge of the auction hoped that some pomp and circumstance—and a special glass case—would help distract from their shoddy appearance and perhaps translate to a lofty price tag. The auction for lot W–1048 commenced, and to Weisz's astonishment, the bids tumbled in, quickly surpassing the most expensive items and besting actress Debbie Reynolds,

* Salman Rushdie, in his short story "At the Auction of the Ruby Slippers," envisioned this event as a dystopian destination spot, where world-weary bidders vied for "a lost state of normalcy in which we have almost ceased to believe and to which the slippers promise us we can return," while journalist Rhys Thomas, author of the definitive real-life mystery *The Ruby Slippers of Oz*, described the auction in starker terms, as "an eighteen-day wake for Hollywood."

who had designs on the slippers but had also underestimated the competition and spent too big a slice of her budget on previous items. In the end, no one anticipated the $15,000 proffered by an anonymous bidder (described by his envoy as a "Southern California millionaire") for the shoes believed to be the only surviving pair of ruby slippers, and thus unique in their claim to a sliver of *Oz*'s magic.

Weisz was pleased and the winner went home satisfied. But as news of the auction broke, Roberta Jeffries Bauman, a middle-aged mom and lifelong Tennessee resident, peeked in the back of her closet. She spied the pair of original ruby slippers she'd kept there safely since 1940, taking them out at home to entertain her children's friends, and once in a while, to loan them out for display at the Memphis Public Library. At sixteen, she'd won a local newspaper contest, and her prize had been Dorothy's red-sequined shoes, presented to her by a representative from MGM—another lucky classmate had received the *Mr. Smith Goes to Washington* gavel. Bauman adored the shoes, and until reading about the events at MGM's Stage 27, she'd never questioned the authenticity of her personal treasure, and certainly hadn't thought to investigate their worth.

She contacted the MGM costume department and received no reply. Eventually her story went to press: Was there more than one pair of ruby slippers? Did Bauman's pair, marked size 6B, actually belong to Judy Garland, whose shoe size had elsewhere been documented as anywhere from a 6½ to a childlike 4? If the bidder who paid fifteen grand for his shoes wrote out a check under the assumption that they were the only existing pair, he had been duped (he was reportedly, and understandably, miffed that his one-of-a-kind purchase turned out to be only semioriginal). It's now believed that Kent Warner didn't find just one pair, or even one version, of Dorothy's famous shoes. He was working the MGM auction with a

goal in mind, and when he found a store of dusty ruby slippers, he saw fireworks.

The auctioning off of MGM's past was symbolic: the age of starry-eyed starlets in sparkling shoes had died off, maybe for good. The ruby slippers assumed a new level of significance as real life became less and less innocent and a sense of nostalgia for simpler times brewed. On August 8, 1969—just a week before Woodstock's three-day-long paean to peace, love, and understanding took place on the East Coast—pregnant movie star Sharon Tate was murdered in her home in California. Enjoying after-dinner drinks on a warm LA night, Tate and her guests were assaulted by members of Charles Manson's Family and brutally stabbed to death. Just a few months later, *Life* magazine published photos of the victims, the crime scene, and the subsequent trial, calling the helter-skelter murders "the end of the sixties."

It wasn't just that the murders took place at the tail end of the decade; the crime reinforced a suspicion that had mounted through the many cycles of hopefulness, followed by devastating assassinations, that characterized the era. And then there was the grueling Vietnam War and the draft. The world was brutal, random. There was no justice. Standing trial for their crimes, the Manson killers were empty-eyed and unapologetic. Thus a prolonged period of trust and optimism gave way to something else: the challenge of rebuilding the American Dream in the face of disappointment, with all of the petulance and Sturm und Drang of an adolescent who has recently realized that his or her parents are deeply flawed.

And just like a moody adolescent, early-1970s culture was hopelessly and unapologetically fixated on sex. In 1972, a little porno-

graphic film called *Deep Throat* cost $40,000 to make, and within a
year of its theatrical release, it grossed $1.5 million. Linda Lovelace
and her unusual talents ushered in an era of porn chic. That same
year, the first stand-alone issue of *Ms.* magazine, a feminist monthly
founded by Gloria Steinem and Letty Pogrebin, hit newsstands, and
three names appeared on the cover: Steinem's; Simone de Beauvoir's
(whose 1949 book, *The Second Sex*, laid the groundwork for Second
Wave ideology); and then the cover girl's. She was wearing blue and
white star-spangled shorts, a red and gold bustier, and skintight
knee-high red boots. The eye-catching headline read "Wonder
Woman for President," and the consummate booted superheroine
was officially embraced by the feminist collective.

However, average women grappled with the question of what it
meant to be Wonder Woman in this new era. Was Linda Lovelace,
for her incredible sexual uninhibitedness, a feminist role model?
As Steinem and Pogrebin advanced the Second Wave agenda, many
young women—from hippies to girls in the up-and-coming disco
scene—slept around, their sexy outfits and promiscuous behavior
underscoring the fact that they'd been "liberated" by faraway activ-
ists fighting for reproductive rights, and disentangling the deep-
seated rules about how one should act as a woman. Nora Ephron, in
her *Esquire* magazine "Women" column, summed up two versions of
the modern woman in her 1973 profile of Lovelace and *Deep Throat*:
"And there we are, Linda Lovelace, 'just a simple girl who likes to
go to swinging parties and nudist colonies.' And me, a hung-up, up-
tight, middle-class, inhibited, possibly puritanical feminist who
lost her sense of humor at a skin flick." A woman could either be a
free-spirited nymph(o) or an intellectual killjoy, too obsessed with
the implications of sexual politics to loosen up and get down.

In 1973, the American Psychiatric Association declassified

homosexuality as a mental disorder, and while the intelligentsia over at the *New York Times* continued to advocate for a kind of don't ask/ don't tell policy in the workplace, at night, under the hot lights of the party, it was every man for himself. In the burgeoning London punk scene, sex and violence informed not only the music and its presentation but the clothing as well, which referenced sadomasochism in its liberal use of metal and black leather. Schoolteacher Vivienne Westwood and her boyfriend Malcolm McLaren—who managed the Sex Pistols—ran a boutique called Sex (later Seditionaries) that sold punk and fetish gear, and catered to a mix of music enthusiasts and sexual adventurers looking for bondage outfits and dangerous, spiky shoes. Among the in-house collection curated by the skinny Brit and his spunky, bleached blond girlfriend were fingerless gloves printed with swastikas, defaced images of the queen, T-shirts silk-screened with naked images of men and boys, and Snow White and her dwarfs wrapped up in an orgy.

Nothing was sacred—pornographic images appeared everywhere, from the rebel boutique at 30 Kings Road in London to the pages of mainstream fashion magazines. Photographer Guy Bourdin's ads for the high-end shoe company Charles Jourdan showed models in various compromising states, one suggestively splayed over a couch in a miniskirt and raspberry spike heels, another girl arched backward to expose a hint of garter belt, using her shiny red slingbacks to grip a black-and-white photo of teen heartthrob and soon-to-be disco king John Travolta between her ankles. Bourdin, a former student of Man Ray's, shot ads for Charles Jourdan from 1967 to 1981, in which he reduced high-heeled women to disembodied limbs, aestheticizing raunchy sex, death, and violence. And it wasn't just women at this time who found themselves under an objectifying, dispassionate gaze. In 1972, thirty-six-year-old Burt Reynolds posed

nude on a bearskin rug for *Cosmopolitan* magazine, a rolled cigarette clenched between his teeth and an arm strategically draped between his thighs. Before challenging Reynolds to appear in the shot, editor Helen Gurley Brown wondered why men didn't bare all for centerfold shots, like the beefcake equivalent to *Playboy* models. Her experiment, which sold 1.6 million copies, predated *Playgirl* magazine by a year.

Androgyny was in. In some ways, the sartorial temperature of the 1970s could be summed up in two white pants suits: Bianca Jagger's in 1972, and John Travolta's (as Tony Manero) in *Saturday Night Fever* (1977). The latter inspired a nation of clones; as Donna Pescow, who played Tony's number one groupie Annette in the film, remembers, "Once the film was released, there were twenty to thirty people at a time wearing white suits walking down Forty-fourth Street." Imitators sought to channel Travolta's charisma, cool, and intensity. On the other hand, when Bianca Jagger strutted through Heathrow Airport in a white three-piece suit, accessorized with a black bowler hat and matching cane, she inadvertently signaled the start of an *anything goes* era. Born in Nicaragua, far away from fashion capitals London and New York, Jagger married her English rock-star husband just one year before, wearing a similar Yves Saint Laurent white suit, this one with a deep V neckline, ankle-length skirt, and a white floppy hat with a beekeeper-esque netted veil that would have made the bourbon-drinking ladies at the Kentucky Derby jealous.

The shoe styles in the 1970s—from designers like Biba and Terry de Havilland, and companies like Kork-Ease—were outrageous. Platform heels dominated: clogs and wedges for daytime, made of natural materials like wood, cork, raffia, and rope, and for nighttime, higher

versions in a rainbow of colors, bedazzled with glitter, rhinestones, and sequins. For the first time in the twentieth century, men's and women's footwear options were strikingly similar; many young, adventurous men, inspired by the Peacock Revolution, experimented with platforms and Cuban heels, giving male and female night crawlers alike an otherworldly, towering appearance. As the *New York Times* reported in 1972, "The young men who are clumping into the jazzy shoe stores that have mushroomed this past year in Dry Dock Country around Bloomingdale's agree that the shoes are great. Learning to walk in platforms that look like chair rocers [*sic*], and price tags that are as high as $85 aren't stopping the teen-to-30 crowd from buying the gold and silver, or pink and purple, or green and yellow monster shoes that rival anything their girl friends are wearing." In their quest for personal style, these men got to know the discomfort that comes with walking in elevated shoes; one male platform shoe enthusiast interviewed for the article admitted "that when he first started wearing 3-inch and 4-inch heels, the tilted stance necessary to walk in them made his back and calf muscles ache."

Not since the courts of Louis XIV had men worn heeled shoes with any regularity—for hundreds of years, men walked in variations of boots, loafers, and oxfords, all with sensible soles designed only to support posture, gait, and balance. But just as women's shoes have evolved to communicate things like economic rank and social status, men's footwear has also developed as a mode of distinguishing the haves from the have-nots, the tastemakers from the followers. Take, for instance, the *poulaine*: a flat-soled shoe with a long, skinny tip à la Pinocchio's nose. When the Crusaders arrived home to Europe with these unusual shoes from the East, *poulaines* caught on with the aristocracy, but then "people of modest means imitated this eccentric fashion. . . . The authorities responded by regulating the length of

the shoes' points according to social rank: a half foot for commoners, one foot for the bourgeois, one and a half feet for knights, two feet for nobles, and two and a half feet for princes, who had to hold the tips of their shoes up with gold or silver chains attached to their knees in order to walk. The shoe length hierarchy led to the French expression *'vivre sur un grand pied'* (to live on large foot) denoting the worldly status represented by shoe length." At a time when social status was so culturally ingrained, codifying shoe lengths was gratuitous, yet nonetheless the *poulaine* became yet another form of exclusivity, another way of driving a wedge between the elite and masses.* Later, in the palace of Louis XIV, aristocratic men not only wore high-heeled shoes but their heels were also painted red to indicate that they were members of the court. The fashion flourished up until the French Revolution, when Louis's lavish and impractical tastes went abruptly out of style.

In the 1970s, the practice of men wearing heels was decidedly more democratic, extending on the one hand to hippies in supple leather clogs and to hustling, platform-wearing disco kings on the other. If anything, the prerequisite for a man who dared to wear them was a powerful stride and a take-no-prisoners attitude; until this point, the only breed of twentieth-century American dude to regularly walk in heels was the cowboy—and he practically invented swagger. A cowboy could get away with wearing elevated boots because they're a useful tool for riding horses. While a flat shoe might slide too easily out of a stirrup, the heel stops the foot from moving forward and thus allows a rider more control from his comfortable

* The shoe's phallic shape also interested William Rossi, author of *The Sex Life of the Foot and Shoe*, who claims that at civilized dinners "the man's erect *poulaine* would reach across to lift the skirt hem of the female guest seated opposite him."

perch on the saddle. In fact, high-heeled shoes came into fashion for precisely this reason, appealing to men because they allowed for additional mastery over an animal. "Heels had been worn throughout the Near East for centuries before they were introduced into Western dress," one wall plaque reads at the Bata Shoe Museum in Toronto, Canada. They were embraced by both Western men and women at the end of the sixteenth century because of the "political and economic developments between Europeans and powers to the East, specifically the rising importance of Persia on the political stage."

But in the 1970s, men wore heels for one reason alone: to be cool. Marc Bolan (originally, Marc Feld) of T-Rex (originally, Tyrannosaurus Rex) took elevated shoes to the next level, helping to spark the glitter and glam rock movement that began in England but quickly made its way overseas. Musically, the Beatles primed American audiences for new sounds; as Nancy Erlich reported for the *New York Times* in 1971, "The American general public . . . is a pretty sophisticated audience by now. We've learned that music can be more than entertainment and that listening to a songwriter on his own terms can be a very rewarding kind of hard work." In other words, our minds had been collectively expanded, bro. Listening to Marc Bolan "on his own terms" meant embracing his flair for the theatrical, both in his style of composition and in his live performances. It started with just a sprinkling of glitter or a feather boa, but concurrent with his success in the early 1970s, the frizzy-haired, dark-eyed singer with a masculine cleft in his chin took to wearing top hats, velvet, and leopard print and silk scarves, often with towering shoes that made his onstage persona that much more untouchable. Rock stars started wearing women's clothing to look, paradoxically, ultramasculine. As rock-and-roll-centric menswear designer John Varvatos recalls: "I was talking [to Iggy Pop] about Iggy and the Stooges in the

early 1970s, and he was reminiscing about how they used to buy girls' tops, or even girls' jeans because—as he put it—*they show the package better.* . . . Robert Plant has said the same thing to me about wearing [women's clothes]. It's not like they were gay or feminine guys. It was just a way to do something more interesting onstage, and to create a stage presence which also turned into their personal style." Marc Bolan was straight—he fathered a child with singer Gloria Jones in 1975—but his dramatic rock-and-roll persona channeled an other-worldly, pansexual being that existed only to dazzle and make glorious, mind-blowing music. Bolan's friend David Bowie (born David Robert Jones) took the idea one step further, releasing a 1972 album under the name of his alien alter ego, Ziggy Stardust. Ziggy wore full face makeup, leotards, body stockings, capes, and metallic fabrics meant to signify his arrival from a distant planet. His collection of shoes—red vinyl knee-high platforms; black lace-up stiletto fetish boots—exaggerated Bowie's lanky proportions and his unusual sex appeal.*

* So with all of this sex in the air, the babies must have been soon to follow, right? Interestingly, the 1970s and early 1980s showed some of the lowest birth rates this country had ever seen—lower than they were in the 1930s, during the Great Depression. While the birth control pill seems an obvious culprit, William Rossi, in *The Sex Life of the Foot and Shoe*, offers an alternative theory. Rossi is not a fan of platforms on men: "Who wears peacock shoes? Insecure men who have a driving need for personal identity. This style, garish and pretentious, is a conspicuous look-at-me shoe. That's why they're worn mostly by the young and some ethnic minority groups—because they are vying for attention, admiration and status." Rossi believes that androgynous platform shoes, which elided the differences, and thus the air of mystery, between the sexes, ultimately diminished the wearers' sex drives, in the same way, perhaps, that overexposure to sexual images can reduce their effectiveness, and eventually lead to disinterest in all things erogenous. He even cites a biblical verse: "The woman shall not wear that which pertaineth to the man, neither shall a man put on a woman's garments, for all that do so are abomination unto the Lord thy God."

The marriage of androgyny, permissive sexuality, and outer space proved to be a good one, and the updated version of an alien invasion involved fewer geeky green men with advanced weaponry, and more polymorphously perverse sexual liberators (offering an altogether different take on the classic fear of an alien probe). Never had an extraterrestrial been so led by his loins as Frank N. Furter, the glam rock transvestite from Transsexual, Transylvania, in Richard O'Brien's *The Rocky Horror Picture Show*. Played licentiously by Tim Curry, Frank N. Furter seduced men and women alike, using his space-age technology to cook up a blond male sex slave, with a body like Atlas's tucked into scanty gold lamé briefs. Frank was seductive in (or perhaps in spite of) his wardrobe of traditional women's lingerie: he wore black silky thigh-highs, a garter belt, a corset, a pearl necklace, and of course, four- to five-inch glittering platform pumps with a dissonantly dainty ankle strap. The shoes were designed by Terry de Havilland, the "rock-and-roll cobbler" from London who initially created them for the 1973 stage production of *Rocky Horror*. De Havilland was the son of an East End cobbler, and like Bolan and Bowie before him, he sexed up his surname from Higgins, in keeping with the flamboyant fancies of the era. Though not initially attracted to his father's shoemaking business, he showed great promise working with python skin, folding it into a multicolored patchwork that would eventually become his signature. His shoes attracted celebrity clients like Bowie, Mick Jagger, and Keith Richards's longtime model-actress girlfriend Anita Pallenberg. With his irreverent point of view and flashy shoes, he was a perfect fit for *The Rocky Horror Picture Show*, which was written by O'Brien as a tip of his cap to willful hedonism. "It can be read as an allegory of a drug trip, a paean to [or warning about] sexual experimentation, a love letter to old B-movies, even as a satire on the political degeneracy

of America," he told the London *Times* in 2009. Frank N. Furter—"a drama queen . . . a hedonistic, self-indulgent voluptuary"—he said was based on his *mother*.

Shocking—but also unsurprising, given the time period. *Tommy*—the 1975 movie version of the Who's popular rock opera—gave fresh insight into the Oedipus complex. Tommy's mum, played by former squeaky-clean teen dream Ann-Margret, leaves her "deaf, dumb, and blind" son in the company of a gypsy–drug pusher–prostitute, before suffering a breakdown—expressed by a sequence in which she rolls around in brown liquid wearing a crocheted body suit. *Tommy* featured some of the most outrageous platforms of the decade; Tina Turner as the Acid Queen stomps around in red glitter platforms (sort of the anti–ruby slippers) before enclosing her helpless charge in a metal suit pricked with drug needles. Yet even these shoes are outdone by Elton John's, who was cast as a snotty pinball champion (the "Local Lad") unseated by Tommy, an arcade-game savant. John brought his best sneer to the role, wearing oversize disco ball glasses, a blue beret, a shiny patchwork shirt, and red glitter suspenders, channeling Liberace—much as he did in his own stage shows. To cement the Local Lad's top dog status, John wore the entertainment industry's most vertiginous pair of shoes; inspired by the cherry red 1460 Doc Martens popular with London youth at the time, these boots were specially fashioned out of fiberglass by Scott Bader, the Northamptonshire chemical firm, and measured a towering four feet, six and a half inches high. John was so keen on them that he kept the shoes until 1988, when they were sold to R. Griggs (the company that makes Doc Martens), who promptly loaned them to the Northampton museum.

Since the decadent days of Louis XIV, elevated shoes on men have been emblems of power and class, and later were used as props for

reinvention and self-mythologizing. In the 1970s, platforms helped a man become a woman, a singer become an alien, and in 1977, a local Italian boy become a disco legend. They appeared on the fashion scene at a time when pushing boundaries felt enormously important and would soon be immortalized by a character (Tony Manero) and an actor (John Travolta) who exuded a mix of bravado and underlying sensitivity that captivated the public. Joan Didion, writing about the string of motorcycle movies that came out in the late 1960s and early 1970s, says of their brutish antiheroes, "To watch a bike movie is finally to apprehend the extent to which the toleration of small irritations is no longer a trait much admired in America, the extent to which a nonexistent frustration threshold is seen not as psychopathic but as a 'right.' . . . Bike movies are made for all these children of vague 'hill' stock who grow up absurd in the West and Southwest, children whose whole lives are an obscure grudge against a world they think they never made. These children are increasingly everywhere, and their style is that of an entire generation."

The Lord
of the
Gender-Bending
Dance

(1977–1979)

Circa 1977, fashion was all about the music. New York City nightlife could be conjured in three snapshots:

Studio 54: The most mainstream venue, while ironically, the most exclusive. Members paid $125 a year (the equivalent of $445 today) to make it past the threshold of the jutting black marquee, marked with a white art deco "54"—as if the line of eager plebs didn't give away the location. At 254 West Fifty-fourth Street, between Seventh and Eighth avenues, the former opera house and CBS television studio hosted the most decadent nightly party in the city. Famous guests—John Travolta, Mick and Bianca Jagger, Brooke Shields, Andy Warhol, Halston, Jack Nicholson—would strut through the lobby, furnished with sixteen-

foot-tall incandescent fig trees and an imported banana-leaf carpet, toward the main room, where celebrities and attractive wannabes shared dance moves and coke straws. Patrons wore glittering five-inch platform shoes, skintight clothes in stretchy, artificial fabrics that moved with the body and caught the disco ball light. They danced on 1,200 square feet of black AstroTurf, enjoying hot, frenetic disco heaven, partying well past sunrise. Why not—it was always nighttime at Studio 54, and just in case there was any question about what was fueling the merrymaking, a man in the moon with a heaping spoon watched over the pulsing dance floor.

CBGB: Downtown from Studio 54, it was a much grittier club located on a pitiless swath of the Bowery. It could be found by following the sounds of screaming singers, slaphappy bass, and clashing drums, by stepping through the glass in the street and over the passed-out bums to number 315, marked by a white awning and orange bubble letters. The club's full name—CBGB OMFUG—stood for Country, Blue Grass, Blues, and Other Music for Uplifting Gormandizers, and soon enough, it was the birthplace of American punk rock, informed by the sound that sprouted in the States like a brand-new vice and then skittered across the pond. Within the club's dark, graffiti-covered walls, Sid Vicious and Nancy Spungen, in a shared opiate-induced haze, would often swing from being violent adversaries back to being lovers. It was also where the Ramones—four big-haired boys from Queens—first picked up their instruments and decided that it didn't take musical training to rock. The crowds were pierced, tattooed, and riotous; they wore multiple earrings, dyed their hair jet-black or bleached it washout blond, wore crotch-hugging jeans and shoes decorated with spikes and studs—and that's just the men. The women dressed with an eye toward provocation, wearing sexually charged items like miniskirts, fishnets, and high

heels, but then tearing their clothes or shaving their heads and accessorizing, like their boyfriends did, with safety pins.

The Eighth Street Playhouse: Northwest was an iconic New York theater, in the homosexual-friendly stretch of Greenwich Village, where they played *The Rocky Horror Picture Show* every Friday and Saturday at midnight. Watching the film was an interactive experience; audiences crawled through the aisles, barked at the screen, tossed rice for Brad and Janet's wedding, and leaped up from their seats to dance the Time Warp. Fueled by a mix of drugs, alcohol, and adrenaline, filmgoers cast off their inhibitions like the stodgy suits they wore during the workweek, showing up at screenings in glitter, lingerie, towering heels, teased hair, and full makeup. Inspired by the glam rockers of the early 1970s, audiences worshipped at the altars of fantasy and self-indulgence, their rituals officiated by an over-the-top live emcee and, of course, Tim Curry himself, who was larger than life on-screen as Frank N. Furter, the amoral, not-so-sweet transvestite.

A willingness to experiment—with drugs, sexuality, clothing, and identity—characterized each of these scenes, and whether you were a disco dancer or a die-hard punk rocker, chances are, you were testing out life at the fringes and taking chances with your personal style. For the first time in fashion history, street style and ready-to-wear clothing eclipsed couture's trendsetting power. What began in the 1960s with high fashion houses losing their standing to outsider designers like Mary Quant and Betsey Johnson, became the status quo in the 1970s, when the differences between "fashion," the institution that dictates what's in and what's out, and "style," the reinterpretation of that fashion by consumers, became indistinguishable. *The Rocky Horror Picture Show*, for all of its freakish bells and whistles, preached a charming and relatable message: don't dream it, *be* it.

American culture was primed for some collective, built-in amnesia and a pastime ruled by appearances rather than depth.

And so . . . patrons danced. They danced to forget. They danced to the Time Warp—a parody of tacky, choreographed numbers like the locomotion and the chicken dance—in dark movie houses across the country, and they thrashed to Blondie, the Ramones, and the Sex Pistols in underground clubs like CBGB. In discotheques like Studio 54, they lost themselves to Diana Ross, Donna Summer, and the Bee Gees, and white partiers also discovered Motown, which in turn informed the next wave of popular music. After the civil rights movement and a decade of women's lib, dusty walls were beginning to crumble. Change shows its face in strange and unexpected ways, and for a moment, it appeared, mercurially, after hours.

It was only a matter of time before Hollywood set out to capture the magic of trendy New York nightlife. Australian entrepreneur Robert Stigwood produced the film version of *Tommy*, as well as a series of stage productions like *Hair* and *Jesus Christ Superstar* in the United States. In 1971, when holding auditions for the latter musical, he saw a blue-eyed kid from Jersey with a whole lotta raw talent and a killer smile. Stigwood didn't have a role for John Travolta in *Superstar*, but he mentally flagged him as an up-and-comer to watch, and someone he'd like to work with in the future. Then came the 1976 *New York* magazine article that affected American journalism, and the part that Stigwood—and John Travolta—had been waiting for.

Nik Cohn's "Inside the Tribal Rites of the New Saturday Night" was explosive: a stylized portrait of desperate Italian Bay Ridge teens in which the author appeared as "a man in a tweed suit, a journalist from Manhattan." Cohn gained intimate access to The Faces, a

crowd whose one solace in a life of sour relationships and dead-end jobs was their weekend trip to the 2001 Odyssey. He held them up as emblematic of the post-1960s generation, mired in a national recession and deprived of carefree teenage indulgences. Leader of the pack Vincent—with "black hair and black eyes . . . teeth so white, so dazzling, that they always seemed fake . . . five-foot-nine in platform shoes"—owns his status as lord of the dance floor but feels trapped by the inevitable truth that one day a new, younger Face will supplant him. Then he'll choose a wife from the legions of adoring ladies and have children, consigned to a new role as purveyor of the paycheck— that is, if he's not murdered by one of the neighboring ethic groups with which he and his friends are regularly feuding. Vincent has no choice but to live in the moment, to revel in those fleeting triumphs when he buys a new polyester shirt (on layaway), when the disco parts for him like the red sea, when he deigns to kiss a girl and she swoons, declaring to no one in particular that she "just kissed Al Pacino."

Cohn's article was championed as a winning example of New Journalism and was optioned by Paramount soon after it was published.* When Travolta's manager Brian Epstein spotted the piece, he had no doubt that his young client was born to play the part of Vincent. John could dazzle, John could dance, and he could bring

* Though it was celebrated for its gritty realism, "Inside the Tribal Rites of the New Saturday Night" turned out to be fictional. A story that ran with the disclaimer "everything described in this article is factual and was either witnessed by [the author] or told to [the author] directly by the people involved" was made up; in 1994 Cohn, who'd gone on to work as a columnist for the UK *Guardian* after a 1983 drug indictment for selling heroin, admitted in the British paper that he'd never spent time with the Bay Ridge Faces. Hired to write about a scene that was (literally) foreign to him, he says he based Vincent on some London mods he knew back home. Still, the article remains legendary.

tenderness to a complicated, often selfish, character. Luckily Stigwood, who remembered Travolta from that fateful audition, agreed. Producers changed Vincent's name to Tony, and as soon as John sank his feet into Manero's Cuban-heeled platforms, he knew that he was going to work his ass off (literally: the junk-food junkie lost twenty pounds to do the film). Yes, he could dance—he'd taken lessons and learned steps for musical theater—but he wasn't the kind of performer who could instantly clear the floor with his moves. He wasn't interested in faking the dance sequences by using camera tricks and cutaways. John called Robert Stigwood in a panic.

The answer, it quickly became clear, was that the lead actor would just have to practice. For months he rehearsed three hours a night and ran two miles a day to make himself plausible as the king of Brooklyn disco. In the meantime, costume designer Patrizia von Brandenstein considered the movie's aesthetic. The filmmakers were committed to a sense of authenticity, and so, for inspiration, she checked out the Manhattan club scene. She found, however, that the styles on the island were "too sophisticated [and] too rich," so she expanded into the boroughs to scope club goers whose economic circumstances would have been closer to Tony Manero's. She always kept it in mind that *Saturday Night Fever* was "a story about kids who lived for Saturday night. They were nothing in their day-to-day lives [to be proud of] and yet they were everything—they were *princes*—on Saturday night, so every spare nickel went into their Saturday night appearance. Not just their clothing and shoes, but their haircuts . . . and getting their teeth cleaned and whitened, even very, very subtle makeup. The girls too. So when we got closer to the neighborhoods, that's where the inspiration came from."

While out at the clubs in Brooklyn, Staten Island, and Queens, von Brandenstein noticed that men were still wearing platform

shoes, which had mostly gone out of style in the more cutting-edge, exclusive venues. Because Cuban-heeled shoes are also traditional garb for male dancers, she asked Travolta if he would be willing to give them a try: "John was a superb dancer always, and he knew a thing or two about what looked good on him, because he'd been a Broadway actor before that, so he really had a dancer's understanding of his body. So, when I broached the heeled shoes, he said *if I can dance in them, I'll wear them.* And he loved them. Everybody loved them. And things followed from that. John's legs are relatively short to his height, but his trousers were all rather high-waisted—one pair in particular is very high-waisted—and since they're cut long, when he wears an elevated shoe, he looks great. And of course, because he's dancing so much, the focus is on his feet, and [the platforms helped give him] a very strong presence." She purchased the shoes from stores on Eighth Street, an unofficial footwear district in downtown Manhattan, as well as other niche retailers around the city: "There were a few shoe stores on Thirty-fourth and a few on Forty-second Street, but we're not talking Florsheim here, we're not talking Alan Church, we are talking about another kind of male [customer]. The shoes were well made, mostly Italian and Spanish, but in style and color, they appealed to a much younger guy. And we did utilize all kinds of lifts and pads, and very subtle interior improvements just so the actors could dance properly. Because the shoes had to be quite flexible, we resoled them, and even made sure the soles wouldn't [scuff]. . . . It was a lit floor, so we didn't want black marks on it." (The shoes, despite all of the wardrobe department's precautions, still caused a bit of trouble. After *Saturday Night Fever*'s Grauman's Chinese Theatre premiere, Barry Gibb noted to producers that the clicking of the dancers' heels was audible over the sound track. He rightly pointed out that the sound levels in real discotheques were

so high that one would never hear the noise of dancing feet—never mind that he likely didn't want his own music upstaged. Sound editors readjusted the levels in postproduction.)

John Travolta was just twenty-two years old when production for *Saturday Night Fever* started. A reflective, well-mannered young man who was fiercely opinionated when it came to his performances, he was the youngest of six children and thus found himself the indulged apple of his drama-teacher mother's eye. With his parents' blessing, John left home at age sixteen to pursue acting. After a stint on Broadway, he landed roles in *Carrie*, the Brian De Palma horror flick that went on to become a cult classic, and the television show *Welcome Back, Kotter*, in which he played Vinnie Barbarino, a latter-day Fonzie. He did a television tearjerker called *The Boy in the Plastic Bubble*, where he met girlfriend Diana Hyland, who played John's mother in the movie, and was forty to his twenty-one.

By the time John Travolta stepped into Tony Manero's shoes, he was already something of a celebrity. But director John Badham hadn't anticipated the full thrust of his lead actor's star power, and he discovered that while it might be an asset once *Saturday Night Fever* was released, for the purposes of the shoot, it was most definitely a curse. Even prior to the filming, there were signs that letting John loose on the streets of New York might be challenging. Von Brandenstein remembers that "before the film was announced, when we had begun work on it, I went shopping with John Travolta one day. And we were in the store forty-five minutes, John tried on a couple of things, everything was very pleasant, and we began to realize that there was a big crowd forming outside. So, to get us back into the limo and through the street, we had to make a call to the local pre-

cinct, and get escorted, because within that forty-five minutes there was a huge crowd of kids that gathered outside."

That crowd of kids—die-hard Barbarino fans who came to steal a glimpse of their favorite Sweathog—only became more persistent once the shoot commenced. Badham and Bode wanted to film the opening sequence on Eighty-sixth Street in Bay Ridge, and they played the demo version of "Stayin' Alive" for Travolta so his walk would synch perfectly to the song. For the sake of New York authenticity, the production team intentionally printed fake call sheets and scheduled all street-level scenes to be shot early in the morning, aware that by noon, word of their location would have leaked and the legions of Travolta chasers would once again become problematic. But like all best-laid plans, the crew's commitment to getting it right was eventually challenged, not by the brigade of *Welcome Back, Kotter* groupies, but by tragic circumstances that pulled the lead actor away from the set. Early in the production of *Saturday Night Fever*, John Travolta's girlfriend Diana Hyland tragically passed away from breast cancer. John took time off for the funeral, and he flew back to California on the morning that the opening sequence was scheduled to film. Looking for a quick fix, producers tapped his body double to fill in for the famous walk. Because John's face doesn't appear in the majority of the sequence, they thought they could get away with subbing in another actor for the sake of efficiency.

Rumors persist that the rhythmic swagger doesn't belong to John Travolta, though Patrizia von Brandenstein remembers it differently. Travolta had rehearsed the walk numerous times, and when the team reviewed the dailies featuring his replacement, "it just wasn't the same." Upon John's return, they reshot the "Stayin' Alive" strut, and that replacement footage was edited into the film. The actor himself told VH1, "It's all me except for one shot, which I was very upset

about. The shot that's not me is when the shoe is put in the window, compared to another shoe, and the guy who did it kind of bounced a little bit while he was doing it. And I got furious, because that's not what I would have done."

The bounce in question happens less than a minute into the film. *Saturday Night Fever* opens with three establishing shots: the Brooklyn Bridge against the New York City skyline. Next, an aerial view of Bay Ridge, Brooklyn, that transitions into a shot of the B train speeding on the elevated subway tracks. Then, as "Stayin' Alive" begins, a close-up of two shoes in a store window, one a calf-height black embellished boot with a medium-high square heel (price: $47), and another a classic loafer, but with an even higher one. A man, visible from the knees down, approaches the display, a paint can dangling from his hand. He pauses, holds his left foot, shod in a similar brown loafer, up to the glass, compares it to the one for sale, and bounces in time to the beat.

It's a self-affirming gesture: an acknowledgment not of his desire for new shoes, but of the pair he already owns, and how hot they look hitting against the pavement. The camera swings around. The movie's title appears in knotted red lettering, made to look like a neon sign hanging over a bar. The camera trains on our protagonist's shoes as he struts his way down the sidewalk. Then the lyrics drop—*You can tell by the way I use my walk I'm a woman's man: no time to talk*—and it pans up John Travolta's body, to his skintight black bell-bottoms, his wide-collared bloodred shirt with the first few buttons undone, and the black leather jacket that hugs the sides of his V-shaped torso. By day Manero's a lousy hardware store clerk, but like royalty in disguise, his meager station conceals the pres-

ence of a king. Yet unlike the archetypal royal-in-rags, Manero's clothing—his signature duds—is the very first sign of his greatness.[*] Finally, we see Tony Manero's face, which is as ruggedly handsome as it is sensitive and soft. As Manero maneuvers his way down Eighty-sixth Street, his cool is solidified. He buys two slices of pizza—from a spatula-wielding girl played by Travolta's sister—and stacks them one on top of the other before shoving them into his mouth. He checks out women unabashedly, and although they play hard to get, we never believe he's too far away from a successful pickup. The opening sequence of *Saturday Night Fever* was as adept at conveying the crux of Tony Manero's character as the paparazzi-like Steadicam shot used by Martin Scorsese almost thirteen years later to describe Henry Hill's status before his inevitable fall in 1990's *Goodfellas*. Explains Bode, in the VH1 *Behind the Music* episode devoted to the film: "I wanted to have the camera really low, and to see his feet, to see his shiny shoes. We made a rig on a dolly with a handheld camera, and a very wide lens. That was spur of the moment." By focusing on Mane-

[*] In the same way that women who can't walk in stilettos are regarded by some other women as comical, having failed to conquer that crucial rite of passage, men who couldn't own their platforms didn't earn the right to wear them. Patrizia von Brandenstein, when costuming some of Tony's cohort, took this into consideration, particularly when it came to outfitting Bobby C., the smallest and weakest of the crew. In one scene, he turns away from the camera, and we see him teetering uncomfortably in platforms: "That particular scene, of him walking away and you see the shoes, they're worn by the most awkward and the most troubled of our group. They're all trying to imitate Tony Manero's style, because they feel he's the most accomplished, and certainly the best dancer, that's what makes him the king of this particular circle, so all the guys are trying to follow his lead. And the thing about this very young guy is he doesn't fit those clothes, he's not into those shoes yet, so of course they look very awkward on him." Bobby's unconvincing attempt to copy his friends presages his untimely death later in the film; depressed, drunk, and on drugs, he tries to one-up their stunts on the Verrazano Bridge and plunges disastrously into the water.

ro's platform shoes, which turned out to be so particular to that time period, the filmmakers borrowed a classic cinematic convention and at the same time reinvented it. Travolta was the rare man to receive the on-screen feet-to-face treatment (usually reserved for beautiful women, and specifically, femmes fatales), and it proved equally powerful with a masculine subject. Even in this tiny yet emblematic way, 1970s gender conventions once again revealed themselves to be surprisingly malleable; Tony Manero was both the sex object and the objectifier, a predator when it comes to women, but also the city's working-class, undereducated prey.

Manero was also the ultimate disco peacock—a guy who, when he stepped out onto the dance floor, reflexively commanded all heads to turn. The scene for which John tirelessly trained was a two-minute-plus solo dance number, choreographed to "You Should Be Dancing" by the Bee Gees. In it, he gyrates his hips and performs Russian squat moves and rolling splits—the kind of routine that proved Tony's worth and left no room to question that he could take over the dance floor whenever he was so inclined. To prepare the dingy disco for filming, set designers decorated the walls with aluminum foil and Christmas lights. They installed the famous light-up dance floor, which at $15,000 was by far the most expensive item on the set. The owner of the 2001 Odyssey liked the improvements so much that he kept them in place even after shooting wrapped. However, on the day that the rough cut of the film was screened, John Travolta was horrified to see that neither the Day-Glo floor nor his dancing feet had made it into the shot. After months of shedding pounds—not to mention blood, sweat, and tears—John was crushed by the editor's decision to show his solo entirely in close-up. Fred Astaire, during his run as the master of on-screen musical comedy, had a clause in his contract stipulating that all of his performances be filmed from

head to toe, so that there would be no question about who was doing the dancing. In one miserable instant, Travolta understood why. He broke down.

John had lost his beloved girlfriend and was so depressed that James Taylor and Carly Simon, his upstairs neighbors on Central Park West, would sing to cheer him up in their kitchen. It now appeared as if all of his work had been for nothing. John couldn't live with the edit, so he fought back, insisting that his dance sequence be restored to the print. When the *Saturday Night Fever* team relented, he spent a night standing over the film editor, insisting that he stick to the master. He was right too: In her largely glowing December 1977 *New Yorker* review, Pauline Kael praised the young actor, saying that he "gives himself to his [dances] with a fullness and zest that make his being the teenagers' king utterly convincing." Overall, the dance numbers, she said, "were some of the most beautiful . . . ever filmed."

Audiences were also awestruck. Just as Tony Manero's white suit spawned a series of imitators, *Saturday Night Fever* reignited an interest in disco, which, by 1977, was on its way out. What began as an underground and largely homosexual trend got a shot in the arm on April 26, 1977, when the doors to Studio 54 opened, and another, more potent one on December 14, 1977: the night of *Saturday Night Fever*'s debut. The film was a visual confection of Huckapoo shirts, skin-tight pastel polyester pants, flowing patterned dresses, and platform shoes in gold, silver, and bronze, in keeping with Cohn's article, which described Vincent's wardrobe in detail ("He owned fourteen floral shirts, five suits, eight pairs of shoes, three overcoats, and had appeared on American Bandstand"). With disco, the States founded a movement that it didn't have to share with the UK: an American music trend so powerful that a fashion scene sprouted up around it. It launched Halston's career: born Roy Halston Frowick, the Iowa

native peeked outside the curtain of his fall fashion show in 1971 and alerted the audience that the era of peasant dresses and hippie jewelry was over. He got his start as a milliner, designing the pillbox hat Jackie Kennedy wore for her husband's inauguration in 1961, and though he moved away from accessories, he retained a point of view characterized by sleek, minimalist clothing. Like many 1960s designers, Halston experimented with new fabrics, making a name for himself with a shirtdress in Ultrasuede—pliable, suedelike fabric sold at a fraction of the price of real leather. By 1977 and the reign of Studio 54, Halston's clothes were as much a fixture at the club as he was—and his chiseled face was a mainstay of the scene. Dressing celebrity clients like Bianca Jagger, Liza Minnelli, and Elizabeth Taylor, he could sit back with pal Andy Warhol and survey the dance floor, his flattering draped jersey maxi dresses, one-shouldered gowns, and body-conscious Lurex jumpsuits set in glamorous motion, the platform shoes deceptively silent against the floor.

Halston was a leader in a new group of American ready-to-wear designers like Bill Blass, Calvin Klein, Anne Klein, and Donna Karan known for wearable, elegant pieces that flattered women's bodies. Among all of the excesses of 1970s culture, and shoes so high that the *New York Times* ran an article called "Doctors Predict a Broken Foot," warning against "broken bone syndrome . . . the new fashion malady," national fashion was again moving in a new direction, as accessible and democratic as clubs like Studio 54 were deliberately exclusive. In 1977, Jerome Fisher and Vincent Camuto noticed a gap in the market between low-quality mass-produced footwear and high-end, well-made but prohibitively expensive brands. They founded the Fisher Camuto Corporation, a business devoted to the production of wholesale, trend-focused women's shoes. To keep their products affordable, they collaborated with fac-

tories in Brazil, where raw materials were readily available and labor was cheap. The company, which in its first year brought in $9 million in sales, would ultimately become Nine West, the preeminent midmarket footwear corporation. Feeling a similar push toward accessible fashion, Halston signed on to design a cost-conscious line for mass-market retailer JCPenney in 1982. Halston's renegade move was less respected: after hearing news of this arrangement, Bergdorf Goodman, the first department store to sell his clothes, stopped carrying him.

12

.

Manolo, Molloy,

and the

New Power Shoes

(1975–1982)

Before Manolo Blahnik was a house-
hold name, he was an imaginative
boy who grew up in the Canary Is-
lands, in between the crystal bl
ocean and the banana plant?
with a chic mother who in'
nascent love of art. In the early 1970s after studying l
architecture in Geneva, he put on his best red-and
suit and approached American *Vogue* editor Dia
designs; a letter of introduction from Palom?
hopeful through the door. Among sketches f
of *A Midsummer Night's Dream*, Manolo inc
fashion accessories. Vreeland, a sleek wo'

ele
his r
taste

exaggerated Gallic features, appraised his work and then offered her verdict:

"I think you should concentrate on shoes," the legendary taste-maker told him.

Blahnik listened and found a job designing footwear for a London boutique, and by 1972 he landed his first major commission to create the runway shoes for English designer Ossie Clark's spring-summer collection. Manolo got right to work, drawing seasonally inspired two-tone green high-heeled sandals with ankle ties that crisscrossed up the calf and dripped with red plastic cherries, and electric blue open-toed pumps with red straps and seven-inch rubber heels. The young shoemaker knew what he liked and couldn't wait to see his creations come to life; he found the chunky platform awkward and oppressive and sought to promote shoes that made a woman's foot look delicate instead of heavy. Unfortunately, that quest for lightness proved to be his downfall; on the catwalk, his springy heels buckled and Clark's models couldn't make it to the end. Such a disaster might have felled a lesser designer, but Blahnik understood that his technical expertise did not yet live up to his creative abilities, so he left London for Northampton—the center of English shoemaking—to study craftsmanship. It wasn't long before he rebounded from the Ossie Clark debacle. The handsome Manolo appeared on the cover of British *Vogue* in 1974, opened a boutique in the States in 1979, and designed the delicate gold sandals Bianca Jagger wore when she rode a white horse into Studio 54 on her thirtieth birthday.

Blahnik's shoes appealed to a particular demographic of wealthy, ~~rant~~ women willing to pay top dollar for quality pieces. He made ~~ame~~ designing classic pumps and sandals, prioritizing his own ~~r~~ sexy, elegant shoes over any passing trends. And as the plat-

form flourished in the nightlife scene, the traditional pump—classic and dignified—made a resurgence during daylight hours. Once again, women's needs changed; for a long time, women had been an important part of the workforce, but only as the low-profile nurses and secretaries to the doctors and CEOs they supported. From 1972 to 1985, the number of women in professional roles increased by 5 percent, but their presence in managerial jobs nearly doubled, from 20 percent to 36 percent; the proverbial glass ceiling started to crack, and women's careers no longer had to culminate—by default—shy of the corner office.

Manolo Blahnik, Charles Jourdan, Walter Steiger—these names became familiar to the powerful women who ascended the corporate ladder and invested in high-quality high-heeled shoes to communicate their authority. The new power pumps weren't sexless, but they weren't provocative either: women in the workplace kept their toes covered, stuck to simple materials like matte leather, and kept the embellishments to a minimum, reserving fabrics like shiny satin, and buckles, studs, and bows, for nighttime. The height of the shoes was crucial, because they couldn't be too high or too low. Female executives wanted to convey that they weren't compromising their femininity in order to excel, but they also wanted to be taken seriously. Heels leveled the playing field, so that women in charge could stand eye to eye with their male colleagues.

Style consultant and former English teacher John T. Molloy, who made himself an expert in the politics of corporate dress, advocated for calculated uniformity at the office. As "America's first wardrobe engineer," Molloy believed that clothing sent unambiguous signals about a wearer's socioeconomic status and profession, thereby re-

inforcing (or undercutting) a person's clout. Molloy's early experiments dealt with his hypothesis that the two prevailing colors of men's raincoats sold in the United States—beige and black—carried noteworthy implications for the wearer. After staking out subway stops in high-, middle-, and low-income neighborhoods, Molloy believed without a doubt that beige raincoats signified membership within the upper class, while black raincoats read as pedestrian and therefore had less status. Among other experiments, Molloy—wearing identical outfits save for the difference of a beige or black raincoat—approached receptionists in random office buildings asking to deliver a manila envelope to the company's man in charge: "When wearing a black raincoat, it took me a day and a half to deliver twenty-five papers. In a beige raincoat, I was able to deliver the same number of papers in a single morning."

After working as a wardrobe consultant for various high-profile companies, Molloy published his 1975 book *Dress for Success*, which was an instant bestseller. He followed it up in 1977 with *The Woman's Dress for Success* book, teaching women how to hit just the right mark on the continuum between ultrafeminine, professional, and overly masculine. "In 1976," Molloy wrote, "one-third of the master of business administration graduates of the top American business schools were women," and yet these same women hadn't quite figured out how to effectively align their physical appearances with the corporate roles they yearned to fill. The difference between a secretary and female vice president wasn't just education, drive, and experience; it was a matter of "packaging" too. After scheduling an appointment with three executives whom he'd never seen and knew only by last name, Molloy waited in the bar area of the restaurant where he was supposed to meet them. Watching the time tick by, he eventually re-

alized that the three women who had been sitting at an adjacent table were the company heads with whom he was meant to rendezvous.

Molloy popularized the idea of "power dressing": choosing clothes specifically with the intention of communicating authority in everyday interactions. For women, he recommended wearing a tailored skirt suit in neutral or dark colors; sporting a clean, midlength haircut; developing a minimalist cosmetics routine using lipstick and a light coating of mascara; and wearing simple, closed-toe pumps with an inch-and-a-half-high heel. For both men and women, he was decidedly antifashion, and he came down particularly hard on women's shoes, calling the towering platform "the most preposterous thing manufactured for a woman since the chastity belt." The goal was not to look like Annie Hall co-opting menswear (which he believed men found "cute, not authoritative" anyway) but to distinguish oneself from the kind of woman who male coworkers would rather meet in a bar than sit down with at the conference room table.

Molloy recommended that businesswomen wear the "uniform" only in office settings, to train colleagues to associate high-powered behavior with high-powered dress. One group of corporate women took his advice so seriously that they drafted a pledge "to wear highly tailored, dark-colored traditionally designed skirted suits whenever possible to the office, not to wear such outfits socially, and to encourage other women to do the same. I am doing this so that women may have as effective a work uniform as men and therefore be better able to compete on equal footing." (Note the unconscious shoe metaphor.) Eventually this kind of consistency across female executives helped to create a standard businesswoman "look," so that by the middle of the decade, a man like Molloy would be able to spot his female lunch

date in a crowded restaurant instantly, or to differentiate between a vice president and a secretary.

Since the days of the stiletto, the high heel had been used as a tool to express status, but in the late 1970s and early 1980s another, more modern, style of footwear demanded attention: the sneaker. Over the past few years, sneaker technology and design had advanced so rapidly that manufacturers encouraged buyers to start taking them more seriously, and as part of that effort, they rebranded them "athletic shoes." Historically sneakers had been constructed simply—a few panels of durable canvas for the uppers, stitched to a vulcanized rubber slab sole—but in an effort to attract sporty clients who wanted to protect their feet and legs against damage and to achieve greater success on the field, they had become, in recent years, compact, high-performance tools. In 1972, after their falling-out with the Japanese sneaker brand Tiger, University of Oregon track coach William J. Bowerman and his star runner Phil "Buck" Knight started designing their own shoes, making a breakthrough when Bowerman thought to place a pad of rubber under his wife's waffle iron, inventing the famous "waffle sole," which cushioned the foot and provided increased traction.

Nike shoes—named for the Greek goddess of victory, and created for runners by runners—were an instant hit on the track. Bowerman and Knight enlisted an art student at the university to design the brand's logo, and she came up with the swoosh, which effectively expressed motion in both name and design. Almost immediately, the duo realized that the increasing national interest in sports stars and physical fitness could propel them from popularity within a niche market to top-to-toe success. For grassroots-style marketing, they

began courting small-town heroes at local tracks and gyms, and then extended their manufacturing reach from just running shoes into basketball sneakers, at a time when the NBA was pumping considerable money into its own brand. As a follow-up to the waffle sole, Nike patented the "Air," which used lightweight foam materials and trapped pockets of pressurized gas for increased mobility and comfort. Suddenly, even nonathletic buyers who cared little about a shoe's performance had to admit that in terms of comfort, sneakers—or "athletic shoes"—couldn't be beat.

Because they were producing high-tech sports shoes, Nike wasn't in direct competition with Converse or Keds: both brands had mostly stepped aside in the bells-and-whistles arms race and were focused instead on keeping a grip on their specific clients, who were interested less in team sports and more inspired by rock and roll and leisure activities. However, Nike was neck and neck with two German brands, both with solid footholds in the United States. Adidas and Puma were founded by rival brothers named Adolf (Adi) and Rudolf (Rudi) Dassler, and both companies catered to soccer players and runners. They founded a hand-sewn shoe company together in their Bavarian hometown of Herzogenaurach in 1926, but after a legendary feud—which stirred for years but erupted in the 1940s—Rudi split off to form Puma and Adi renamed his brand Adidas. By the mid-1950s the Dasslers found themselves locked in an epic battle to get their hands on the most effective technology and win the most influential endorsements, with Adi in the lead after Rudi alienated the coach of the German soccer team, who went on to win the 1954 World Cup—with his team wearing Adidas sneakers. It was a business model that informed the footwear landscape when Nike emerged as a frontrunner, and in 1979, when Paul Fireman—who ran a family fishing

business—noticed British shoes called Reeboks at a sporting trade show in Chicago.

In 1980, at the start of the decade, something happened in New York City that—by way of sneakers—again reinforced the relationship between *high heels* and status, beyond just the hundreds of dollars chic women spent to keep themselves in spotless, expensive shoes. On April 1, employees of the Transport Workers Union walked off their jobs, leaving the city's vital grid of subways and buses inoperable. For eleven days, straphangers had to find alternative ways to get to work, and for the majority of citizens living within the five boroughs, that meant crossing bridges and moving up- and downtown on foot. This posed a particular problem for women accustomed to riding to their jobs in heels—what to wear on their feet? Many chose to walk in sneakers, tucking their low-heeled pumps, alongside their lunches, in their briefcases. It became a defining image of the transit strike: businesswomen in skirt suits, nude stockings, and white athletic shoes marching through the streets. And yet, separate from the industrious city dwellers who rode bicycles, scooters, mopeds, and roller skates in lieu of the subway, were the class of people for whom the strike was simply a minor annoyance, a drain in the budget as they shelled out for private cars and taxicabs. In order to keep traffic under control, Mayor Ed Koch enforced a strict carpool rule whereby police checked vehicles at all of the city's entry points to be sure they carried at least three passengers. However, for cars traveling within the city limits—east to west, north and south—it was business as usual, and those who could afford it simply hailed a taxi or called a limousine to make it to their desks by 9:00 a.m.—no muss, no fuss.

Women who hired cars while they waited out the transit strike

didn't have to wear sneakers, unlike the majority, who sweated their way to work over bridges and across town. But after successful negotiations got the transit system up and running again, many women continued to wear athletic shoes to and from the office, opting for ease of travel now that the look had found social acceptance. Yet there also remained that class of women who strutted in the highest spike heels, unconcerned with the vicissitudes of travel and weather, because a ride was always just a phone call—or in the case of yellow cabs, a decisive arm gesture—away. These ladies wore "limousine shoes," and even if it was unwitting, they were, via their footwear, implicitly telling their neighbors not only that they could afford upscale transportation but also that they could get pedicures and foot massages when their feet hurt; they could afford to live in a neighborhood where safety wasn't a concern; and they were able to factor the price of a doorman into their monthly rent or mortgage payments.

In 1981 when former *Grease* girl-next-door Olivia Newton-John released her single "Physical," she may have been dressed like an aerobics queen, but there was no mistaking what she was singing about: "There's nothing left to talk about / unless it's horizontally . . ." Suddenly a woman could be just as assertive as a man, and if she happened to find herself hot and bothered, well . . . she could slip on a leotard and give a come-hither look, determined to get what she wanted.

Money was the engine of the 1980s, and remarkably, women—without the help of their fathers or husbands—were allowed to ride. It was by and large the era of Individualism, Excess, and Greed—the tipping point when capitalism transitioned from an economic system to an encompassing point of view, when "mergers and acquisitions" hit the American vocabulary. Women in business were conscious of the stories that their physical appearances told, and at the same time, sneaker companies identified a change in what women wanted out of

their lives, and thus from their shoes. After Paul Fireman acquired Reebok, he moved the company's headquarters from the UK to Massachusetts and, keeping the Union Jack as the brand's logo, set out to conquer Nike. It seemed an impossible dream, but then, Reebok executives noticed a previously untapped market: sporty women. "Life is not a spectator sport," Reebok told us, and boy, did we listen.

13

· · · · · · · · · ·

The Workout
Is Not a
Spectator Sport

(1982–1988)

Wednesday, March 17, 1982:
Los Angeles, California

At the age of forty-four, Jane Fonda was accustomed to speaking in front of crowds. The actress had appeared in thirty films, had accepted two Academy Awards, and was outspoken—to put it mildly—on the subject of ending the war in Vietnam. However, today's press conference had nothing to do with her acting career, nor did it explicitly concern her well-publicized political ideals. Poised in front of an audience in Beverly Hills, Fonda was set to announce her newest venture: a foray into the world of home videos.

As beautiful as ever, though more angular now that she was the face of a health and body brand, Fonda had opened the Workout two years before. It was a Los Angeles–based fitness studio that offered classes in dance, stretch, and aerobics—a new, trendy style of exercise that honed flexibility and endurance. With only three mirrored studios and a small restroom, Fonda and her teachers regarded the Workout as "very grassroots," a place where clients could uninhibitedly challenge their bodies to move and bend in surprisingly satisfying ways. When Jane published *Jane Fonda's Workout Book* in 1981, no one expected it to zoom to the top of the *New York Times* bestseller list and stay there for twenty-four months. One day Stuart Karl, the man who'd recognized the unmet potential in VHS and pioneered the landscape of how-to home videos, gave her a call.

"My wife, Debbie, read your book and thinks we should do it as a video," he told her.

Jane thanked him for his interest but was unconvinced. She didn't even own a VCR, and more important, she couldn't quite picture herself, a serious, award-winning actress, bopping around on camera in leg warmers and a leotard. She declined Karl's offer, but he was undeterred. There was merit in his proposal—Jane's book could only illustrate the Workout's movements via photographic stills, and wouldn't it be great to reach readers well beyond the scope of Los Angeles and show them how aerobics are done? Eventually, Jane Fonda gave in. She had a thought. . . .

The California press conference on March 17, 1982, was organized to announce the latest development in Fonda's new career as a fitness guru: the first in a series of twenty-three videotapes that would have women "doing Jane" all over America. Jane Fonda's *Workout*, which featured the actress in a pink-and-red candy-cane-striped leotard with coordinated lilac tights and her hair done in bouncy brown

curls, brought the studio experience into viewers' own homes as Jane, backed by a group of limber, perky instructors and some instrumental synth-pop, led classes for beginning and advanced practitioners. A journalist raised his hand.

"Why do you want to work in video?" he asked.

"Money," Jane said.

She was kidding—sort of. By all accounts, Jane Fonda wasn't anticipating a fitness revolution; the revolution she had planned was much more political, and thus literal, in nature, and its most pressing order of business was to install her second husband, politician Tom Hayden, as the Democratic representative of the Forty-fourth District of the California State Assembly. After an unsuccessful run for U.S. Senate in 1976, Hayden founded the Campaign for Economic Democracy: a liberal organization intent on challenging corporate hegemony by standing up for strong environmental policies, renters' rights, unions, and reproductive health issues. By the late 1970s, the CED had thirty chapters and over eight thousand members, had helped elect "dozens of people to governing agencies," and was decried as "socialistic" by its right-wing critics. In the moneyed Forty-fourth District, which includes West Los Angeles, Malibu, and Santa Monica (where Jane Fonda; Tom Hayden; Fonda's daughter, Vanessa Vadim; and Hayden and Fonda's newborn son, Troy Garity,* lived), the liberal-minded pair foresaw a battle for its political soul, between conservative supporters of Reaganomics and the Democrats intent on challenging the status quo.

Between 1966 and 1978, Jane Fonda had undergone a highly visible transformation, in which Barbarella not only hung up her go-go

* A family name used so that he could stay relatively anonymous.

boots but also cut off her signature blond hair in favor of the short, dark shag featured in *Klute*. Film critics loved the new Fonda—she won the Academy Award for best actress for her portrayal of prostitute Bree Daniels in 1971—but the boys who'd hung up her photo in their lockers were less enthusiastic. ("She must never look in the mirror anymore," journalist William F. Buckley zinged as the public got used to seeing the former sex kitten march around town in a peacoat, army boots, and no makeup.) Her marriage to French director Roger Vadim ended, and as Fonda educated herself about foreign policy and feminism, her candid antiwar views earned her the less than flattering nickname Hanoi Jane. By the time she married Tom Hayden and became active with the CED, Fonda's political ideals motivated her. She lent her face, voice, and checkbook to her causes, but political campaigns are expensive, and in the weak economy of the late 1970s, Tom and Jane began to worry about how they would continue to support the CED. Then they spotted an article about Lyndon LaRouche, who founded the National Caucus of Labor Committees. They read that LaRouche bankrolled the organization with profits from his lucrative computer business, and suddenly, the two were brainstorming ideas for a business they could start for the express purpose of sustaining their political passions. They looked for restaurants for sale and considered opening a fair practices auto shop but got discouraged when they realized they knew nothing about either industry. The search stalled as Jane worked on the 1979 film *The China Syndrome*. She fractured her foot on set.

Jane certainly didn't imagine that the revolution would begin with an injury. Since she was a little girl, Jane had practiced ballet to stay in shape, and the fracture prevented her from taking any classes that would put undue stress on her feet. Aware that Jane relied on dance for both her physical and emotional well-being, her stepmother rec-

ommended she take a class at Gilda Marx's studio in Century City, where a thirtysomething instructor named Leni Cazden led students through a series of repetitive movements aimed at strengthening and toning muscles while increasing the heart rate. Though Cazden's routines were inspired by ballet, she used pop rather than classical music as a sound track. Not only was Jane hooked but she also believed she'd stumbled upon her future business endeavor. She invited Leni Cazden to be her partner.

The collaboration didn't last long; Jane wanted the CED to own the Workout, and when that became too complicated, Cazden left with her husband for a trip around the world while Jane rented studio space and set out to hire a team of instructors from the dance world. Doreen Rivera, who appears in the video for 1982's *Workout*, met Jane Fonda in 1978, after she'd been recommended for a position by a mutual friend. Jane had already found teachers for jazz, ballet, and of course aerobics, but she wanted to offer something edgier and streetwise, so she invited Doreen in to discuss the possibility of teaching classes in funk. She made the aspiring Workout instructor an offer.

"If you can teach me how to dance, you're hired," Jane said.

Though Jane had practiced ballet all her life, she stuck with barre work, which is stationary and thus requires less coordination than dance steps set in motion. Despite Jane's protestations that she had two left feet, Doreen had her mastering the Rock—a popular step at the time—within minutes. Doreen got the job, and the Workout opened its doors on Robertson Boulevard in 1979, staffed by a group of enthusiastic young dancers who viewed Fonda, their fearless leader, not as a celebrity but as a kind of head counselor, learning the business as it grew and teaching by example and encouragement ("it was almost like a woman who's been told she makes really good pasta

sauce, and so one day she just starts making batches [to sell] out of her kitchen," Lesley Mallgrave, a former aerobics instructor who joined the team just before the Workout opened its first Beverly Hills location, remembers). Stretch—a kind of variation on yoga—was Doreen Rivera's addition, which she pitched to Jane during that first meeting, when she was hired to bring in the funk. As Rivera started teaching her method to students—up to thirty-five in the smaller studios and fifty-five in the large one—she noticed something extraordinary happening. "People would come up to me after class and say: what's really going on in this class? And I'd ask, well, what are you experiencing? [They'd say]: deep emotion. All of these people who were doing the stretch would become expressive in class. . . . I would have people cry in class, become rageful in class, and the Workout became a sanctuary for everyone who participated."

While the aerobics classes were less explicitly spiritual, Workout instructors noticed a specific change in women who committed to a fitness regimen. In some cases, even making that initial decision to face what could be a daunting challenge empowered them. Lesley Mallgrave says, "[The Workout] wasn't a scene, like when you go to a Crunch in LA now, where everyone is fantastically fit. There was a lot of camaraderie. . . . You would get women who had never done anything [physical] before, who had literally gone from high school to college to [being] stay-at-home moms, who decided to go get a leotard, which is intimidating because the place was set up just like a dance studio with wall-to-wall mirrors." Eventually women learned to look at and even accept their bodies, and though the physical triumphs were individual, the classes felt cozy and communal, with a group of students sweating in unison to contemporary up-tempo music, learning and mastering routines. Mallgrave noticed that after attending Workout sessions, "Women started taking new risks

in their lives because they had come in and mastered something simple and thought *wow*! I can go over here to the left and accomplish *this*, and maybe then I can go over to the right and try something else. It was phenomenal." In the beginning, Jane Fonda taught some early-morning classes before she had to be on the set, and from time to time, she'd sit in on another instructor's class, or even take it over, to the delight of the students who were slowly growing accustomed to seeing other celebrities in their midst. Madonna, in her leather-and-lace "Lucky Star" days, was a regular, and Mallgrave conjectures that Jane's continued presence at the Workout "signaled to the other celebrities that it was okay to come in, and just go there and work on their thighs."

Soon, women—and a handful of men—who had never set foot in a gym before found themselves energized by Fonda's jazz, ballet, aerobics, and stretch classes. By 1982, she had franchised and opened two more locations, in San Francisco and Encino, and between the classes and her book, she was pulling in roughly $30,000 per month for the CED. "I associate Tom Hayden with Karl Marx," Richard Bock, a California investment banker running against Hayden on the Republican ticket, told a reporter for the *New York Times*. "Like Marx, he's spent his adult life contemplating and creating a new, alternative lifestyle for all of us, whether we want it or not. Marx was supported by Friedrich Engels; Hayden's living off his wife."

The instructors were each given a pair of white Reebok Freestyles, a complimentary sample of the brand's new aerobic shoe at a time when most everyone practiced the Workout barefoot. Mallgrave remembers that "it was a big novelty, these shoes that were meant for exercise . . . and we were absolutely thrilled to get [them for] free." As a new, burgeoning business, Fonda's didn't offer a lot of perks, so her employees were thinking less about product placement—which

in the early 1980s wasn't nearly as organized a marketing strategy as it is today—and more about their good luck at being gifted with new leather sneakers. But sure enough, while Jane and her cohort appear barefoot in the 1982 video, by 1985, when *Jane Fonda's New Workout* appeared in stores, the performers are practicing pliés and leg lifts in matching pairs of lace-up Reeboks. It turns out, Reebok had tossed in its chips with the right team.

Marx's revolution would begin in the grim factories of Europe; Jane Fonda's would foment in the palm tree–lined streets of LA. Slowly, as the Workout gained traction and the book and VHS tapes significantly increased its visibility, instructors who had been involved since the beginning noticed some slight yet marked changes to the organization. Busloads of Japanese tourists would arrive to check out Fonda in person, and though the initial goal had been to continue opening new locations, Fonda's new business manager Julie LaFond advised Jane to close down the San Francisco and Encino branches to concentrate on the brand's real income stream: the books and videos, which sold for $18.95 and $59.95, respectively, a considerable price tag at the time. Wearing pairs of white, low-top Reebok Freestyles—the first athletic shoe marketed exclusively to women, which debuted on shelves in 1982—Workout converts were easily spotted on their way to and from the studio. For the first time, "you started seeing people around Los Angeles wearing exercise outfits to go and do their activities," Lesley Mallgrave recalls, which was unusual because before the early 1980s, "you would never [for instance] go to the grocery store in gym shoes."

In the struggle for sneaker supremacy, Nike dominated until 1984, when the company reported a 29 percent decline in earnings, the

first drop in a decade. "Orwell was right: 1984 was a tough year," Knight told Andrew Pollack of the *New York Times*, after confronting the even more sobering news that Nike showed its first losses ever for the first two quarters of 1985. The truth was that consumers in the early 1980s had shifted their footwear fealty to another brand prescient enough to recognize that ladycentric fitness crazes like the Workout and Jazzercise—another Southern California brand of movin' and shakin'—indicated a glaring gap in the sneaker market. There were sneakers for basketball players and sneakers for skateboarders, but no one had designed a shoe intended specifically for women and women's sports. The original Freestyles—which boasted "mid-sole cushioning and lateral stability"—were created as aerobics shoes, to absorb the impact that comes from jumping, jogging in place, and hopping from side to side.

At least that's what Reebok wanted its increasingly loyal base of female customers to believe. As early as 1983, skeptics questioned whether the practice of aerobics required a separate, customized shoe, or if sneaker manufacturers like Reebok as well as New Balance and Adidas—all quick to jump on the aerobics bandwagon—had devised yet another ingenious way of inventing need. Podiatrists quoted in a *Chicago Tribune* article were split on the subject: Jeffrey Liss of Florida told a reporter that aerobic shoes were "just a gimmick" and that "the running shoe, which has been around for longer, is preferable for aerobic activity because of its more sophisticated design." However, Stuart Leeds (also of Florida) told the paper that "aerobic dancing is probably more violent than people think" and that "the aerobic shoe . . . is wider and more stable laterally than a running shoe, which is made primarily for forward, non-side-to-side movement common to aerobics." Whether or not the sneaker companies had legitimately

designed shoes that would, as they claimed, protect women's knees, shins, and feet, they relied on a quaint yet highly effective method of salesmanship. For decades, the value of the majority of women's shoes had been measured in terms of fashion, with function taking the lead only on niche, second-tier shoes like rain boots. High heels, for instance, aren't exactly practical, so the way women understand their efficacy is more abstract: they're sexy, so they'll help capture men's attention; they're tall so they'll give the wearer more authority. With the Freestyle, Reebok initially chose a neutral look—white with white laces—and championed its functionality, in the way sneaker companies had done with male athletic shoes targeted toward a highly specific buyer. By synching up with the aerobics movement and making their sneakers indispensable to it, Reebok in turn used a very literal function to create a fashion, rather than vice versa.*

The Reebok Freestyle became so popular that by the mid-1980s, it accounted for half of the company's total sales, with variations on the original white low-top proving so ubiquitous—white high-tops with two strips of Velcro, high and low versions in rainbow colors— that a veritable style sensation was born. By 1987, the *Guardian* was reporting that "Reebok shoes have become America's ultimate footwear status symbol and are as much at home in Yuppie cafés as in aerobics classes." After someone broke into her gym locker and

* Shoes like FitFlops and the Reebok EasyTone—both of which promise women thinner, more toned physiques just by walking in them—have recently been marketed to buyers in this same way. However, in September 2011 the FTC examined Reebok's claims and ruled that exercise, not just the shoes themselves, should be credited with increasing muscle strength. As of this writing, Reebok is barred from advertising the EasyTone as a body-toning shoe.

stole her Freestyles, fifteen-year-old Trace Tyrell "bought another pair" because, as she told the *Los Angeles Times* in 1986, not only do they make great sports shoes but "you can wear them with an outfit and they'll make it look better." In her *Moonlighting* days, Cybill Shepherd baffled critics when she committed the ultimate fashion faux pas: wearing her black gown for the 1985 Emmy Awards with a pair of Day-Glo orange Freestyles. As she told *People* magazine in 2009, "Everyone was going, 'No, Cybill, don't do it!' But I felt half the women there were envious. They resented that they were torturing themselves!" The sneaker's popularity had soaring financial implications, too: Reebok began trading publicly in 1985, and the stock was so instantly lucrative that short-sellers predicted its epic fall.

Indeed the prediction that Reebok, which rose meteorically from a $1 million company in 1980 to an $800 million company in 1986, seemed destined first to plateau, and then plummet, was not unfounded, if based solely on the principle of *what goes up must come down*. But it wasn't just that: one San Francisco investment banker called it "Nike all over again," meaning that Reebok's days as the footwear front-runner were numbered, because its success could be credited almost entirely to the popularity of the Freestyle, which was a shoe meant for aerobics. Even though people started wearing Freestyles as far away from the gym as the Hollywood red carpet, their cachet relied at least in part on the staying power of the aerobics trend—*trend*, by definition ephemeral, being the key word. If gyms, working out, and health consciousness became less fashionable, so would the looks identified with the lifestyle, like headbands and leg warmers. Reebok, at least publicly, felt they were ahead of the curve. In a 1986 *Wall Street Journal* article titled "Reebok: Keeping a Name Hot Requires More Than Aerobics," the

multimillion-dollar company assured cynics that by keeping the shoes stocked only by upscale retailers and not overproducing, its Freestyles would continue to feel exclusive and therefore special. By 1987, both Reebok and Nike were out to corner a new, complementary demographic: walkers. Reebok released the nylon and leather Pro Fitness Walkers for $45.95, and Nike countered with the leather Airwalker for $49.95 in July, both manufacturers intending to take advantage of the fact that sneaker enthusiasts were already wearing Nike and Reebok shoes on the streets and—if sales of the Freestyle and other specialized styles were any indication— were amenable to buying different pairs of sneakers for various athletic activities. Again, podiatric evidence was invoked: "While the walking motion is gentler than that of running in terms of impact, it is also more of a rolling motion that takes greater advantage of the foot's remarkable flexibility," the *Washington Post* reported in a cover story.

By the end of the decade in 1989, Nike, as predicted, finally inched past Reebok with its expensive "Just Do It" campaign featuring recognizable athletes like Bo Jackson, John McEnroe, and, of course, Michael Jordan, who shilled the $110 Air Jordan shoe via his brand of sleek, übermasculine cool. For the moment, Reebok lost the battle, but both manufacturers, along with other profitable brands like Adidas, New Balance, and L.A. Gear, ultimately won the war. "Twenty years ago, the average American may not have owned even one pair of cheap, all-purpose, rubber-soled sneakers. Today, he owns two or three pairs," Bernice Kanner reported in 1989 for *New York* magazine. In the 1980s, buyers had officially acclimated to "expensive, brand name 'athletic shoes'—some with 'air suspension systems,' molded ankle collars, 'outrigger' soles and adjustable support straps." The sneaker market boomed, along with the idea that

consumers needed scientifically designed, fashion-forward shoes that would help them to achieve concrete physical goals by protecting and augmenting the human body's natural resources—and there was no going back.

The aerobics trend changed longstanding ideas about what was attractive. In *Barbarella*, Jane Fonda was all soft curves, with rounded hips and thighs arching out from her high-cut bikinis. Sixteen years later, *Time* magazine, quoting an unnamed male filmgoer, described Fonda's tanned, toned physique in *On Golden Pond* as "like wood . . . you don't want to stroke her, you want to sand her down." It may have taken some getting used to, but as the health and fitness trend took root, womanly, Botticelli-esque bodies gave way to firmer, narrower frames. Muscles weren't just for men anymore. In the same way that the me-first, "greed is good" mentality took hold of the business world, men and women alike in the 1980s began to reassert *themselves* as their first priorities, taking time out of their lives to work out for no other reason than that they liked the results. Mothers in particular, who had grown up with the understanding that their families and children should be their number one concerns, felt satisfied knowing that the thirty to sixty minutes (for beginner versus advanced practitioners) they took out of their days to "do Jane" wasn't negatively affecting their abilities to care and nurture. And for those high-ranking women in the corporate world, a toned body could actually be an asset. For one, being in shape communicates to others that you're in control, and that you value yourself and your time. Perhaps more important, at a historical moment when the vision of a female executive was still novel, a svelte woman registered as less traditionally sexy or maternal than one with pronounced curves.

A womanly body was a handicap in the workplace; Gordon Gekko didn't want to go head to head with Mom.

High-earning women had plenty of time to experiment with their style in their off-hours, cashing in on all that unchecked femininity and sexiness that they intentionally downplayed during the workweek. Given the cultural emphasis on money and all that it can buy, it's unsurprising that labels—showy and expensive—were coming back into focus. As Holly Brubach reported in 1988 for the *New Yorker*, "Couture, having regained its stature, is once again in full swing." Wealthy customers who could afford high fashion once again wanted to flaunt it, along with the terrifically toned bodies they worked hard to sculpt. The resulting designs were body and label conscious and carried outrageous price tags that appealed to a woman's sense of vanity in more ways than one. Azzedine Alaïa, anointed the "King of Cling" by the fashion press, used synthetic materials like Lycra to craft snug dresses that left little to the imagination, and Hervé Léger, Karl Lagerfeld's French protégé, founded his own eponymous label in 1985, making a name for himself in 1989 with the "bandage" dress that used highly structured corsetlike construction usually reserved for the innards of a gown, making a leap that would, like Madonna's Jean Paul Gaultier cone bra, help legitimize the underwear-as-outerwear trend.

Skintight dresses were surprisingly successful, yet thanks to the popular acceptance of the athletic shoe, the typical head-to-toe silhouette was dramatically changing. Suddenly it wasn't considered bizarre or unfashionable to pair a dress or skirt with a shoe that *didn't* lengthen the leg or minimize the appearance of the feet. As the world adjusted to seeing women walk down the street in Reebok Freestyles and other high-performance sneakers, the door was

opened to other "unflattering" shoes that might appeal for reasons of comfort or personal style. Liberated from the narrative of Cinderella and her itty-bitty feet, more and more women pulled on sneakers and boots, confident that the unusual combination of feminine outfits with clunky, masculine shoes was making an important but still socially acceptable statement, positioning them somewhere in between the mainstream and fringes.

.

The Cool Kid Trinity: Vans, Chuck Taylors, and Doc Martens

(1982–1994)

Not every popular shoe in the 1980s signified an acquisitive nature or a go-getter spirit. The black-and-white checkerboard slip-on sneaker by Vans remains one of the most recognizable shoes of the decade, thanks to the 1982 teen movie *Fast Times at Ridgemont High* and a pot-smoking slacker named Jeff Spicoli, played by the young, up-and-coming actor Sean Penn. Spicoli is the lovable loser who has "been stoned since the third grade," orders a pepperoni pizza to be delivered to his history class, and wants nothing more out of life than "tasty waves and a cool buzz." He's so charmingly boneheaded that teenage audiences tried

to emulate his laid-back Southern California style—and they especially wanted the checkerboard shoes he wore throughout the movie.

Fast Times was a defining pop-culture moment for Vans. As the brand gained a loyal following in Southern California, the Van Doren family noticed that kids who bought Vans liked to customize their sneakers with a DIY checkerboard pattern on the white sole. In response, Vans started manufacturing slabs of rubber with a checkerboard print and eventually, black-and-white-checked canvas. When the shoes ended up in Amy Heckerling's high school comedy, Steve Van Doren, founder Paul's son, credited Vans' PR lady Betty Mitchell, and it wasn't until 2009, when Mitchell was ninety-two years old, that he learned the real story. "Betty would hear about movies and she would bring shoes up to the [studios] and drop them off there. I always thought Betty dropped the first shoes over at Universal [where *Fast Times* was filmed] but she told me that actually Sean Penn went into our Santa Monica store [on his own] and bought a pair." According to Van Doren, when the time came to work with the *Fast Times* costume department and outfit Spicoli, Penn said, *hey, there's a cool store [in Anaheim] and I got these checkerboard shoes and they're pretty cool*, and then after being contacted by Universal, Betty Mitchell sent shoes over to the wardrobe department. *Fast Times* went on to become a cult film, and it contained a particularly memorable advertisement for the Van Dorens' company: when Jeff Spicoli, on a superstoned phone call with a surfing buddy, whacks himself on the head with a checkerboard slip-on, he has a prominently displayed Vans shoe box in his lap.

Steve Van Doren saw the moneymaking potential in the movie and brainstormed a slick way to promote the brand. He remembers: "My dad . . . I won't say he's cheap, but very thrifty. I said, 'Dad, this movie is coming out, I know we don't advertise but if you give me

one thousand pairs of these checkerboard shoes, I will give them to every [radio] DJ in the country so that they play the sound track and get kids thinking about *Fast Times*.'" Every time a DJ played Jackson Browne's "Somebody's Baby" in the weeks leading up to the premiere, he or she would give away another pair of checkerboard Vans. The shoes became so closely affiliated with the film's music that the cover of the original sound track featured a pair of them in a yellow-and-white-checked circle against a black background, with the band names listed on either side. "The seeds that we planted in the early 1980s are the roots of the company," Steve Van Doren recalls fondly. In 2001, when Vans financed pro skateboarder Stacy Peralta's documentary *Dogtown and Z-Boys* about the early days of the sport in Santa Monica, Steve Van Doren ran into Sean Penn—who narrated the film—on the red carpet.

"Because of all the kids who wanted to be Jeff Spicoli, you made my life easier, so thank you," Van Doren told him.

At first, Spicoli-mania seemed to make sense as a reaction to stiff-collared corporate culture, but in some ways, the surf-dude's appeal had roots in a similar overarching value: individualism. Jeff Spicoli is so appealing because he does what he wants (whether it's order a pizza to fifth period or hotbox a bus before class), and he doesn't let others' expectations or rules bring him down. As a corporation, Vans needed to take a lesson from Spicoli's playbook; just a year and a half after their unprecedented success with *Fast Times at Ridgemont High*, it filed for Chapter 11. As Steve Van Doren remembers it, the company felt pressure to create athletic shoes to keep up with brands like Nike and Reebok. Unfortunately, this caused Vans to drift too far out of its comfort zone and to gamble with the integrity of its product, thus losing the very skateboarders and surfers who had sworn by them, and not converting enough of the majority to make up for it. By the

late 1980s, Van Doren and his father were able to bring the business back to life—paying "100 cents on the dollar," he adds proudly—with a stronger sense of the company's core identity.

By staying true to its original, and loyal, customer base—"skateboarders, surfers, BMX motocross people, [as well as] fashion for women in our realm," according to Van Doren—Vans was able to weather the particularly stark transition between the 1980s and the 1990s, when nationwide priorities did an about-face, and the counterculture, which prides itself on its ability to react against the mainstream, suddenly found itself front and center. In the late 1980s, a burgeoning music scene in Washington would go on to shape a generation's music tastes. Grunge was Seattle's local answer to flashy mainstream rock-and-roll acts played in heavy rotation through MTV's inaugural decade. Musically, it emerged from a blend of thrashing heavy metal and defiant punk rock, and it featured a stripped-down aesthetic typical to that area of the country. Whereas Kiss would spend hours getting decked out for their live performances, grunge acts would get drunk and high and stumble onto the stage in their unwashed flannel shirts. Initially, grunge music's power came from its palpable sense of longing, disappointment, and antipathy—not, as it would eventually seem, from its sense of style. Later, when *grunge* became a fashion buzzword and suburban teens across the nation had adopted the northwestern look, Seattle natives would bemusedly shrug their shoulders and insist that their sartorial motives had always been strictly utilitarian. Flannel oxfords, knit caps, and heavy boots were weather appropriate and available secondhand for negligible prices at the Salvation Army. Grunge emerged from a chasm created by deprivation. In the 1980s, the difference between Seattle bands and the ones on MTV was plain: hair metal and new wave required costumes and thus money.

Eventually the Reagan recession that crippled Seattle would sweep the entire country, and grunge, for its fundamental sense of disenfranchisement, felt compellingly prescient. When the 1980s ended, the decade took off like a fun but entitled dinner guest who ordered champagne and caviar for the table, but then left without paying the bill. For Americans in the 1990s, the balance was due in the form of job losses, the Persian Gulf War, and AIDS, which as part of a public health campaign received nonstop edifying (yet scary) media attention. Suddenly, the marginalized freaks with their glassy eyes and greasy hair didn't seem quite so off target. Grunge's hammering guitar, reverberating bass, and whining vocals said everything the country couldn't, and the self-described losers inherited the earth.

Two shoes eventually shod the all-stars of grunge: the Converse Chuck Taylor, and the Dr. Martens 1460 boot. The former had been strongly associated with a previous alternative scene in the United States. In the late 1970s, the company realized it had a solid foothold in youth culture and expanded beyond the original black-and-white color palette to produce Chuck Taylors in an assortment of candy colors. The fact that the canvas sneaker easily lent itself to further home customization—e.g., cutting, embroidering, or decorating—helped to secure it a place within the American punk rock scene. Menswear designer John Varvatos, whose collaboration with Converse began in 2002 and is currently contracted to continue until 2015, noticed that men and women alike wore Chuck Taylors when going to see bands like the Ramones, Blondie, and the Patti Smith Group in the late 1970s at CBGB (the groundbreaking club closed in October 2006, and music lover Varvatos himself now inhabits the

space with an eponymous downtown boutique). As he tells it, grown-up former punk lovers who have gone on to pursue conventional careers—and buy correspondingly conventional wardrobes—still hold on to Converse sneakers as a souvenir of their defiant youth. "I have a friend in Hollywood," Varvatos says, wearing his own pair of Chucks, "he's probably fifty-eight years old. And when [the John Varvatos brand] started doing Converse shoes, he rediscovered them, and he wears them every single day, with his suits, with everything. And for him—he's never told me this specifically, but I know it's to show that he's rebellious. He's a pretty straightforward guy, but there's this edge about him that he wants to be able to [project]." But what's unique about Chuck Taylors, and what has ensured their enduring success, is their ability to filter through the generations without losing their cachet. Varvatos explains that his "son, [who] is twenty-five—I don't think he's ever gone a day without wearing Converse sneakers. And he wore them because he was pissed off as a kid and he was rebellious and he wanted to do everything that was *anti*, and that's what's interesting about what that brand represents. Whether you're the fifty-eight-year-old guy or the fifteen-year-old kid, it's your way of putting your own stamp on your personality, and [aligning yourself with] the counterculture."

Somehow parents and their kids can both wear Converse sneakers without damaging the shoes' credibility, and that's due in part to the company's decision to groom the Chuck Taylor as an "underground" shoe rather than push to widen its consumer base. It's been a very long time since Converse was peddling the most technologically innovative basketball sneaker, but by the early 1990s they were no longer interested in that game. Instead the company realized they were rivaling other hipster brands like Puma and Vans. Then, a pop-culture coup: a black high-top Converse Chuck Taylor tapping along

with grunge god Kurt Cobain's guitar riff is the opening shot of the video for Nirvana's "Smells Like Teen Spirit." Cobain himself was partial to Chuck Taylors, which signaled the presence of an outlier: someone who is paradoxically participating in fashion and tiptoeing outside of it, wearing shoes that have been culturally approved as cutting-edge.

Like Vans did, Converse realized that by muscling too far into the mainstream, the company would alienate its most loyal fan base and thus lose its grasp on that elusive coolness that keeps their shoes relevant. In 1994, the *New York Times* profiled Converse executive Baysie Wightman, who trolled "the clubs of New York, Tokyo and London . . . the rock-and-roll bars of Seattle and Portland [and] the streets of Los Angeles"—all "in search of hip feet." Her strategy was to observe the footwear worn by hard-partying transvestites and decked-out club kids, and create shoes that would appeal to them—not the jocks and cheerleaders who are more commonly assumed to purchase sneakers. This choice, as trend analyst Irma Zandl remarked in the article, was unusual for a big-name brand. "Most companies are interested in maximizing sales and gaining bigger and bigger market share," she said. "Converse seems to have decided that what they want to do is have the biggest market share possible of the alternative world."

For the title of coolest alterna-shoe, Converse's competition was a UK-based boot company with a sprawling, varied history within the underground. Fifty years ago in the Bavarian Alps, Dr. Klaus Maertens, a German soldier on leave from the battlefield, injured his foot while skiing. At home convalescing in Seeshaupt, the twenty-five-year-old envisioned a shoe like the sturdy ones he wore in

combat, but with a supportive sole made from springy rubber rather than the flat leather slab typically used at the time. He fashioned a prototype from found objects: "The week the war ended, everyone started looting. But while most people were looking for valuable stuff like jewels and furs, I picked out a cobbler's last, some leather, needles and threads, and made myself a pair of shoes with the thick air-cushioned soles I'd been thinking about." With makeshift boots in hand, Maertens headed to Munich, where he ran into an old friend, Dr. Herbert Funck, who took an immediate interest in the shoes and suggested that the two of them go into business. Again culling recycled materials, they built their original shoe—one that barely resembled the iconic 1460 to come, but that made use of an innovative method of cobbling that would define the brand going forward. Dr. Maertens had dreamed of a well-cushioned shoe, and rather than stitch the sole directly to the upper, he and Funck figured out a way to heat-seal them together, creating elastic air pockets in the process. *Voilà*—the shoes were indeed comfortable, and after finding immediate success with German hausfraus who spent their days on their feet, Maertens and Funck licensed the new technology to the Griggs family, an established name in English shoemaking. Bill Griggs revised the shoe's silhouette and dubbed the soles Air-Wair, advertising the brand via a quirky looped tag that read, "With Bouncing Soles" in a cheerful yellow and white font that was modeled after Griggs's own handwriting. The time had come to name the shoe. They considered both "Dr. Funck" and "Dr. Maertens," but the latter won out because of the resemblance of Funck's name to a certain unsavory expletive. *Maertens* was anglicized to *Martens*, and on April 1, 1960, the eight-hole Doc was born.

The 1460 was named for its birthday. As British exports like the Beatles and Mary Quant transformed international fashion, Dr.

Martens—comfortable, durable, and costing just two pounds a pair, eminently affordable—quietly found a place in the UK as functional shoes for blue-collar workers, police, and postmen. This working-class legacy gave them their original underground appeal; skinheads, proud of their proletariat roots and looking to distinguish themselves from the financially flush and flashy mods on Carnaby Street, adopted them as their go-to footwear. They wore them with Levi's red label jeans, meticulously rolled up to three-quarter length in order to highlight the boots, which they kept immaculate (Martin Roach, Dr. Martens historian and author of *Dr. Martens: The Story of an Icon*, points out that "as they needed no time to style their hair, skins spent literally hours on their clothes and footwear, polishing their DM's almost obsessively"). Interestingly, although a branch of skinheads later developed into the right-wing, white supremacists most often associated with neo-Nazism, the preeminent bald-headed mischief makers were actually more racially inclusive and tolerant than other contemporaneous groups. Skinheads listened to reggae, ska, and soul—all styles of music derived from African and island culture—and partied peacefully in ethnically diverse dance halls. However, the sinister changes within skinhead culture, combined with the detail that Dr. Martens were invented by a former World War II soldier from Germany, led to the erroneous conclusion that the 1460 started out as a Nazi boot that then filtered into the mainstream, rather than vice versa. It was also within the skinhead movement that one of the most notorious Doc Martens practices was born.

Skins used their shoelaces to communicate, swapping out different colors as a concise sartorial code. This system—which continued well into the 1990s when Doc Martens were worn not just by skinheads but also by a series of ideologically disparate alternative groups looking to self-identify—was never made consistent, so the

relationship between a certain color and its implicit meaning could change from place to place. So, for instance, a white lace might signify white supremacy (in the UK, allegiance to the National Front), or it could specifically suggest the opposite, particularly if the white laces were intertwined with black ones. In Canada, yellow laces were understood to identify a police killer, while in other regions, blue laces carried the same connotation. Red laces might herald not only the presence of a neo-Nazi but also could suggest Communist or ultra-left-wing leanings. In the late 1980s, a girl wearing purple laces might be perceived—in some cities—as a lesbian. Even with so many geographical variants, the use of laces to relate information is a fascinating crystallization of a task that shoes perform as a whole. If footwear is a language, then Doc Martens's laces-as-signifiers is a highly specific dialect, in the same way that regional accents work to identify a speaker's city or country of origin.

In the late 1960s, the steel-toed versions of Doc Martens were classified as "offensive weapons" and fans were prohibited from wearing them to British football games. The sense that the boots were forbidden made them only more attractive to skinheads, who, even if they weren't planning to hurt anyone, wanted at least to look like they could. Then, in the 1970s when punk arrived on the scene, the connection between Doc Martens and skinheads gave the shoes a whiff of underground illicitness, and punks started wearing them as well. Roach goes on to explain: "One of the most unique things about Dr. Martens is [that when a] subculture [emerges], part of its raison d'être is to destroy the subculture that came previously, and revel in being the opposite of what was fashionable six months ago. And yet each time a subculture springs up . . . it throws everything out of the wardrobe but keeps the boots." Part of the reason why, is that no matter the brand, the appearance of combat boots,

for their suggestions of war and authority, remains subversive and not so subtly intimidating. When, for instance, *A Clockwork Orange* premiered in theaters in 1971 and audiences saw the way Alex De-Large (played by Malcolm McDowell) dressed, they began buying Doc Martens in imitation, despite the fact that he didn't actually wear them in the film. DMs were an accessible, affordable approximation of the heavy black boots used in the movie, and thus they became central to the 1970s street-style interpretation of De-Large's frightening gang-leader look.

Unlike a person who flits from subculture to subculture and thus loses credibility, Doc Martens manage to rise phoenixlike within each one, taken more, not less, seriously for their historical lineage. In the late 1970s a band emerged from the low-income city of Coventry, England, where adolescents came of age under the cloud of the region's high unemployment rate. The Specials blended reggae, punk, and ska—a genre that derived from Jamaican dance music—and filled the void left by the dwindling punk scene. They started a record label called Two Tone, and the hybrid sound of the Specials went on to influence the subsequent bands they signed. The label didn't survive long, but its name came to stand for a particular style of music and inspired a retro mode of dress that managed to combine 1950s-era looks with the ubiquitous pairs of Doc Martens.

Soon the shoe company with a traditionally masculine clientele started to appreciate the power of the female consumer, harking back to the days when they were de rigueur for German housewives. According to Roach it was "right around 1985, 1986, [when] someone at Dr. Martens noticed that there was a surge in very small men's sizes being sold, so they phoned around shops, and they tried to find out what was going on, because they were [curious] why suddenly England was full of men with size 4 feet." Of course, English men hadn't

gone minuscule en masse, and the people at R. Griggs realized that because the company didn't manufacture women's sizes, female customers were buying Doc Martens boots in the smallest men's sizes they could find. R. Griggs responded not only by producing smaller shoes but also by creating styles exclusively for women—most famously, the floral 1460 that juxtaposed a traditionally feminine pattern and color palette against the aggressively masculine boot.

In 1984, Doc Martens—aka Dr. Martens, aka Docs—became widely available in the United States, and they were promptly adopted by various subcultures in the same way that they had been overseas. Male and female buyers wore them; the ankle-high boot with the signature yellow stitching was quickly associated with the burgeoning grunge scene in Washington State, where heavy-bottomed army boots were ideal for dragging through the muddy streets and lawns native to the damp Pacific Northwest climate. Dr. Martens and its parent company R. Griggs were so confident in the fidelity of their alternative consumer base that they didn't even have a marketing department until the early 1990s, when the sales numbers shot so high that they could no longer do without one. As Roach says, "As quintessentially English and appealing as it is to think that we could sell twelve million boots from a former cottage in Northampton and not have a marketing department, it just isn't practical. But even to this day, they are extremely low-key in their marketing approach; they never ever like to force the boot on people. They put the boot out there, and they do marketing and advertising campaigns, but what they know very well is that they have a fifty-year history that the biggest brand checkbooks in the world cannot buy."

In the 1990s, when people slipped Doc Martens boots onto their feet, they were subscribing to this diverse and sometimes checkered lineage, and communicating to the world that in one way or another,

they wanted to be a part of it. This is why, in 1993, a Texas high school banned students from wearing them, for fear that they signaled the presence of skinheads on school grounds. After a series of racially charged crimes upset the Dallas–Fort Worth suburb of Grapevine, school officials started pulling students out of class for wearing Doc Martens and threatening to suspend them if they didn't change their shoes. These students, who bought the boots not for any political reasons but because they saw their pop-culture heroes wearing them on MTV and in magazines, protested. Ultimately, the school district caved, confessing that they had conflated fashion with fascism. "We goofed," a spokesperson for the school told the *New York Times* soon after the incident received national attention. "We wanted to get rid of skinheads, but the way we went about it didn't work." What the school officials had failed to take into account was that although skinheads wore Doc Martens, so did rock-and-roll legends like Pete Townshend and Joe Strummer, and that legacy is powerful to a young person looking to define him- or herself. "If you're twelve [for instance], and you have that relationship with your parents that's a bit fractious because you're a teenager . . . [and] you put on a pair of boots that Pete Townshend was wearing in 1967, or punks were wearing in 1976, or Two Tone were wearing in 1979, people take you more seriously. It shows that you've got an interest in the alternative," Roach opined.

Grunge became a short-lived yet highly successful and definitive fad. For grunge acts, and in a way for Seattle as a city, the sense that they were being lauded as the kind of mainstream tastemakers whom they grew up wanting to both vilify and emulate proved destabilizing, and the bottom fell out. The beginning of the end came

in 1992 when Marc Jacobs, then a young designer for Perry Ellis, debuted a runway collection inspired by grunge. In an impressive move that underscored both the fashion world's incredible cultural insight and its tone deafness when it comes to the average citizen, Jacobs showed thrift-store chic at couture prices, commandeering the very style that nonprivileged youth had adopted to distinguish themselves. Though it had been created as a reaction to the 1980s and its excesses, grunge's demise came via the mechanics of commercialization that its originators had intended to flout. Within just a few years of Nirvana's rise up the ranks of the Seattle music scene, upper-middle-class suburban teens started wearing Doc Martens and Chuck Taylors as an homage to their favorite bands. The result: a sense of manufactured authenticity gripped the nation as celebrities and consumers alike competed to be the most "real," the most intuitive, the most entitled to feelings of alienation and pain. A network show like *My So-Called Life*—in which a fifteen-year-old girl makes a conscious choice to explore the fringes of her high school social scene, and in her inimitable teenage wisdom vacillates between moments of self-obsessed myopia and pitch-perfect perceptiveness—captivated a generation. In the early to mid-1990s, Doc Martens boots turned mainstream, signaling the era of the poseur: a multi-year freaky Friday during which the rich wanted to look poor, the cool wanted to look lame, and the "losers"—who thought the spotlight would never turn their way—basked in the heat of its brightness, before withering and disappearing again.

15

.

Girl Power
and Mary Janes

(1994-1999)

1995: Los Angeles, California

Unlike many rock stars in the early to mid-1990s, there was nothing particularly tragic about Gwen Stefani. On October 10, 1995, when *Tragic Kingdom*—No Doubt's third studio album—was released, she was a twenty-six-year-old platinum-blond pinup in the mold of Jean Harlow, Lana Turner, and Marilyn Monroe. Like the Old Hollywood It Girls who came before her, Gwen was classically beautiful: she had full lips and big baby doll eyes, and she played up her features with cherry red lipstick, retro arched eyebrows, and false eyelashes. The front woman looked like a star, but before *Tragic*

Kingdom, the band hadn't achieved anywhere near the kind of success they'd all dreamed about back in high school when they first started playing together in Southern California. In 1992 when No Doubt's eponymous debut album hit shelves, it was at the height of grunge music's popularity, and this band, which played poppy, upbeat, melodic songs, was told it would take a miracle to get them national airplay. Still, Stefani and the boys didn't give up. They settled for shows at tiny clubs and a loyal, if nominal, fan base and kept working until grunge's dirtball hegemony ended, burning out in a blaze of greasy hair and flannel.

The cover of *Tragic Kingdom* shows Gwen in the foreground, in a red vinyl A-line minidress that matches her bright lipstick and nail polish. She's holding an orange, which allows her toned biceps to flex, giving a hint of the athletic physique that would soon be her signature in the era of pubescent Kate Moss and heroin chic. In the background, populating a sparse orange grove, are her bandmates—Tony Kanal, Tom Dumont, Adrian Young, and Gwen's older brother Eric, who had quit No Doubt before *Tragic Kingdom* went to press but appeared reluctantly on the cover after Gwen insisted that he should receive some photographic credit for cowriting a significant number of songs on the album. Regardless, like the rest of the boys on the cover, Eric Stefani's features are barely discernible. In what became an all-too-familiar snub for the majority of No Doubt, photographers would focus on Gwen while unabashedly cutting her bandmates out of the frame. Magazines wanted the doe-eyed vocalist on their covers, begrudgingly including the rest of the musicians as a package deal. Ironically, as No Doubt vanquished their critics and became increasingly famous, the boys felt themselves being treated less and less like rock stars. Resentment swelled, and Gwen, who enjoyed the spot-

light, felt torn between the rush of her newfound celebrity and the hurt feelings of her best friends.

The band almost broke up. Then, guitarist Tom Dumont suggested they act out their frustrations in their third video off *Tragic Kingdom*, for the heartfelt power ballad "Don't Speak." In a clever bit of MTV-generation catharsis, No Doubt dramatized a photo shoot in which Gwen, at the photographer's urging and holding a Tree of Knowledge— and *Tragic Kingdom*—esque orange, edges her bandmates so far out of the shot that they end up pouting on the sidelines. The video helped to stay some of the real anger brewing within the band, but it also publicly acknowledged the most frequent condemnation against No Doubt's credibility: they'd resorted to the oldest trick in the music industry's book and simply hired a sexy front woman to get noticed. In 1996, one particularly sour reviewer griped that "female rock stars like Gwen Stefani aren't supposed to exist anymore. . . . The success of *Tragic Kingdom* appears to reaffirm one showbiz tenet: sex still sells, even when it comes to women musicians. Maybe we don't live in such progressive times after all." Did Gwen, as the bare-midriffed alternative to the Seattle-centric alternative nation, really represent a step backward for women in rock?

It's true that she was different from grunge goddess Courtney Love, who seemed to claim feminist indignation as her birthright and who treated each live performance as an opportunity to exorcise her rage. Gwen herself admitted that she was partly a boyish fantasy of a female pop star; her brother had wanted to start a band but he couldn't sing, so he molded his little-sister-who-could into the perfect front woman. "Gwen used to say that Eric, always a talented cartoonist [and who left No Doubt to draw for *The Simpsons*] invented her . . . as a cartoon," Chris Heath, who profiled No Doubt for *Rolling Stone* in 1997, wrote about her. The band's first hit single, called "Just

a Girl," invoked a litany of girlish stereotypes (existing solely as an object for the male gaze; having no opinions; being incapable of operating a motor vehicle at night), and the video, some of it shot in extreme close-up, shows a caricatural Gwen pouting and making eyes at the camera. But to take the song at face value would be to ignore the sugary slick of sarcasm in Stefani's delivery. To dismiss Gwen as *just* a pretty girl—photographer's bait, a marketing ploy—would be to overlook her contribution to the *Tragic Kingdom* record, where twelve out of fourteen songs were written at least partly by her, lyrically tracing the dots of her recent breakup with bassist Tony Kanal and mining her subsequent heartbreak. Gwen was a new kind of female role model, one who looked like the old masculine fantasies but who also talked and behaved like a rowdy boy, frequently doing push-ups onstage. She gave audiences a clue about who she wanted to be on the *Tragic Kingdom* album cover. Yes, in some ways she was just a girl from Orange County, California. But there was something else about her too—blink and you'll miss it. She was wearing Doc Martens on her feet.

After grunge made Doc Martens popular, they became the shoes that female outcasts (like MTV's cartoon cynic Daria) and avengers (like Tank Girl) wore. But when Gwen wore Doc Martens on the cover of *Tragic Kingdom*, she wasn't visually affiliating herself with grunge at all, but with the British musical genres of ska and Two Tone that had influenced No Doubt's sound. In the subsequent music videos for "Just a Girl" and "Spiderwebs," she wore black-and-white DMs wingtips in the classic ankle-high cherry-reds. The shoes signaled that although Gwen may have looked like just another pretty face, she—like a handful of female recording artists in the mid- to late 1990s—had an element of the renegade in her. Straight off the heels of grunge's male-dominated spate, Stefani and others were trying to

renegotiate the space for women in music, using fashion as a mode of communication and defiance.

She was one of many female musicians at the time who were challenging the limits of rock stardom via their lyrics and their dress. Early in her career, Gwen was often compared with a different front woman who was inextricably bound up with the Seattle legacy: Courtney Love. Not only was Love the lead singer of the aggressive band Hole but she was also Kurt Cobain's widow, which ensured her a seat within the rock-and-roll pantheon. As a performer, Love was irrepressible: she was known to curse out the audience, flash her crotch, and dive, in a frenzy of her fans' adoration and rock-and-roll-induced madness, from the stage. She toured for Hole's album *Live Through This* immediately after her husband's suicide, living through *that* among Nirvana's fans who either felt that her grief was theirs to share in, or that she, a psycho shrew, had singlehandedly driven Cobain to suicide.

In the early to mid-1990s, the ratio of joy to tragedy in Courtney Love's life seemed decidedly, and mesmerizingly, uneven. She had struggled with drugs and her husband's various overdoses and suicide attempts, walking around in the jacket Cobain died in—after washing it, of course, so that his blood came out. Like her persona, her personal style was explicitly confrontational. At the time of *Live Through This*'s release, Courtney Love wore baby doll dresses with knee-high stockings, and childlike plastic barrettes in her messy hair. When it came to footwear, she took a decidedly different tack from Stefani. Instead of counterbalancing ultrafeminine pieces like lace nightgowns and round-collared blouses under jumpers with masculine shoes, Love paired them with patent-leather Mary

Janes, creating the scandalous impression of a young girl in a woman's body. With round breasts and hips, Love looked different from the athletically slender Stefani, but the end result was similar—she played up her sexuality in unconventional ways, challenging audiences to confront their notions of female attractiveness.

Love's style was dubbed Kinderwhore. Pouting at the camera with sloppy red lipstick on her face, she looked like an overgrown child prostitute. The Hole singer gave a few different reasons for why she chose to dress that way, but at her most ideological, she claimed that she was drawing attention to the way the world infantilizes women, denying them their power. As a woman in rock and roll, Love felt she was pushing up against long-standing barriers that said a girl couldn't rock like Mick Jagger. As she told *Rolling Stone* in 1994, "I recall growing up with Leonard Cohen records and going, 'I wish that was me he was writing about.' I wanted to be Suzanne, I wanted to live down by the river. . . . And then I came around. 'No, no, no. I don't want to be the girl. I want to be Leonard Cohen!'" Her approach, however, wasn't to ape male iconic musicians but instead to carve out a new space where women could be equally potent, where they could scream and swagger and overtly push the envelope. As a teenager in Olympia, Washington, Love developed her point of view alongside the burgeoning Riot Grrrl movement, which derived from punk and loudly drew attention to women's issues, rather than ask questions and placidly reflect like Joni Mitchell (whom, interestingly enough, Courtney Love greatly admired). By dressing in such provocative and subversively sexual clothing, she was both highlighting her femininity—and all of its supposed limitations—and taking advantage of it. Despite her well-founded protestations that it was unfair that a woman had to be beautiful to succeed in the public eye, Love understood that, well—a woman had to be beautiful, or at

least camera-friendly, to get her voice heard. As Hole commenced its bid for the top, Courtney asked her bandmate Eric Erlandson for the money to get her nose, long a source of adolescent insecurity, fixed. "I just didn't photograph well and I didn't feel confident. And I saw the cover of *Flipside* magazine, and I said Eric, we can sell four thousand or we can sell four million, it's totally up to you. You're the one with thirty grand, not me. And so, Eric Erlandson bought me my nose job."

Courtney's version of "Just a Girl" was decidedly darker: "Doll Parts" speaks to unfulfilled longing while the narrator breaks her body down into doll pieces, as if to defy her very human feelings of pain. The notion of dissociating from one's looks and body may have been informed by Love's stint as an exotic dancer in the 1980s but was likely exacerbated by the sense that she had to submit to conventional ideas of female beauty in order to upend them. Courtney's decision to wear Mary Janes was both intellectually complex and uncomplicatedly primal. When reporter Mark Seliger inquired about her Lolita-like getups in 1994, she swung from one direction to the other: "I would like to think—in my heart of hearts—that I'm changing some psychosexual aspects of rock music. . . . Then again—my friend Joe pointed this out to me—ever since he'd known me I had little baby teacups and blocks and toys. Maybe it had to do with never having patent-leather shoes. Never having gender-specific dolls. I absolutely insisted on taking ballet classes when I was young—which caused a big, big fight in our house. Nothing was gender specific."

Courtney was raised by hippies who listened to the Grateful Dead—her biological father even managed them for a brief spell—and who likely were influenced by the tenets of Second Wave feminism, which in 1964, when Courtney was born, was in the throes of a groundswell. But by the time *Live Through This* was climbing the

charts, a new brand of feminism had taken root that germinated in reaction to the beliefs of the Second Wave. Unlike the suffragettes and the women's libbers of the 1960s and 1970s, Third Wavers didn't have a specific political goal in mind, but instead took issue with more abstract, postmodern ideas like the construction of femininity in culture and how gender, as something separate from someone's biological sex, is created and perceived. Moreover, the women's movement had long been criticized as specific to upper-middle-class white women who, unlike poor and even middle-class African-American women who had worked all their lives, had the luxury of treating work as a privilege. Third Wavers aimed to accommodate ethnic and economic differences, and regarded some of the basic principles of the Second Wave to be dated. They considered talk of men as oppressors and women as oppressed to be unproductive, and even disempowering. One of the goals of the Third Wave was to take control of highly sexualized notions of femaleness and reclaim them; by *choosing* to wear makeup and high heels, for example, and doing it in full awareness of their cultural legacy, a woman could theoretically divest them of their ability to undermine—almost like acknowledging an unfriendly spirit in order to take away its menace.

Women who dressed in Kinderwhore styles aimed to do just that, and in some ways they weren't so different from an earlier generation of women who also wore Mary Janes. When the flappers rolled down their stockings and rouged their knees, it was to suggest that they were in control of their sex lives and could cavort with men without feeling used. Of course, some skeptics aren't sold on the idea of hypersexualization as empowering, believing that it simply reinforces the sense of women as sex objects, even if they're making a conscious decision to present themselves that way. Bata Shoe Museum curator Elizabeth Semmelhack draws a connection between the terrific

advances women made first with the Nineteenth Amendment, and then during the 1970s and 1980s in the workforce, and believes that in both cases, the fashion trends that almost immediately followed were a clear backlash: "I think there's a huge connection between flappers and girl power, or the Kinderwhore look and the hypersexualization of females, and I think it's interesting that those two things flare up after times of major advances by women. I think it's ultimately [fashion's way of saying] that no matter what you think you've achieved, your [looks are still the most important thing]."

As the decade progressed, the sociological aspects of women's looks and dress did in fact take a backseat to . . . looks and dress. In other words, the medium got stripped of the message. An era that began as anticorporate and anticelebrity did a veritable 180, beginning with low-fi garage rock and ending, somehow, with boy bands. The Mary Jane lost its subversive edge, launching one of the biggest names in the midmarket: Steve Madden. A Long Island native who took an after-school job at a shoe store during the heyday of the platform in the 1970s, he founded his eponymous footwear company in 1989 by selling samples out of his trunk while his doorman posed as his chauffeur. His shoes were affordable and trend conscious, and his big break was the "Mary Lou": a rounded Mary Jane that found a foothold with teenage girls.

Costume designer Mona May views the mid-1990s as "the breaking point," when "fashion was ready, and the kids were ready. . . . I think at that point we'd had enough of grunge." Though Kinderwhore was notable for its provocativeness, it wasn't particularly accessible for young girls, who either imitated male rock stars by wearing oversize ripped jeans, flannel shirts, and knit caps, or wore baby doll dresses

and barrettes, but without that original sense of confrontation and irony. Girls and boys alike paired their outfits with 1460s or Chuck Taylors, which had officially trickled down to mall level. When May received the call from writer-director Amy Heckerling to outfit *Clueless*, she was thrilled, because it meant she could marry her passion for costuming with her love of high fashion. "We wanted to counteract grunge and do something super girly and fun and European influenced," she recalls, not knowing at the time that the movie would initiate a major change of direction for fashion. In *Clueless*, May created a fantasy world where high school royalty dressed in an original blend of classic schoolgirl looks—oxford shirts and vests, plaid skirts, knee socks—and couture—feather-collared jackets, show-stopping hats, and Alaïa dresses. In many scenes, the protagonist, Cher (played by the charming and pretty Alicia Silverstone), wears Mary Janes, though in this case, the intrinsic youthfulness of the shoes was not intended to be provocative. In fact, May and Heckerling had the opposite objective in mind when they picked the footwear for the film. "In the fittings we tried different shoes," May remembers, "stilettos, platforms, and really the Mary Janes felt to us like the quintessentially youthful shoe. A shoe that a girl can wear, maybe even with a shorter miniskirt, and it keeps her very young, very sweet." She wanted the girls to look precocious—they were rich Beverly Hills teens, after all—but not sexual: "It was important to me that it wasn't slutty."

This emphasis on girly-ness shaped the candy-coated appearance of the film, which included calculated snapshots of grunge as real-world referents. When Tai—Cher's clueless disciple played by Brittany Murphy—first appears on-screen, she's wearing a typical early 1990s-era uniform, complete with a Kool-Aid red dye job. In what instantly became a classic speech, Cher even invokes the popu-

lar style of dress as one reason why she refuses to date high school boys: "So okay, I don't want to be a traitor to my generation and all but I don't get how guys dress today. I mean, come on, it looks like they just fell out of bed and put on some baggy pants and take their greasy hair—ew—and cover it up with a backward cap and like, we're expected to swoon? I don't think so." Apparently, audiences agreed. Soon after the film's release in July 1995, teenagers started giving themselves Cher-quality makeovers. Mona May delighted in seeing *Clueless*-style outfits on the street: "It was so cute to see girls everywhere . . . with the Mary Janes, with the over-the-knee stockings and the little plaid skirts. . . . It really was endearing to see the trend going back to being sweet, to being feminine again." This in turn influenced the high fashion designers: "It was crazy, [Karl] Lagerfeld had little phone carriers that we designed for the film in his runway show." It wasn't unusual to see schoolgirl-esque styles in the pages of *Vogue*. And as the fashions of *Clueless* captivated the nation, so did another, less innocent aspect of the movie: wealth. While Heckerling's treatment of West Coast–bred, head-in-the-sand high schoolers was very clearly tongue-in-cheek, it whetted an appetite for massages, fancy cars, and shopping, after dark years when the only thing more culturally tone-deaf than flashing a platinum American Express card was to use it to buy a Huey Lewis album.

Soon, gone were the days when a show like *My So-Called Life* would give each character a "closet" so that they could mimic the normal experience of owning a limited number of clothes. Once again, teens aspired to a *Clueless*-level fantasy world where—well before the ubiquity of the Internet in everyday life—girls could digitize their wardrobes and take Polaroids of their outfits rather than rely on mirrors. In the 1990s, the cultural relationship to money, celebrity, and gender was so fraught that when the O. J. Simpson trial introduced

buyers to high-end men's shoe brand Bruno Magli, sales skyrock-
eted, even though the defendant himself referred to them as "ugly-
ass shoes"—and allegedly wore them to commit a double murder.
Theoretically inflected Kinderwhore gave way to the phrase "girl
power" and the Spice Girls, who preached the values of female worth
and friendship . . . while wearing skintight bodysuits, miniskirts
with bikini tops, hot pants, and towering vinyl platform boots. Even
the schoolgirl look drifted from Mona May's original aim of "sweet-
ness" to something altogether less pure. In 1998, a sixteen-year-old
pop star debuted with a video in which she wore a white oxford shirt
tied to expose her belly, a pleated miniskirt, gray knee socks, and
black platform loafers. Britney Spears had pigtail braids and a face
full of makeup when she sang " . . . Baby One More Time," proving
she wasn't too young to have a broken heart. The same year, Hole re-
leased a follow-up to *Live Through This*, in which a sleeker Courtney
Love, recently nominated for a Golden Globe for her performance as
Althea Flynt in *The People vs. Larry Flynt*, confessed her love for her
new hometown: Los Angeles. Edginess was officially over. And soon
a new image of female power—in which money played a pivotal role—
captivated the world, cementing the relationship between women
and shoes in the new millennium.

16

Shoes
and the
Single Girl

(1998–2008)

In the classic fairy tale "The Elves and the Shoemaker," the brothers Grimm tell the story of a humble and kindhearted cobbler who finds his business in dire straits until a team of magical elves bail him out. Late at night, while the shoemaker and his wife are asleep, the elves appear in his workshop, turning what meager supplies he can afford into beautiful shoes that sell quickly come morning. Eventually the two use their new earnings to make clothes for the elves, who then disappear, leaving the shoemaker to tend to his thriving business, never to suffer the cruelties of poverty again.

In the new millennium, top-tier shoe designers experienced an updated version of unprecedentedly charmed success.

The latter-day elves were less hocus-pocus and considerably more Hollywood: Candace Bushnell, Darren Star, Sarah Jessica Parker, and Michael Patrick King. Together they worked on the HBO original series *Sex and the City*, which ran from 1998 to 2004, and turned one shoemaker—Manolo Blahnik—into a high-fashion deity. Since the Ossie Clark runway disaster of 1972 (when the models' rubber heels buckled), Blahnik had persistently built his business, banking on elegant, well-constructed shoes that are considered by his devotes to be as wearable as they are exquisite. After winning over the Studio 54 set, he gained the devotion of all sorts of wealthy, fashion-conscious women, from the upscale tastemakers—like Anna Piaggi, Grace Coddington, and Anna Wintour at *Vogue*—to those women of status who share their sartorial secrets with their equally well-heeled friends. He received the haute couture seal of approval, signing on for a runway collaboration with John Galliano at Dior in 1997.

In the late 1990s and early 2000s, Blahnik—a man with silver hair, Mediterranean olive skin, and crisply tailored suits—was unquestionably the patron saint of high fashion footwear. His sovereignty went unchallenged. Naomi Campbell called him "The Godfather of Sole" while Anna Wintour, in her introduction to a 2003 collection of his sketches, admitted that she "wear[s] no other shoes but his." By the time Candace Bushnell was writing her mid-1990s column in the *New York Observer*, women of her ilk—Upper East Siders—were already versed in all things Blahnik. "There are thousands, maybe tens of thousands of women like this in the city," Bushnell once wrote, referring to the class of single, self-sufficient women that she

belonged to, who were financially independent but still looking for love. "We all know lots of them, and we all agree they're great. They travel, they pay taxes, they'll spend four hundred dollars on a pair of Manolo Blahnik strappy sandals." The television show, based on a collection of Bushnell's columns, didn't introduce the shoes to this kind of women. Rather they introduced this kind of women, who could afford to be fluent in luxury footwear, to the average television viewer.

After that, Blahnik became a household name. "Manolos," as the shoes were affectionately nicknamed, became a shorthand for communicating not just a brand of shoes but also all of the information about a woman's status that goes along with wearing them. (For example, it was clear to the salespeople that the woman who walked into a store would be willing to spend—after all, she was wearing Manolos.) Buying a pair of $400+ shoes, once a birthright for a very particular class of women, turned into a rite of passage for anyone who aspired to be like Carrie from *Sex and the City*. It was a pricier form of drinking a cosmo, or eating a cupcake from the Magnolia Bakery; after the downtown dessert spot was featured in episode five of season three, viewers made pilgrimages to the West Village, lining up at all hours to try its confections. As the show's audience swelled to a high of roughly seven million viewers per week, it quickly became clear that whatever Carrie Bradshaw had, *Sex and the City*—philes wanted. And as for what *Carrie* wanted—the loves of her life were her friends, her clothes, and her shoes.

The series followed the stories of women whose twenties had come and gone without marriage, babies, and white picket fences. These

ladies, descendants of Erica Jong and Helen Gurley Brown, were focused on their careers and willing to indulge their sexuality without the promise of a ring—or even a monogamous relationship. Carrie Bradshaw was a new kind of role model, because she was thirty-three when the series premiered—almost past her ingénue prime according to traditional Tinseltown standards—and she was still single, living a life she'd created sans partner. As a well-known sex columnist and party girl, Carrie is a fictional socialite, the kind of freewheeling New Yorker who attends gallery and restaurant openings, blending work and pleasure in search of column topics and eligible bachelors. Wearing costume designer Patricia Field's outrageous high- and low-fashion outfits, Carrie was free to do whatever she pleased. She had little accountability: no family to hold her back, and no mouths to feed when she blew her paycheck on sandals. Though her ninety-eight-episode story arc centered on her search for Mr. Right (or in this case, Mr. Big), Carrie became, for many female viewers, the paragon of stylish fun and postfeminist freedom.

Sarah Jessica Parker's name was already well known by the time *Sex and the City* debuted, but at thirty-four, she hovered just shy of the type of full-blown celebrity status that would have distracted from her work on-screen. A former child actress who had once dated tabloid-ready men like Robert Downey Jr. and John F. Kennedy Jr., she married Matthew Broderick in 1997, and their low-key, drama-free union kept her clear of the gossip columns. With unconventional, perfectly imperfect good looks that served to endear, rather than alienate, female fans, Parker morphed seamlessly into the Bradshaw character, so that viewers imagined themselves spilling secrets with her over a round of drinks. The line between the fictional woman and the actress got so fuzzy that the Carrie Bradshaw/

Sex and the City brand preceded interest in Parker herself—a sign that the show quickly gained a cultlike status.[*]

"The City," of course, was New York—playground for the rich, the restless, the sybaritic, and the bohemian. For those living outside of Manhattan, the show's depiction of its endless supply of designer storefronts, upscale bars, and, of course, attractive singles made for a tantalizing faux-travelogue. For New York City natives, however, it was a badge of honor to ignore the series completely: "No one I know in New York watches *Sex and the City*," English transplant Rebecca Mead reported in the *Guardian* in 2001. "The show's viewers are entertained by what purports to be a sympathetic presentation of a demographic whose constituent members care about nothing more significant than their footwear." Indeed, that particular class of women's preoccupation with shoes, as depicted first in Candace Bushnell's column and then exaggerated for comedic effect on HBO, has a decidedly New York–centric pedigree. As award-winning costume designer Suttirat Larlarb observes: "In New York where we don't have cars, it's shoes and bags that are the status [items]. Whereas in LA, your car might show off your status, we spend so much time waiting on the subway platform, or at the bus stop, or walking, that shoes are the thing that flaunts your assets. It might not even be a conscious decision." To spend several hundred dollars on one pair of shoes—and to risk exposing them to the elements—is like driving a BMW in more ways than one: it depreciates as soon

[*] Of course, it wasn't long before SJP's own commercial power was fully exploited. "It's hard to define precisely when it was that the Carrie Bradshaw brand turned into the Sarah Jessica Parker brand, but that transition was definitely made," Vicki Woods wrote in a 2010 *Vogue* profile of the actress. By then, the onetime small-screen star had launched multiple perfume lines and was named chief creative officer of Halston.

as the key turns in the ignition the first time. To the untrained eye, high-ticket footwear simply looks glamorous, while the initiated mentally connect the shoe to the price tag.

Shoes provide touchstones throughout the series, as something not only light and pleasure filled but also extremely important to the protagonist. When Carrie hits her thirty-fifth birthday without a boyfriend or a husband on her arm, she goes shopping. "With no true soul mate," Parker (as Bradshaw) quipped in the show's weekly voice-over, "I spent the afternoon with my shoe soul mate, Manolo Blahnik." When Carrie is mugged in an incident that she believes to be karmic retribution for her behavior in her most recent relationship, her strappy sandals become a point of contention. "Give me your Blahniks," the gunman demands, and Carrie, shocked that he would ask for them by name, argues that they're her favorite pair; she got them half price at a sample sale. (Blahnik, though he claimed not to watch the series, was alerted to this specific episode and called it "so funny.") In the *Sex and the City* universe, Carrie's Manolos bolster her self-esteem not just because they make her look taller, leaner, and more attractive but also because they're evidence of her independence: she can use the money that she earns to treat herself. Never is this more apparent than in episode nine of season six, called "A Woman's Right to Shoes." In a story arc that has now become gospel for women who splurge on expensive footwear, the episode begins when Carrie, the poster girl for sassy singlehood, treks to yet another baby shower. New mommy Kyra (played by Tatum O'Neal) beams as she asks Carrie to remove her shoes upon entering her spotless apartment. Reluctantly, Carrie kicks off her silver, open-toed, stiletto-heeled Manolos, leaving them in a pile with the rest of the discarded footwear. Kyra is unsympathetic when Carrie's new shoes go missing and counters that she shouldn't have

to pay for her guest's "extravagant lifestyle" when Carrie reveals how much they cost, which is $485. At lunch, Carrie tells her friends she's been "shoe shamed," but then, over the course of the half hour, she comes to terms with her choices, material and otherwise. The shoes become a metaphor for standing up for oneself and feeling confident of one's own path. "The fact is, sometimes it's really hard to walk in a single woman's shoes," Carrie resolves, after righting the situation by sending Kyra an invitation to the marriage of Carrie Bradshaw to herself, and the gift registry is the Manolo Blahnik store. "That's why we need really special ones now and then to make the walk a little more fun."

"A Woman's Right to Shoes" first aired on August 17, 2003. By that time, *Sex and the City* was a full-blown phenomenon, and the "shoe thing"—the sense that women across age, race, class, and marital status take special pleasure in buying and wearing shoes—was so widely publicized that it had been positioned in the cultural vernacular as a fact. "*Sex and the City* introduced shoe obsession to a whole group of women who wouldn't have been into them other-wise," a selling specialist with fourteen years of experience working for a high-end department store confirms, having observed a shift in the clientele concurrent with the series' increase in popularity. As Carrie added to her collection, reporters investigated this so-called connection between women and shoes, reinforcing the idea that there was "a little bit of Imelda Marcos in every woman"—as the Fashion Institute Museum's curator Valerie Steele put it—or, if not the former first lady of the Philippines, then Cinderella, waiting for the shoe, in one way or another, to magically lure in a man. Shoes, which may have always been a casual source of camaraderie among women, became codified as such. In other words, whether or not women have long used shoes as a conversation starter (as in, "I like

your shoes!"), or even a wellspring of passionate bonding, there was suddenly, with the advent of *Sex and the City* and its rippling impact, an expectation that women love shoes and thus have this individual predilection in common with one another.

As *Sex and the City* glamorized the fabulous life of the single girl, the question of whether it is worth settling for something—or some*one*— less than ideal, just for the sake of having a man around, came up for discussion. In fact, some male viewers reacted negatively to the show, in part because though it glorified female friendships, it also tended to regard men as disposable (an attitude that the series actually winked at in episode six, season five, when Michiko Kakutani fictionally reviewed Carrie's newly published collection, based on her columns). However, it's no wonder that young women watching the show would respond to the foursome's extravagant lifestyles, in which shopping for men and shopping for shoes were treated with the same kind of breathless anticipation, as if the city were Bergdorf Goodman writ large. Bushnell herself confessed that her writing addressed a very real conflict playing out among her and her peers: "Before the 1980s," she told an audience at Stanford University, "women went to college to get their M.R.S.* and all of a sudden they began to get real diplomas and real careers. This led to a lot of changes in their relationships toward men and we ended up with a whole generation of really, really confused young people."

* A fictitious, and often disparaging, term used to describe the "degree" received by women who enrolled in college for the single-minded purpose of meeting their future husbands—the Miss Bradshaw who became *Mrs*. John James Preston by the end of her four years.

To Manolo Blahnik, powerful, hardworking women gravitate toward his shoes for their ability to deliver an instant uplift. "It's almost like when an actor puts on a costume," Blahnik has said of his creations. "It's theatre, it's an act of instant transformation. The woman who buys my shoes, she's exhausted all day, working, and then she puts on the shoes. I'm not a psychoanalyst. I always knew there was an element of desire in shoes. The quick fix is the high heel. . . . You put it on and you just have to walk." Along with his American CEO George Malkemus—who since 1982 has owned the North American and South American rights to Blahnik's name— the brand has grown into a $100 million empire that is still privately held. (Blahnik refers to his company as "a little family business.") When it comes to the design process, Blahnik is more than hands-on; asked "if he still gets his hands dirty when he visits his factory in Italy," he exclaimed, "Dirty! . . . Blood sometimes! They have these chain mail gloves to protect yourself. I cannot work with things like that, so sometimes it's dangerous. My hands are in such a state of corruption, destruction, they look like workers' hands."

Across stories about Manolo Blahnik, there's a sense of his monk-ish self-sacrifice for the greater purpose of his pristine shoes. The designer is celibate: "[Sex] is not my priority in life," he told jour-nalist Sarah Lyall in an article for the *Times* in 1998. "You see, some people just make sex paramount, but I don't think it's important at all, except maybe as a function, a release. Sex is utterly nonsense; it's in your mind, yes. I have an incredible sex life in my mind . . . but I don't really like to apply it to people. . . . I put everything I think is sexy into my shoes." And interestingly, despite the almost cartoon-ish explicitness of *Sex and the City*, as attention to the relationship between women and shoes heightened, a notable group got edged further and further out of the conversation: men. Luxury shoes, in

the narrative that emerged in the late 1990s and the early 2000s, were increasingly painted as a feminine indulgence: something that women coveted not to appeal to their partners but to please themselves. For all of the talk about the connection between high heels, sexuality, and male-dominated views of female attractiveness, men were increasingly sidelined as being everything from confused observers of this strange ladies' "sport" to beleaguered eye rollers, asked to hand over the credit cards. The language used to describe the feelings women have for their shoes took on the attitude of a love story. "If you want to know what sets fashionable women's hearts aflutter, just look at their feet," Anne-Marie Schiro wrote, reporting on the influx of luxury shoe storefronts in Midtown in 1998, including the Manolo Blahnik boutique's move from a small space on West Fifty-fifth Street to a five-story town house on West Fifty-fourth. "More even than clothes, shoes are the not-so-obscure objects of desire that cause many women to throw logic to the wind and succumb happily to temptation." Replace the word *shoes* with *rock stars* or *princes* and the sentiment—while less au courant at the time and significantly less politically correct—still stands.

Madonna called Manolos "as good as sex . . . and they last longer." In a 2007 *Time* magazine article called "Who Needs a Husband?" Tamala Edwards addresses the growing demographic of women who are "single by choice"; financially independent and emotionally self-satisfied, they are unwilling to take steps toward marriage unless the relationship feels exactly right. "Marriage is not what it used to be, getting stability or economic help," a representative from the National Marriage Project attested. "Marriage has become this spiritualized thing, with labels like 'best friend' and 'soul mate.'"

It's fair to assume, however, that of the more than 40 percent of adult women who were technically single in 2007—a number that

includes women who were cohabitating with lovers, either male or female—only a small percentage of them were living the lush life of Carrie and Co. One of the advantages and innovations of a television show that focuses on successful women in their midthirties to their early forties is that they are believably well off, and the idea that a lawyer, a PR maven, and a gallerist, all with no dependents, would be able to afford eating at trendy restaurants and buying $400 shoes isn't too much of a stretch. The series drew criticism because it was unlikely that Carrie, a weekly columnist, made enough money to support this lifestyle, and the writers acknowledged her questionable money management in season four—but this was one of the rare moments when the characters' finances were explicitly referenced. As a result, real-life single women who were less established in their careers tried to emulate the *Sex and the City* lifestyle, swiping their credit cards for pairs of Manolos. In her 2001 article "To Young Single Women, Thrift Is a Dowdy Virtue," Julie Flaherty reported, "Fifty-three percent of women [ages twenty-one to thirty-four] questioned [in a recent] nationwide [survey] . . . said they lived paycheck to paycheck, and three-fourths said it was important for them to look successful. Fifty-four percent said they were more likely to accumulate thirty pairs of shoes before accumulating $30,000 in retirement savings."

For a culture that's all too aware of what's lost when a woman passes her marrying prime without landing a husband, the show pointed out what might be gained: financial flexibility. For Carrie in particular, shoes represent all that her single, disposable income can buy her. She rewards herself for never choosing the wrong life, the wrong man. Instead, she chooses Manolo Blahnik.

In the show, the act of shoe shopping becomes an act of defiance, a declaration of individual empowerment. This fueled the great high-heeled debate: are vertiginous shoes accessories of female power, or are they something else—silly and unreasonable items that have been imposed on women by a male-dominated world? Valerie Steele believes that high heels are neither intrinsically "empowering nor disempowering," but by identifying how they'd like to spend their hard-earned money, women are now indulging themselves in a way that men have long felt entitled to do. "Americans in general tend to think that money spent on fashion is somehow wasted, while money spent on other consumer items which are entertaining—like watches or camera equipment or studio equipment—is somehow not also wasteful, even if you're just playing with them." She goes on: "There's a sense now that women have a right to spend money on themselves, and clearly what a lot of women have said is that they want shoes, and that they had a special relationship with them." Elizabeth Semmelhack continues the line of thought: "I was driving home from work once [listening to the radio], and a woman, a Microsoft executive, was describing the takeover of Yahoo dot com as like the acquisition of a pair of high heels. And I almost drove into a ditch! Wow—men have used these sports metaphors to explain business transactions since, I don't know, the dawn of time? And to hear this woman using a fashion slash consumption metaphor—not in a wry way—[made me wonder if] we are reaching some kind of equity." The women of *Sex and the City* hunt for shoes, and in doing so they make self-assured decisions about what they like and don't like, what they have earned and what they still feel they have to work toward. "What's interesting is that they didn't go for jewelry," Steele notes. "[But] jewelry is some-

thing that much more traditionally, men have bought for women. It's one thing to pay $500 for a pair of shoes—yes, you can make jokes that you could have bought an apartment with the money you've paid for your collection—but realistically if you're talking about very high-end jewelry, then you really need Mr. Big."

However, some critics felt that the series used ostensibly "empowered" rhetoric to conceal deep-seated conservatism at its heart: that no matter what, the true measure of a woman's success is whether she's found a man. The first *Sex and the City* movie further complicated the conversation. After Carrie and Big put in an offer on a new, sprawling apartment, the two decide to make their relationship official in a no-frills city hall marriage ceremony. However, as a soon-to-be bride, Carrie gets carried away and alienates the man, who after two failed marriages and years of commitment phobia, spooks at the thought of an opulent wedding and leaves her just shy of the altar. For the duration of the movie, Carrie tries to forget about Mr. Big until a pair of Manolos—the "Something Blue" pumps she intended to wear with her couture Vivienne Westwood bridal gown—brings the couple back together. Big proposes, and to seal the deal, he slips one of the shoes onto her foot, once again bringing into question whether the ultimate goal of wearing high heels is to attract a husband. (Or, as humorist Patricia Marx put it in a *New Yorker* article about fall 2008's shoe trends: "The victor, clutching her spoils—namely, a single left or right shoe—will then be approached by a fetching young salesman who will ask, 'Do you need a mate?' And perhaps this, as Cinderella knew all along, is what shoes are really about.") The blue satin pumps with a square crystal buckle saved Carrie and Big's relationship, and they certainly didn't hurt Manolo Blahnik, who claims those "stupid shoes"—a term of affection that he often uses to describe

his creations—which retailed for $895,* made 2008 a "very good year" for the company.

Sex and the City set a precedent that a popular television show could be a powerful trendsetting machine. It also alerted the footwear industry that with the right women providing an example, everyday buyers could be convinced to spend hundreds and hundreds of dollars on one pair of high-end shoes. In 1996, Jimmy Choo was a humble Malaysian cobbler with a small custom business, operating out of a shop in the London borough of Hackney. He was a second-generation shoemaker, and his skill and sense of discretion earned him his highest profile client, Princess Diana, who needed a steady stream of new, tasteful shoes to wear to her various appearances while married to Prince Charles. (Choo would supply her with a suitcase full of samples, which Prince Harry would obligingly carry back to the car for his mother.) At a rebellious seventeen years old, Sandra Choi, Choo's niece, who had grown up with her grandparents in Hong Kong, came to live with him. She applied to school to study fashion design but after working part-time for her uncle she eventually decided to drop out and commit full-time to his business. The pair established the Jimmy Choo brand in the fashion world, and it was in the pages of British *Vogue* where Tamara Yeardye, later known as Tamara Mellon, first spotted his shoes. Mellon—daughter of a former Chanel No. 5 model and entrepreneur Tom Yeardye, who made his fortune when he paired with friend Vidal Sassoon on his American hairstyling business—"had an obsession with shoes that

* Compared with $525 in the movie.

was extraordinary even by fashion magazine standards," her old boss, fashion director Sarajane Hoare, told *Vanity Fair.* She also had a bit of a drug and alcohol problem, and in 1995 she entered rehab.

Clean and sober six weeks later, and with a renewed sense of purpose, she wondered if she might be the right person to commercialize Jimmy Choo. She already had a good relationship with Choo and Choi from her time working as British *Vogue*'s accessories editor. More, Manolo Blahnik was virtually unchallenged in the women's luxury footwear market, and she could easily secure an investment; Tom Yeardye later joked that the $250,000 he initially forked over was strategic, given the money he was already spending on his wife's and daughter's shoe habits. When Mellon approached Choo and Choi, they were stunned and suggested she first spend some time working alongside them to get to know the industry. Mellon, whom Choi regarded as "a rich girl," was undeterred, and soon after making her bid, the new trio—Choo, Choi, and Mellon—was tasked with cranking out Jimmy Choo's first official collection.

But what had gone smoothly in Mellon's imagination instantly hit up against snags. Choo, who was painstakingly old-fashioned in his approach, was accustomed to working from samples, which he would then tweak to his clients' specifications. He wasn't trend focused; he got his start making shoes to wear with high-fashion clothes at a moment in English society when footwear was expected to match, rather than complement, an outfit. (In 2005, Michael Kors introduced American *Project Runway* audiences to the fashion world pejorative "dyed-to-match," used to describe head-to-toe looks that are—again in Kors's words—priggishly "matchy-matchy.") Choo struggled to design a collection, and Choi, who normally handled the more administrative aspects of the business, had to step in. It turned out that she was creatively gifted, and Mellon, breathing a

sigh of relief, set out to establish the next big luxury brand, hoping to surpass modest one-man shops like Blahnik's, and eventually to diversify in the mold of megalabel Gucci. As she promoted the business, Mellon envisioned a specific client: a hip, successful woman "with many occasions to wear high heels." In other words, a woman like herself. Quickly Mellon promoted a narrative that would help create a space for Jimmy Choo shoes in the footwear market; Manolos were stuffy, made for pinched, privileged mothers, while Choos were perfect for cutting-edge It Girls and jet-setters.

To Manolo Blahnik, however, Mellon and Choi—who are said to design in tandem—were too much talk and not enough innovation. (Choo himself, after winning Accessory Designer of the Year from the British Fashion Council in 2000, was bought out by Equinox Luxury Holdings for $25 million in 2001. It had been a contentious few years working alongside Mellon, and he left to resume his bespoke business. Choi remained in partnership with Mellon, causing friction between uncle and niece.) Blahnik believes that in their attempt to compete with him for the title of Top Cobbler, the ladies at Jimmy Choo have, on numerous occasions, edged uncomfortably close to plagiarizing his own work. No matter—whether or not their critics believed that Choi and Mellon were groundbreaking designers, the duo certainly understood how to promote the brand. To provide celebrities easy access to their shoes, they began renting a room at the Peninsula Beverly Hills hotel for the days prior to the Oscars, setting it up as a swanky salon where stylists, publicists, and It Girls themselves could come browse and borrow shoes for upcoming events. There are luncheons and preawards dinners for the stars to attend, but the real deal is obviously the red carpet, where actresses are filmed, photographed, and grilled about their outfits. "Most of the time," Dana Thomas writes in *Deluxe: How Luxury Lost Its Luster*,

"as Choi points out, no one can see the Choos underneath the long gowns. But every chance an actress gets, she'll mention to a television commentator or reporter that she's wearing Choos and give a little flash of ankle to prove it. . . . The morning after a red-carpet event, Choo, like all the other major luxury brands that dress stars, e-mails a press release to reporters around the globe that details who wore which Choo shoes, often with a red-carpet photo attached." Just a few years later, the E! network, known for its live-from-the-Oscars preshow specials, debuted its "shoe cam," which, like a 1940s film noir shot, scans each star's look from feet to face.

17

.

The Search
for Ruby Slippers

(2000–present)

May 24, 2000: New York

As overall shoe consciousness reached new, un-
precedented levels, a classic, covetable pump
appeared back on the scene. On a spring morn-
ing in Midtown, a pair of authentic ruby slippers
went up for auction at Christie's East in New York:
the ones originally owned by Memphis-based
contest winner Roberta Jeffries Bauman since
the 1940s, until she let them go in the late 1980s. Her pair was about
to change hands for the second time, but another set of slippers was
safely ensconced in public view. In 1979, the anonymous bidder who
bought his ruby slippers at the MGM auction donated them to the

Smithsonian Museum in Washington, D.C., where they continue to sparkle in the *Icons of American Culture* exhibition, alongside Kermit the Frog, Oscar the Grouch, Jack Dempsey's and Joe Louis's boxing gloves, and Apolo Ohno's speed skates. Displayed in a Plexiglas case against a piece of the original yellow brick road, they're positioned to be the first thing one sees upon entering the room, and visitors come to pay homage to Dorothy's shoes in such incredible numbers that the patch of carpet in front of them has been replaced several times.

Thanks to Kent Warner's discovery of multiple sets of Dorothy's shoes in the MGM warehouses back in the 1970s, there are four pairs of "original" ruby slippers floating through the annals of the collecting world, with rumors of more being peddled in the underground circuit. The morning of the Christie's auction, David Elkouby—a Los Angeles native whose impressive private memorabilia collection fills five thousand square feet of warehouse space, and includes Batman's and Robin's costumes from the 1960s television show, Charlton Heston's robes from *The Ten Commandments*, and a fair share of Marilyn Monroe's costumes—arrived in New York with modest expectations. Among the scores of collectors and enthusiasts, he registered for his paddle. "Someone at the auction had said that, supposedly, Bill Gates was on the phone," he says of that day, "and if Bill Gates was on the phone, we had no chance." The bidding, a mesmerizing, repetitive rumble, commenced, and potential buyers no longer concerned themselves with eyeballing the competition. The gavel fell in Elkouby's favor, which to him felt like a stroke of dumb luck: "For whatever reason [at auctions]—and I have to say, it's happened a couple of times—you're sitting there in the audience, and you're looking at something, and you blank for a second, and that's what happened to this person on the phone! And then they're like, OK, sold, and pow, we got them! And I never thought we were gonna get 'em. I really—I thought, we didn't have a shot. And it worked out."

David Elkouby and his partners won the shoes for a final purchase price of $666,000: a fantastical amount to a disinterested party, but appropriate, if not a bargain, to those invested in the ruby slippers' legend. The ruby slippers "are the Holy Grail of prop collecting," Elkouby explains, while Michael Siewart, owner of the largest private collection of Judy Garland memorabilia and proprietor of JudyGarland.com, compares the ruby slippers to "a rare jewel," that harks back to a different, more innocent time, before issues in politics and religion became so relentlessly divisive. Cathy Elkies, senior vice president at Christie's New York and director of Iconic Collections, maintains that in the scheme of Hollywood props, the only ones to come close to the ruby slippers' historical and sentimental value would be Rosebud—the sled from *Citizen Kane*—and the Maltese falcon: both pieces that, like the slippers, function in classic films as pivotal plot points. Dorothy's shoes, she says, "are one of the most recognizable symbols of film history, and [given] their value—which obviously has gone up over the years—it doesn't mean that just anybody can play." In other words, not every film buff and *Wizard of Oz* enthusiast has three-quarters of a million dollars lying around to purchase his or her own pair of ruby slippers. The higher the price they command at auction, the more special and celebrated they seem.

And celebrated they are: In 2008, a group of the world's most respected footwear designers like Manolo Blahnik, Christian Louboutin, Roger Vivier, Sergio Rossi, Stuart Weitzman, and Jimmy Choo submitted one-of-a-kind updated versions of the ruby slippers, to be exhibited at Saks Fifth Avenue during Fall Fashion Week and then to be auctioned for the benefit of the Elizabeth Glaser Pediatric AIDS Foundation. The lot garnered $25,000 at a *Wizard of Oz* seventieth anniversary party hosted at Manhattan's Tavern on the Green. There

are Web sites, Facebook pages, fan clubs, and even eBay stores devoted to Dorothy's shoes—all signs that ruby slippers fever isn't anywhere near breaking.

Elkouby is banking on that momentum. He's a businessman: a collector who is not only passionate about Hollywood memorabilia but also a realist who understands that the ruby slippers, like a competitive piece of real estate, should ultimately yield a considerable profit. He claims that he'd like to display them one day, but for the moment they're locked away in a vault, exhibited once a year to the insurance company representatives who come to check up on their own risky bet. If the past is to be trusted, Elkouby and his partners will have no trouble recovering the amount they paid and then some, which is impressive, given that the slippers, unlike a sturdy highrise, weren't built to last, and they aren't getting any younger. That said, the cultural connection to the ruby slippers has never been entirely rational. There's the growing fetishization of "old Hollywood glamour" and the sense that Judy Garland's legacy becomes more powerful with each passing day. And then there's the magic of shoes in general, defined in fairy tales of yesteryear and constantly adapting to fit our shifting values. Even if the ruby slippers turn dusty and dull, shoes continue to shimmer in the collective imagination. As more footwear options present themselves—in stores, online, on blogs, in the streets—the search continues for that perfect, transformative pair that, when slipped onto a worthy foot, will bring out the very best in the wearer.

Just as the real-life ruby slippers did, that perfect, aspirational pair continued to get more expensive. The new millennium—up until the Wall Street crash of 2008, anyway—saw an economic boom that en-

abled the triumph of an ubiquitous celebrity culture, in which stars turned into walking, talking commercials for their favorite brands. As consumers, with the help of the Internet, became increasingly knowledgeable about fashion, It Girls like Kate Moss, Sienna Miller, Mary-Kate and Ashley Olsen, Blake Lively, and Alexa Chung could change a designer's fortunes just by mentioning his or her name. While the couture runways have long been the stomping ground of the elite, virtual access to the shows via style Web sites has demystified the fashion world, democratizing it in an altogether new way. Though in most cases designer price tags remain prohibitive, accessories like shoes offer an entry point, so that average buyers don't feel like they're on the outside, just pressing their faces up against the window. A couture gown will likely always be out of the question, but one can imagine saving up for a pair of high-end strappy sandals.

This past decade saw the meteoric rise of Paris Hilton: a young woman (with a little dog too) set to inherit an estimated $30 million of her family's hotel fortune, and who made no apologies for her sense of entitlement. "There's nobody in the world like me," Paris announced in 2006. "I think every decade has an iconic blonde—like Marilyn Monroe or Princess Diana—and right now, I am that icon." Elliot Mintz, her onetime publicist, described Paris's inimitable quality as "the light," suggesting that the public was merely picking up on something intrinsically and objectively spectacular about her. Light notwithstanding, she also arrived on the scene at a time when her uninhibited lifestyle—both economically and otherwise— was particularly appealing to her fans. Paris admitted that she had trouble buying high-end shoes, but not because she couldn't afford them: "I desperately hate one thing about my body. I have size 11 feet. Yeah, it sucks, because I see all these super cute shoes in the stores: Guccis, YSLs, Manolos. And when they bring them out in my

size, they look like clown shoes." Of course, that didn't stop her from walking into Patricia Field's boutique in New York City, eyeing a pair of $1,000 pumps, and then convincing the saleswoman to give her the shoes—which she could obviously afford—gratis, "because once I wear them, you know that they are going to be in all the magazines and everyone is going to write about them."

In 2008, trend forecaster Irma Zandl affirmed that marketing had become increasingly celebrity driven and that consumers gravitate toward brands that their favorite stars endorse. Endorsements can be formal—the star is paid to be a spokesperson for a brand or, as a thank-you to a designer for allowing her to borrow or even keep an article of clothing, she makes explicit reference to their name on the red carpet or in an interview—or informal, which can mean anything from her character wearing a certain brand on-screen, to being photographed on the street wearing an item that she has purchased or been gifted by the designer in the hopes of increasing the brand's visibility. In the late twentieth and early twenty-first centuries, a trend in magazines such as *InStyle* emerged to dissect celebrity outfits, thus increasing readers' fashion fluency and consciousness. The Internet makes it even easier for enthusiasts to engage in a *what was she wearing?*—style dialogue. Suttirat Larlarb, who costumed the colorful, Bollywood-themed film *Slumdog Millionaire*, recalls that "after *Slumdog*, I got an e-mail from somebody asking me if I would answer this question for a magazine, which was trying to track down items from films that their readers were interested in buying for themselves, like the yellow scarf [that Freida Pinto's character Latika] wears at the end. And I wrote back saying, 'Well, actually, we designed it for the film, it was made by hand, so I don't know!' When the print issue came out, I saw they had used my response, which was basically that it was one of a kind, but here are my suggestions for

similar things. And when I went online, there was a whole spread of people saying, well, *I saw this at Pier 1 imports, and maybe you could do this, and I saw this at the Tahari shop,* and all these people trying to help track down look-alike scarves, which I thought was quite interesting." College friends Hilary Rosenman and Barry Budin, who started their shoe company Madison Harding back in 2007, learned the power of celebrity firsthand after Lindsay Lohan—who was still something of a role model at the time—was photographed wearing their fringed flat sandals. They had been struggling to get their name out, but after *InStyle* and *People* magazines ran photographs of the redheaded starlet in their shoes, they sold out their collection to Nordstrom.

No designer has benefited more from the rise of celebrity culture than the current grand *homme* of the contemporary luxury shoe market: Christian Louboutin. It's the name on every wide-eyed starlet's lips. If the ladies at Jimmy Choo proved there was room at the top alongside Blahnik, French designer Louboutin swept in with his $700 heels, raising the bar for exclusivity, opulence, and cutting-edge cachet. As Manolos, thanks to *Sex and the City*, became increasingly popular (and therefore common), Louboutins filled the void for the latest It shoe that fell painfully—yet tantalizingly—outside of the average woman's economic reach. Unlike Mellon and Choi, Louboutin rarely gave his shoes away for free, yet his sky-high platform pumps with a signature ruby red sole were wholeheartedly embraced by the kind of trendsetters that other designers have to chase: Naomi Campbell, Lady Gaga, Mary-Kate and Ashley Olsen, Angelina Jolie. Jennifer Lopez likes his shoes so much that she released a 2009 single, in anticipation of her upcoming *Love?* album, called

"Louboutins," in which a mistress gets fed up and steps into her Louboutins, a metaphor for mustering the strength and confidence to leave a cheating man. And in 2010, the unthinkable happened: the *Sex and the City* franchise shifted its allegiance to Christian Louboutin for the sequel to the first full-length feature, kissing good-bye to Blahnik, who had served over ten years as Carrie Bradshaw's faithful stiletto supplier.

Mary-Kate Olsen told journalist Vanessa Grigoriadis that Louboutin reminded her of the quintessential fairy-tale cobbler: "When I was on the set of *Full House*, my favorite story was the Grimms' fairy tale about a poor shoemaker . . . and when you meet Christian, you realize a man like that really exists." Louboutin's own origins are modest yet charmed: he was raised in a working-class neighborhood in Paris with his four sisters, his doting mother, and detached father, and remembers becoming interested in women's shoes after he spotted a sign with an *X*'d-out stiletto in front of the Musée National des Arts d'Afrique et d'Océanie (spike heels damaged the museum's floors). He received a book about Roger Vivier as a gift, and in pursuit of this new passion approached couture houses until, at age sixteen, he was offered an apprenticeship at the Charles Jourdan* factory in Nice by Dior. Soon he was helping curate a museum retrospective for his idol, Roger Vivier, who was in his seventies at the time. "It was like an angel looked down on me," he has said. He opened his Paris shop in 1991. The blueprints for Louboutin's early career may have been written in the stars, but today, the bald-headed designer with

* An innovative French designer who had opened his own women's boutique in 1957, Jourdan began manufacturing and distributing shoes under the Dior label in 1959. He passed away in 1976, but his three sons remained at the helm of the business.

an impish grin is attended by an altogether different band of angels: the women who, at the height of a global recession, gladly paid $6,295 for a pair of limited-edition embroidered "Marie Antoinette" pumps. At least part of the reason why wealthy women clamor for his shoes is that as a designer, Louboutin is a bit of a throwback. He owns his own shop, consistently rejecting bids for the business, and designs each and every one of his shoes (which isn't true at larger houses like Yves Saint Laurent and Dior, where young artists toil under an umbrella label). He doesn't advertise but is aware that for many of his clients, his shoes represent a substantial purchase, so he's willing to put in face time with them by way of in-store appearances and private parties.

Also, the significance of the red sole can't be underestimated. Whereas spotting a Manolo Blahnik or Jimmy Choo (or Nicholas Kirkwood or Pierre Hardy or Loeffler Randall) requires a trained eye, identifying a Louboutin takes just a smidge of pop-culture consciousness. Therefore, almost everyone who walks behind a woman wearing Louboutins will be able to recognize them, associate the shoes with their three- to four-digit price tag, and thus venture to guess at the weight of the wearer's wallet. "The red sole was absolutely genius," proclaims Valerie Steele, who makes the point in her book *Shoes: A Lexicon of Style* that it harks back to "Roman courtesans [who] sometimes had the soles of their sandals engraved so that their footprints read 'Follow me.'" That invitation was clearly sexual, but there's also historical precedent for soles that convey information about status; in the nineteenth century, Sioux who had the advantage of riding on horseback intricately beaded the soles of their moccasins, which would be visible to those less powerful tribesmen traipsing below. However, Louboutin cites neither example when he describes his eureka moment, which journalists recount in two ver-

sions. In the first, a posh couple enters his Paris shop, exactly the kind of people the designer would like to sell to. They appear interested, but then the man lifts a shoe to examine it and, upon flipping it over to look at the sole, replaces it on the shelf in haste. The couple leaves without buying anything, and Louboutin is determined to make his soles more remarkable. In the second story, Louboutin spotted an assistant painting her nails with red polish and imagined how beautiful a varnished coating would look on the underside of his shoes.

Regardless, his choice of red—instead of green or gold, for instance—has distinct erotic appeal. Louboutin told *Vanity Fair* that the red soles are "a green light," and it's clear the sexual implications of his footwear aren't lost on him: "Half of my women want a shoe to make them look a little tarty, and the other half are big tarts who want a shoe that looks classy. . . . I think in both cases the shoe completes the woman, gives them the element they don't have in themselves." Blahnik has been known to speak of his creations in a similar way, pointing out that his shoes bring something valuable to the wearer. And if she tries on a pair and doesn't recognize the transformation? "If you don't see the magic," he told the *Guardian*, "stick to Reeboks." The idea being promoted is that Louboutin's red-soled, towering shoes—or Blahnik's elegant stilettos—are like contemporary ruby slippers, poised to bring out the best in a woman. That is—if she's willing to embrace her full potential. If not, she can keep her hard-earned $700 and buy shoes that might make her feel pretty, but won't—to speak in magazine copy—unleash the goddess.

In September 2010, a London *Telegraph* article reported on a study done at Northumbria University, in which men were asked to identify

whether or not a woman is wearing heels based on her walk. Preliminary results showed that they could not tell the difference. The study made headlines, but despite reports that "men don't notice women in high heels," Manolo Blahnik begs to differ. "It's the height [of the shoes] that gives women that sexy rhythm when they walk—and that's what men love most. . . . Anyone who says men [don't notice] must be out of their mind: the first thing that men look at are a woman's legs, and there is nothing more flattering than high heels. The male reaction to heels is half normal and half perversion, but some men tell me I've saved their marriage."

Still—if men notice a woman in high heels, the implication is that it's mostly because of the physical effect the shoes have on her body, and not necessarily the design of the shoes themselves. Therefore it stands to reason that if a woman walks confidently in a pair of $70 pumps, they are just as valuable as the $700 ones when it comes to catching a man's eye. So why buy the Christian Louboutins when Steve Madden is selling similarly proportioned shoes at a fraction of the price? It could be that women are actually dressing to impress one another: their friends and neighbors who also read fashion magazines and style blogs, and who are knowledgeable enough about designers to recognize the difference between a five-inch Chinese Laundry platform pump and the real-deal Jimmy Choo. Luxury shoes are made in Italy, and mass market ones are made in China; the differences in quality are genuine, and it's often women, not men, who can discern them, particularly because they themselves know how it feels to walk in cheap versus expensive shoes. There's a competitive aspect to dressing—flaunting one's fit body or announcing one's economic status—but there's also a sense of community that materializes around women who pay attention to trends. Melissa O'Shea, who founded the shoe club Hello Stiletto in 2004, explains that well-shod

women enjoy the respect of their peers, who never fail to comment on an eye-catching pair. A Boston native, she started the club after living in London for a spell, where she often had reason to step out in her finest footwear. O'Shea organized a shoe-themed night with her girlfriends, and after it caught on by word of mouth in her hometown, she took Hello Stiletto online. The press paid attention, and by 2010, the club had grown to over 10,000 members.

These days, there are endless resources for the Web-savvy shoe enthusiast, from Sea of Shoes, a popular blog maintained by a teenage Texan with a high-fashion footwear collection, to the *Shoe Goddess*, an online shoe magazine founded by Florence Azria, wife of designer Serge Azria and an active philanthropist. In December 2007, the century-old shoe company H. H. Brown founded another online shoe magazine called *Running with Heels*, which features footwear-friendly content as well as lifestyle advice. (H. H. Brown keeps its affiliation very low-key but benefits from overall shoe consciousness and features its brands in periodic giveaways.) Traditional tastemakers like *Vogue* and *Elle* have expanded online, but the Internet has also given rise to amateur style bloggers: nonexperts who post photos of their outfits and offer style-related guidance. This has been a boon for affordable, youth-oriented footwear brands like Jeffrey Campbell, Surface to Air, Seychelles, and 80%20, which have all benefited from informal endorsements by the hip, trendy girls who have become role models to women who can afford only so-called fast fashion, from global powerhouses like H&M, Forever 21, Topshop, and Zara. In 2009, the Federal Trade Commission decreed that bloggers would be subject to restrictions regarding endorsements and testimonials, forcing them "to disclose the material connections they share with the seller of the product or service," with an imposed fine of up to $11,000 per post. Before the FTC ruling,

bloggers had become powerful enough that they were receiving free samples from shoe and clothing companies. In some cases, bloggers would then feature these items as if they'd been plucked from their own closets. Journalistic ethics aside—some bloggers have complained that the FTC's decision unfairly targets them, as fashion magazines don't pay for the clothes, accessories, and products they use in print—the Internet has raised our collective style consciousness and provides readers with new ways to make choices about what they want to wear. There has also been an influx of street style photo-chroniclers, in the mold of Bill Cunningham, who has combed the streets of New York on his bicycle in search of chic city-dwellers for the *New York Times* for the better part of three decades. Camping out next to the tents at global fashion weeks, as well as at other stylish haunts in major cities, these ad hoc photojournalists chronicle metropolitan fashion and in doing so, ensure that cutting-edge looks quickly spread to places where fashion is less accessible. To Lisa Mayock, who is one half of the celebrated design duo behind Vena Cava and Viva Vena, all of this represents a "fantastic" step toward the democratization of fashion, in that the abundance of information online forces people to make decisions about what they like and what they don't. She describes the rise of the nonexpert blogger as "parallel to CNN," because punditry isn't necessarily fact based, and the twenty-four-hour news cycle provides an almost infinite amount of space to be filled.

As the fashion world becomes more democratic, the midmarket—the area of the footwear industry devoted to fashionable, affordable, and often disposable shoes—has been able to thrive. A sector once dominated by Nine West and Steve Madden, it's growing rapidly,

thanks to the emergence of the "cool girl" client who can't afford to wear Manolo Blahniks or Christian Louboutins every day but is fashion fluent and demands high-trend, accessibly priced footwear. Today the midmarket is dominated by the Los Angeles–based company Jeffrey Campbell: a seven-person team that consistently puts out collections featuring more than four hundred distinct styles, that run the gamut from sensible jazz flats to six-inch-high studded platform sandals. Campbell started his career in the stockroom at Nordstrom, then moved up quickly to brand representative: "He's a trend forecaster—so he always would pick up a brand early," branding expert Ty McBride, who worked with Campbell for seven years, explains. Eventually Campbell realized that if he "[knew] the trends and knew the [footwear] market—which he did—and he knew production and he knew sales," then creating his own shoe company could be an "evolutionary" career step.

Campbell started the company out of his garage, and it was a struggle to support his wife and three children while laying the groundwork for the first collection. He waited tables, and the family held tight while they patiently awaited revenue. "With a shoe collection it takes a minimum of six months [to see any income]. You show your first collection, you get orders, you produce it, you deliver it, and they usually want thirty-day to sixty-day terms on payment from a new vendor," McBride explains. Still, Campbell received enough orders after showing his first collection to keep the business afloat. After that, he steadily—and patiently—built the Jeffrey Campbell name, selling his shoes from more and more locations. "He is obsessed with shoes, almost in a way that it haunts him," McBride attests. "And I think when you're midmarket like he is, there's always that fear that one season you're gonna have a bad season, and the next season you'll do OK but if you aren't back on it [the cool girl client]

is not gonna want you. That's really scary. He doesn't think that he's Manolo Blahnik, he doesn't think that he's Giuseppe [Zanotti]—those people are going to have shoe careers. They're legendary. He knows what we sell is disposable, it's high trend, and it's quick turn-over. I think that there's this underlying fear if you want to be the top at midmarket, because it's fast."

Campbell, with the help of McBride, reached that apex at an un-likely time. In 2008, after stepping up the company's online pres-ence, McBride recalls that "there were three things that coincided: we launched our site, blogs and blog relations got big, and the econ-omy went to shit. When the economy went bad, Jeffrey and I had a dinner meeting, and he was [worried]. And I was like, well, we have a lot of momentum right now, we're coming off of two great seasons, I think our competitors are going to produce a lot of black flats and black jazz shoes. And I said: I think we should just bump it up. I think we should give [the client] something to shop for. All my friends that wear 40 percent vintage shoes, 40 percent Jeffrey Campbell–like brands, and 20 percent designer—they weren't rebuying their basics. They were getting them repaired, and then saving up for a new Marc [Jacobs], or something they didn't have when they were going to a wedding, gonna see an ex, going out—whatever. So we took the 'Mel' sandal—it's covered in chains, diamond, and pyramid studs, and it's all straps—and pushed it. It weighed so much, it was inspired from a runway trend, and it blew up. It hit the blogs."

The decision to lead with outrageous shoes at the height of a re-cession turned out to be prescient. Following the financial fallout, warrioresque shoes with five-inch-tall needle-thin heels, high-angle wedges, metal studs, straps, and buckles started to fly off the shelves. These kinds of shoes commanded attention, especially at a time when skinny jeans and leggings were so trendy, and allowed for

head-to-toe looks to be footwear-centric. Valerie Steele opined that heels have reached new heights in the past few years "because they could! Fashion always goes to the highest extreme—skirts went as high as they could and then they went down again, and the second time around they went higher. It was the same with heels. When they figured out ways to make them higher, and people went for it, and could train themselves to walk in them, then they went as high as possible. If [designers] could come up with some other invention that will make it possible to have them even higher, they will."

Steele doesn't buy into the much-bandied economic correlation between the heights of heels and hemlines, nor does she feel the recent bust affected footwear styles. Elizabeth Semmelhack has a different take, prompted by curiosity about the emergence of the vertiginous wedge during the Great Depression. To her, the fact that very high shoes came into fashion first after Black Tuesday, and then again after the Vietnam War and the oil crisis in the 1970s, and then *again* after the dot-com bust in the 1990s, is too consistent a fashion cycle to dismiss as mere coincidence.

"Maybe it has to do with the fact that people want greater gender dimorphism between men and women [at times of economic stress]," she conjectures. "Maybe it is that the haves want to really make sure that everyone knows they're the haves. Maybe it is that women are buying less [clothing] and they're willing to invest something more in a pair of literally uplifting shoes."

To Ce Ce Chin, shoe designer and founder of the brand 80%20, appealing to women in the new millennium is less about the particulars of each footwear style, and more about seeing into a woman's soul, in the spirit of Ferragamo: "Where does this girl want to be in her life and how is she going to get there? How can our shoes literally help take her there?" Although outrageous, highly editorial shoes—

like Alexander McQueen's otherworldly armadillo platforms—had a powerful recession-era stint in the limelight, we've reached the age of great variety, when shoes are as diverse as the women who wear them. Now, for every bestselling extremely studded sandal, there's a philanthropically inflected TOMS canvas slip-on that's equally successful. In the first decade of the 2000s, the relationship between women and shoes was cemented, when footwear—in an unprecedented array of colors, styles, and shapes—became synonymous with women's personal agency. *I want shoes, I deserve shoes, and I'm going to buy them for myself*—this was a fresh and overwhelmingly prevalent point of view. Just like the ruby slippers before them, today's shoes are symbolic of the wearer's hopes and dreams. Be it wealth, fame, career success, or a happy marriage, the nature of the goal itself is less important than identifying the heart's deepest desire and—without question, fear, or apology—going out to get it.

AUTHOR'S NOTE

· · · · · · · · · · ·

In August 2010, when I was in the thick of the writing process, my then-boyfriend (now husband) and I took a road trip to Toronto to visit the Bata Shoe Museum. We thought driving, rather than flying, would be romantic, and it was—we passed sprawling upstate farms dotted with cows and wind turbines, and bought fresh-picked "Airloom" tomatoes from a roadside stand. We stopped at the American side of Niagara Falls and took cheesy pictures against the backdrop of spraying water. Unfortunately, when we reached the border, our sunglasses-wearing customs agent was unimpressed with our decision to embark on a daylong drive, and he barked questions at us, the most accusatory being *why didn't you just take an airplane?*

Only two days later, we looped back toward the border. I'd logged an interview with the museum's brilliant senior curator, Elizabeth

Semmelhack, and we'd peeked at the Canadian side of the falls to see how it compares (frankly, it blows ours away). I was relaxed, sun-kissed, happy. Yet I felt my shoulders tense as we waited our turn to slide through customs. This time the agent was a petite young woman with a ponytail, roughly my age.

"What business did you have in Canada?" she asked sharply as she examined our passports. My boyfriend, in the driver's seat, motioned to me.

I told her I came to visit the shoe museum in Toronto.

Her ears perked up. "There's a shoe museum?" she asked.

"Yes," I told her. "I interviewed the senior curator for a book I'm writing."

"On what?"

"On the history of shoes."

Instantly, her demeanor changed. A huge smile spread across her face. "You are?!? That's so cool. I want to read it!" After grilling me—in the notably different attitude of an acquaintance rather than a cop—about the book's title and when it would be published, she waved us through, and I giggled to myself, thinking once again how amazing it is that just the mention of shoes can form a bridge between two women, and breach even the most uncomfortable, impersonal circumstances.

More often than not when my research comes up in conversation, it sparks a discussion about the other person's shoe collection—or, if the raconteur is male, his daughter's, his girlfriend's, or his wife's. These stories often include a self-deprecating invocation of "Imelda," and end with a kind of bemused shrug, as if to say, *I just love 'em, I don't know why.* When I started working on this book, I had a specific question in mind: what is that *thing* between women and shoes? There was evidence of it everywhere, which only became more acute as my report-

ing progressed. Ultimately I came to an answer not only by digging up these historical stories and searching for their meanings but also via my own relationship to shoes, which has changed dramatically since I started this project. I would describe these past few years as a coming-into-consciousness about my own very real shoe obsession. In retrospect, it had been latent since my childhood, but I've gone public as an out-and-out shoe lover only within the past few years.

I had an image of a real shoe person stuck in my head: she was the girl I met at a party once, who sheepishly admitted that her e-mail address was Shoe_Obsessed@blank.com, or she was Carrie Bradshaw, a woman who cut deep slices into her paycheck in order to be the proud owner of a museum-quality closet full of pristine Manolo Blahniks or Jimmy Choos. She couldn't possibly have been a regular twentysomething living in Brooklyn, tripping over the rows and rows of boots that lined the walls of her bedroom—cowboy-inspired boots, boots with buckles, boots with pointy toes, knee-high ones with laces, and ankle-high versions with zippers. I had so many pairs that my boyfriend embraced them as a decorating choice, and guests, upon seeing my apartment for the first time, often couldn't help making a comment. I didn't necessarily wear them all, but every time I tried to cull the herd, I experienced a strange shock of separation anxiety, as if I'd been asked to break off infrequent—yet revitalizing—contact with a distant friend.

Looking back, it's a fixation that began early in my childhood, when I preferred fire-engine red high-top Reeboks and teeny-tiny Caterpillar work boots to pink patent leather Mary Janes. But it reached new heights in 1993, when I borrowed a friend's pair of one-size-too-small matte black eight-hole Doc Martens 1460s and wore them with everything: leggings, jeans, miniskirts, denim cutoff shorts, and even the crushed velvet spaghetti-strapped dresses

that I slipped on to attend bar and bat mitzvahs almost every Saturday. I adored them: the way the leather smelled, the way the uppers felt loose but also sturdy around my ankles, the way the bouncing soles molded to my instep. I was a bookish, shy adolescent, and like nothing else in my life at the time, they made me feel so *tough*—like maybe, if given the right opportunity, I could steal a kiss from Kurt Cobain or, at the very least, convince him to pull me onstage to sing backup at a Nirvana concert.

Turning my eye to more attainable goals, I managed to convince my mother to buy me my own pair of properly fitting 1460s for Christmas that year, and after that, I was hooked; I asked for oxblood Doc Martens Mary Janes for my fourteenth birthday, and a few years later, when grunge had become a distant memory, for the aggressively tall twenty-eye version, which took a corresponding twenty minutes to lace. I proudly walked around in them at a time when most girls in my high school were pairing skintight black pants with Steve Madden platforms. I loved my clunky, steel-toed, ass-kicking shoes so much that when I grew older, and embraced a wider spectrum of femininity, I held on to them like a time capsule meant to capture a critical juncture in my development: relics of a younger, less conventional self.

When looking back at these moments I began to really understand what it is about shoes that makes them so beloved. They provide an incomparable opportunity for self-expression; they allow the wearer to define herself, and then to communicate that information to the world. There's no greater feeling than knowing exactly who you are, or perhaps, who you want to be, at any given moment, and then feeling confident that your choices are your own. Shoes, in an easy, nonconfrontational, and—I should note—a nonrevolutionary way, give us that chance every time we get dressed in the morn-

ing. They're unique from the rest of one's wardrobe because clothing choices are still, by and large, dictated by dress codes and social mores, but footwear—with the wide array of perfectly acceptable options available—allows for a flash of personality even in the most inflexible of environments.

Shoes allow a teenage girl to play at making statements about who she is, before she grows up and has to make bigger, more lasting decisions with decidedly higher stakes. I was lucky enough not only to have parents who honored self-expression but also to be born at a time when the world valued social variety over conformity. Writing this book has made me feel extraordinarily blessed to be living in this current era, in a culture that acknowledges that not every woman wants to wear the same shoes or, for that matter, wants to live the same life. Trends will come and go, but I strongly believe that we'll never revert to a landscape where only one or two styles of footwear are considered appropriate (not least because it's much more profitable for manufacturers if most consumers aspire to owning a multifaceted shoe collection).

As I write this, the shoes of my teenage years are pushing their way back into fashion: lace-up boots, but also Birkenstocks, flatforms, creepers, and clogs—styles that had already been recycled once before when they cropped up again in the 1990s. This tells me that the initial reactionary moment that followed the 2008 recession, when women began stomping around in five-inch heels and other equally outrageous, expressive styles, has given way to something else: a collective settling into political, social, and economic instability. It is an era much like the early 1990s, when the alternative seems brighter than the mainstream, and buyers want to align themselves with the "other" by wearing aesthetically stripped-down shoes that express shades of clunky, chunky defiance.

This too shall pass; the atmosphere of anxiety will dissipate. But for the foreseeable future, picking out shoes will remain a trusted way to express our agency and individualism, even at times when the suspicion that most things lie outside of our realm of personal jurisdiction feels intolerable. Like that old friend on the other end of a phone call, shoes have evolved in a way that helps us know ourselves better. And that, to me, isn't frivolous at all—in fact, it's pretty fantastic.

Rachelle Bergstein
Brooklyn, New York

ACKNOWLEDGMENTS

· · · · · · · · · · ·

This book would not exist without the tireless support, advocacy, humor, and friendship of my agent, David Halpern, whose belief in me, and hard work on my behalf, have made writing it possible. I am lucky to have a wonderful mentor and friend in Kathy Robbins, who made crucial suggestions throughout the process—whether it's in conversation or on the page, her ability to cut right through to the truth of the matter will always seem a little bit extraordinary. I'm indebted to Julia Cheiffetz: she took a leap of faith when she signed up to work on this book, and her energy, enthusiasm, and creativity improved it from the second we started working together. I'm also grateful to Jennifer Barth, who stepped in at a pivotal moment, offered terrific insight and guidance, and never treated me or the manuscript as anything less than her own.

The seeds of this book were planted by Richard Cohen, and in keeping an eye out for shoe-related material over the past few years, he generously volunteered his services as the world's most over-qualified research assistant. Katie Salisbury offered smart editorial advice and helped introduce me to the next frontier: Twitter. Jason Sack in Jennifer Barth's office has been ready with answers to all of my many questions. Juliette Shapland made a secret dream come true when she brokered a deal overseas. The book would look a lot less stylish if it weren't for Jennifer Daddio, Archie Ferguson, and the talented Nami Matsuo Scott, whose illustrations are even more stunning than I could have imagined. At the eleventh hour, Noah Kalina cleared time to take the author photo and his artistic gift was obvious even to a very unpracticed photographic subject.

A handful of friends and colleagues read drafts of the proposal or manuscript and provided honest, insightful feedback: Neal Dusedau, Erin Jones Eichenstein, Kristin Hodgson, Ian King, and Sam Wasson. Without the help of these "reality checks" I would have certainly gone off the rails. I also benefited from the guidance of Betsy Carter, Elizabeth Currid, and Mireille Guiliano, who all were so generous to share wisdom and professional connections. Carole Sabas was kind to help me navigate the vagaries of the fashion world; Valerie Salembier and Laurie Ridgeway opened up their offices and archives. My friends also mined their contacts; Neal Dusedau, Jodi Hildebrand, Paige Newman, Kamali Robinson, Peter St. John, and Lydia Turner all took the time to make introductions. Without Robert Jenkins, my research on valkyries past and present would have been a lot more difficult (and significantly less fun).

I'd like to extend huge thank-yous to all of the authors and experts who agreed to be interviewed for the book: Anna D'Agrosa, Barbara D'Agrosa, Patrizia von Brandenstein, Barrie Budin, Ce

Ce Chin, Alicia Collins, Lauren Durgin, Cathy Elkies, David El-kouby, A. J. Langer, Suttirat Larlarb, Kristen May Lee, Lesley Mallgrave, Mona May, Lisa Mayock, Ty McBride, Melissa O'Shea, Doreen Rivera, Martin Roach, Hilary Rosenman, Mary Rovetto, Elizabeth Semmelhack, Michael Siewart, Nancy Sinatra, Valerie Steele, Steve Van Doren, John Varvatos, John Wells, and Irma Zandl. It was an honor to speak to this assortment of smart, ac-complished people. To that end, I'd also like to acknowledge all of the gatekeepers who deemed my introductory letters important enough to pass along.

At the start of the research process, I sent out a "shoe survey" to see what I could find out about women and shoes. I'd like to thank the people who took the time to fill it out: Allison Bergstein, Annette Bergstein, Deanna Bergstein, Pauline Bergstein, Nicole Brown, Liz Byer, Rachel Drake, Erin Jones Eichenstein, Kate Eickmeyer, Dani-elle Florio, Simone Garabedian, Ellie Glicklich, Janie Gustafson, Jodi Hildebrand, Kristin Hodgson, Emily Howorth, Gillian Jankie-wicz, Jessica Lattif, Kate Leiserson, Lynn Lobban, Tia Maggini, Mimian Morales, Nancy Newman, Paige Newman, Jessica Ralli, Nadya Richberg, Jean Rosenberg, Carrie Gustafson Santiago, Gwen Schantz, Torey Schantz, Kathy Sollitto, Kristen Vetter, and Lily Zahn. Your answers helped me formulate some preliminary thoughts on shoes and stayed with me though the duration of the project.

My colleagues and friends at the Robbins Office have been enor-mously supportive of my work: Mike Gillespie, Louise Quayle, Ian King, Arielle Asher, and Jackie Wakeen have all shown great interest in this project (even when I was being secretive about it) and were gracious to pick up the slack when I had to take time off from the office. I'd like to thank Morgan Williams and Carmine Iandiorio at Running with Heels for giving me a chance to write about shoes, as

well as the wonderful staff at the New York Public Library, who are always personable and well informed.

For moral support, I've relied on the generosity of my astounding group of friends, who encourage me but also serve as motivation: you all consistently raise the bar in ways that are genuine and well deserved. And as for my family . . . at moments of both struggle and success, I am lucky to have a crew of people who will bolster me, champion me, laugh with me, advise me, and go out of their way to make sure I feel loved. I could not have written this book without them, and their various contributions. Jean Rosenberg is a big-hearted cheerleader who will call everyone in town until a problem is solved. Herb Rosenberg inspires with his endless pursuit of great art. My sisters, Deanna and Allison Bergstein, are true friends who support everything I do. My stepmother, Annette Bergstein, has a special confidence in me: she reminds me to look past the roadblocks and be patient. My stepfather, Jeff Wilson, is one of the kindest (and yet, darkly funniest) people in the world, and he'll surmount any inconvenience in order to be helpful. My father, Jay Bergstein, has made it clear all my life that he believes in me, and he'll do whatever he can to ease the journey. My mother, Pauline Bergstein, taught me to love shoes—and more important, to be hardworking, honest, and determined.

Andrew, the only thing more exciting than writing a book was having you around while I did it. You are my perfect fit.

NOTES

.

PREFACE

xi *to differentiate between the left and right foot:* See Mary Trasko, *Heavenly Soles* (Cross River Press, 1989), p. 18.

xiii *footwear sales continued to rise:* Stephanie Rosenblum's "Shoes, the Recession's Not-So-Guilty-Pleasure," which ran in the print edition of the *New York Times* on November 6, 2009, p. B1, contemplated why "sales of shoes were $1.5 billion in October, the highest they have been in any October since at least 2006."

1: FERRAGAMO AND THE WARTIME WEDGE (1900–1938)

A note on the illustration (p.1): This drawing reflects a real pair of shoes Ferragamo designed in 1935 or 1936. He achieved the mirror effect by gluing

gilded glass tiles to a cork wedge. See Mercedes Iturbe, *Salvatore Ferragamo: Walking Dreams (1898–1960)* (Editorial RM, 2006), p. 76.

For Salvatore Ferragamo's biographical material, I am indebted to his comprehensive autobiography *Shoemaker of Dreams*, which was first published in the UK in 1957. I relied on Crown's 1972 reprint. I also consulted the photo-illustrated *Walking Dreams: Salvatore Ferragamo (1898–1960)*, which was published alongside an exhibition of the same name at the Museo del Palacio de Bellas Artes in Mexico City.

4 *What Ferragamo didn't appreciate*: For the early-twentieth-century shoe history in this chapter, I used a cluster of references that proved indispensable throughout the research process, including Caroline Cox's *Vintage Shoes: Collecting and Wearing Twentieth-Century Footwear* (Collins Design, 2008); Mary Trasko's *Heavenly Soles: Extraordinary Twentieth-Century Shoes* (Cross River Press, 1989); Elizabeth Semmelhack's *Heights of Fashion: A History of the Elevated Shoe* (Periscope Publishing/The Bata Shoe Museum, 2008); Valerie Steele's *Shoes: A Lexicon of Style* (Rizzoli, 1999); and Jonathan Walford's *The Seductive Shoe* (Stewart, Tabori and Chang, 2007).

5 *if a woman was caught in bloomers*: Mary Trasko, *Heavenly Soles*, p. 21.

5 *giving burgeoning shoe companies the chance to brand themselves*: Jonathan Walford, *The Seductive Shoe*, p. 123.

6 *she might even take her cues from the movies*: For much of the social history in this chapter and the next one, I consulted David E. Kyvig's exhaustive *Daily Life in the United States, 1920–1940: How Americans Lived Through the "Roaring Twenties" and the Great Depression* (Ivan R. Dee, 2002). Kyvig writes on p. 95 about a new style of silent film that showcased elegant protagonists and "encouraged audiences to think of material opulence as widespread."

6 *"Why do you waste your time working here in Bonito?"*: Alfonso's words come from Ferragamo's own remembrances in *Shoemaker of Dreams*, p. 38.

7 *"a provincial"*: This was Ferragamo's fear, as described on p. 42 of his autobiography, *Shoemaker of Dreams*.

8 *"This was an inferno"*: Ibid., p. 45.

9 *"the West would have been conquered earlier"*: This quotation comes from Cox, *Vintage Shoes*, p. 68.

11 *pinch the foot into submission*: Trasko, *Heavenly Soles*, p. 23.

12 *roughly fifty-four million people*: Kyvig, *Daily Life in the United States, 1920–
 1940*, pp. 10–12.

12 *two-thirds of the population was thirty-five or younger*: Ibid.

12 *proved more successful than their overweight friends*: Ibid., p. 115. "Popu-
 lar novels for young middle-class females routinely had a fat comic
 character as a contrast to the popular, smart, and always slim heroine.
 Seeking to remain or become slender became a frequent preoccupa-
 tion. Systematic efforts to lower one's weight through exercise and es-
 pecially diet became widespread."

13 *birthrates to plummet by 33 percent*: Ibid., p. 137.

13 *brushed rouge on her knees to imply sexual acts*: Semmelhack, *Heights of
 Fashion*, p. 38.

14 *"on the ground of mayhem and mutilation"*: Elizabeth Semmelhack
 quotes a May 6, 1920, *Washington Post* article titled "Lay the Heel Low"
 on p. 40 of her book: "Animated with holy zeal for the preservation of
 both health and morality, he [the surgeon] denounced the vile thing
 [the high heel] in every mood and tense. . . . No wonder the assembled
 women, in a panic of repentance, came to a unanimous resolution de-
 creeing the permanent abolition of so terrible an instrument of tor-
 ture."

14 *they hit against the leg*: Walford, *The Seductive Shoe*, p. 140.

14 *Party girl Ruth Snyder*: Landis MacKellar's *The "Double Indemnity" Mur-
 der: Ruth Snyder, Judd Gray, and New York's Crime of the Century* (Syra-
 cuse University Press, 2006) walked me through the details of this
 case.

15 *"Ruthless Ruth"* and *"like a poisonous serpent"*: These charming epithets
 and the prosecuting attorney's words both come from MacKellar, pp. 91
 and 221.

18 *"You have nothing, nothing!"*: George Miller's and Manuel Gerton's reac-
 tions both come from Ferragamo's *Shoemaker of Dreams*, pp. 114–120.

19 *"in one stroke my growing export trade was killed"*: Ibid., p. 139.

20 *"Why not fill in the space"*: Ibid., p. 143.

21 *"you designed that horrible thing?"*: Duchessa Visconte di Madrone's
 words come from ibid., pp. 144–45.

21 *"the good-old American language"*: Alice Hughes, "A Woman's New
 York" column, *Washington Post*, June 10, 1938, p. xii.

2: MGM, THE GREAT DEPRESSION, AND PULLING YOURSELF UP BY YOUR RUBY SLIPPERS (1936–1939)

Four books were particularly helpful in reconstructing Judy Garland's experiences on the MGM lot—fighting her weight, feeling competitive with Deanna Durbin and then Lana Turner, and ultimately winning the role of Dorothy—as well as her time on *The Wizard of Oz*'s set: Sheridan Morley and Ruth Leon's *Judy Garland: Beyond the Rainbow* (Arcade, 1999); Scott Schechter's *Judy Garland: The Day-by-Day Chronicle of a Legend* (Taylor Trade, 2006);* David Shipman's *Judy Garland: The Secret Life of an American Legend* (Hyperion, 1993); and Rhys Thomas's *The Ruby Slippers of Oz* (Tale Weaving, 1989). I also consulted the film documentary *The Wonderful Wizard of Oz: The Making of a Movie Classic* (Jack Haley Jr. Productions and Turner Entertainment, 1990) and conducted a phone interview with Garland expert and prop collector Michael Siewart on August 29, 2009.

24 *Fire the fat one*: This anecdote appears in both Morley and Leon's and Shipman's accounts (*Judy Garland: Beyond the Rainbow*, p. 21, and *Judy Garland: The Secret Life of an American Legend*, p. 60).

25 *"Adolescents Get Chance in Pictures"*: Sheilah Graham, "Adolescents Get Chance in Pictures: Success of Deanna Durbin Gives Youngsters Who Have Outgrown Child Roles New Hope," *Hartford Courant*, February 7, 1937, p. A1.

26 *starring an ageless heroine named Dorothy Gale*: L. Frank Baum's *The Wonderful Wizard of Oz* was first published in 1900; I read the Barnes & Noble Classics edition (2005).

26 *examined page twenty-six of his script*: For reprinting this page of Noel Langley's May 14, 1938, script along with his scribbles, I'm grateful to Rhys Thomas and *The Ruby Slippers of Oz* (no page number; photo insert).

28 *clear soup and cottage cheese*: Detail taken from Shipman, *Judy Garland*, p. 75.

* Written in pencil in the NYPL Performing Arts Branch's copy of this book was the following: "There is much more to her career—good, bad and indifferent yet her highest level of artistry is a transforming experience. The source of her artistry is what it is—she was what she was, and she is at that rainbow's end she yearned for—and there for us."

28 *"she wasn't pretty—she was plump"*: Ray Bolger's recollections are fea-
 tured in *The Wonderful Wizard of Oz: The Making of a Movie Classic*.

28 *if she couldn't breathe, she couldn't sing*: On p. 69 of *The Ruby Slippers of
 Oz*, Thomas quotes Garland who, long after filming on *The Wizard of
 Oz* wrapped, recalled: "I don't know why they didn't go out and find a
 girl that looked like Dorothy instead of bending me out of shape for
 the part. I was a chubby little girl, so they'd truss me up in a corset so I
 couldn't sing very well. They put caps on my teeth. They starved me to
 lose weight. They even put stuff in my nose to make it look different. . . .
 I played Dorothy Gale of Kansas in that picture, but I was tortured little
 Tillie during the whole damned thing."

28 *particular choices about Dorothy's look*: Schechter's *Judy Garland*, pp. 47–50,
 provides a thorough description and timeline for Judy's *Oz* makeover.

29 *The foppishly handsome Adrian*: Biographical information taken from
 Elizabeth Leese, *Costume Design in the Movies: An Illustrated Guide to the
 Work of 157 Great Designers* (Dover, 1991). Other details about the shoes
 and their many iterations are provided by Rhys Thomas.

31 *as film journalist Aljean Harmetz*: As quoted by David Shipman in *Judy
 Garland*, p. 68.

31 *"What America Thinks About the War"*: A "Fortune Poll" featured in an
 article titled "The Second World War," *Life*, September 25, 1939.

31 *cheerily declared gray the color of spring*: Rhea Seeger, "Tones of Gray Are
 Smart for Spring Season," *Chicago Daily Tribune*, March 17, 1938, p. 15.

32 *"Red, with a dozen new names"*: "Red: It Blazes in Fall Accessories," *Life*,
 December 6, 1939.

34 *glass doesn't stretch*: Interview with Elizabeth Semmelhack, Toronto,
 Canada, August 30, 2010.

34 *Many cultures have a version of the Cinderella story*: The wall plaques at
 the Bata Shoe Museum were helpful in rounding up these multicultural
 fairy tales. I visited the museum on August 30, 2010.

3: BACK TO THE DRAWING BOARD (1937–1943)

39 *"In the Not-So-Merry Land of Oz"*: Cartoon by Herblock. Reprinted here:
 http://chicagohistorybooks.wordpress.com/2010/05/15/the-rise-and-
 fall-of-the-wonderful-wizard-of-oz-as-a-parable-on-populism/.

40 *1,500,000 women into the workforce*: From *Life*, October 30, 1939. "England Mobilizes 1,500,000 of Her Women for the War," pp. 42–50.

41 *Lana saw "a Thing"*: "Cinema: Life of a Sweater Girl," *Time*, November 26, 1951.

41 *Lana became "The Sweater Girl"*: For Lana's story, I looked at Jeanine Basinger's *Lana Turner* (Pyramid Publications, 1976); Lana Turner's own *Lana: The Lady, the Legend, the Truth* (Dutton, 1982); and Jane Ellen Wayne's *Lana: The Life and Loves of Lana Turner* (St. Martin's Press, 1995). I also worked from the following articles (in chronological order of publication date): Hubbard Keavy, "Star in Ascendant," *Hartford Courant*, April 13, 1941, p. SM3; Brindley Graver, "America's 'Sweater Girl' Soars to Stardom," *Hartford Courant*, May 11, 1941, p. SM5; Moakley Christoph, "Lana Turner Here but Visit Proves to Be Mystery," *Hartford Courant*, November 28, 1941, p. 6; "Lana Turner Tries V-Style Haircut," *Hartford Courant*, March 27, 1941, p. 10; Louella Parsons, "Lana Turner Puts Aside Sweater Girl Act," *Atlanta Constitution*, September 27, 1942, p. 7D; Sheilah Graham, "Lana Turner Goes Off Screen for a Year's Absence," *Atlanta Constitution*, February 6, 1943, p. 10; "Lana Is Called 'Vamp' of Today," *Atlanta Constitution*, April 18, 1943, p. 13B; Kate Holiday, "Lana Turner Is Weary of Glamour Role," *Hartford Courant*, June 6, 1943, p. A8; "Cinema: Life of a Sweater Girl," *Time*, November 26, 1951.

42 *"Who do you think you are, George Petty?"*: Alberto Vargas's life story is sourced from Alberto Vargas's and Reid Austin's *Vargas* (Harmony Books, 1978).

43 *"out-Petty Petty"*: Ibid., p. 22.

44 *as early as the 1800s in pornographic images*: On p. 35 of *Heights of Fashion*, Semmelhack provides this fascinating background: "The eroticization of the high heel can be directly linked to the explosion of imagery in the second half of the nineteenth century. Immediately following the invention of photography, pornographers initiated the curious convention—which persists to this day—of depicting women stripped of all clothing except their shoes. The presence of contemporary shoes in an image prevented models from drifting into the allegorical realm."

45 *A January 11, 1941, "Talk of the Town"*: As quoted in Vargas and Austin, *Vargas*, p. 29.

46 *She would be Wonder Woman*: Les Daniels's *Wonder Woman: The Complete History* (Chronicle Books, 2000) proved invaluable, as did an e-mail

interview with John Wells, coauthor of *The Essential Wonder Woman Encyclopedia* (Del Rey, 2010), on March 6, 2010.

46 *"like westerns or space opera"*: JW to RB, March 6, 2010.

46 *"Frankly, Wonder Woman is psychological propaganda"*: Quotes from Daniels, *Wonder Woman*, pp. 22–23.

47 *"Not even girls want to be girls"*: As quoted by JW to RB, March 6, 2010.

47 *Explains Byrne Marston, William and Olive's son*: Daniels, *Wonder Woman*, p. 31. Biographical material sourced also from pp. 12, 19–20, 27–31.

48 *"Bullets never solved a human problem yet"*: As quoted by JW to RB, March 6, 2010.

48 *this tidbit about Wonder Woman's footwear*: Ibid.

49 *shoe rationing would go into effect*: Shoe rationing was a crucial and nationally covered event. I relied on the following articles to piece together the periods leading up to, and then following, the government's announcement that footwear would be rationed (in chronological order of publication):

"Rationing Is Expected in Spring but Quality Will Suffer Before Then," *Wall Street Journal*, January 3, 1942, p. 1; "The Shoe Industry: A Dow-Jones Survey for Investors," *Wall Street Journal*, July 9, 1942, p. 6; "Shoe Rationing Predicted Only as Last Resort," *Chicago Daily Tribune*, September 13, 1942, p. B7; Marshal Andrews, "Americans Go on 3 Pairs Yearly Shoe Ration Today," *Washington Post*, February 8, 1943, p. 1; "New Rationing Plan Explained: Chieftain of O.P.A. Tells How Program on Shoes Will Work," *Los Angeles Times*, February 8, 1943, p. 8; "Shoe Ration: 3 Pairs A Year," *Chicago Daily Tribune*, February 8, 1943, p. 1; "Text of Official Statement on Shoe Rationing," *New York Times*, February 8, 1943, p. 13; Ernest Lindley, "Shoe Rationing: A Stitch in Time," *Washington Post*, February 10, 1943, p. 11; Rita Fitzpatrick, "Flood of Sales Follows Thaw of Shoe Freeze," *Chicago Daily Tribune*, February 10, 1943, p. 2; "Women Buy Sturdy Shoes for Duration: Heavy Soles Reported in Higher Priced Stores; Dealers Laud OPA Regulations," February 10, 1943, p. 9; "Mrs. Roosevelt Caught by Shoe Ration Order," *Atlanta Constitution*, February 11, 1943, p. 5; "White Shoes a Problem: Merchants See Gain with Next Ration Beginning June 16," *New York Times*, February 14, 1943, p. 41; Sheilah Graham, "Shoe Rationing Causing Confusion Among Stars: Must Provide Own Footwear for Films, Players like Claudette Colbert, Veronica Lake, and Dorothy Lamour Face Disconcerting Problem Under New Restrictions—Other Shortage

Headaches, Too," *Hartford Courant*, March 7, 1943, p. A7; "Rationing Made Easy," *Washington Post*, February 17, 1943, p. B3; Prentiss M. Brown, "How to Make Rationing Work," *New York Times*, February 21, 1943, p. X15; "End of Shoe Rationing This Year Predicted," *Hartford Courant*, August 16, 1945, p. 14; "Shoe-Buying Rush Set Off by Rumor: Story That Stamps Now Valid Would Be Canceled Causes Many to Use Them Up," *New York Times*, January 3, 1945, p. 20; "OPA Halts Rationing of Shoes: Soaring Productions Expected to Reach Prewar Levels by Next Month," *Washington Post*, October 31, 1945, p. 1; "Imported and Domestic Shoe Creations Presented by Saks in First Post-War Show," *New York Times*, April 23, 1947, p. 28.

49 *to sort their footwear into rationed:* Andrews, "Americans Go on 3 Pairs Yearly Shoe Ration Today," p. 1.

49 *the Associated Press explained on February 8:* "Text of Official Statement on Shoe Rationing," p. 13.

50 *"In a close-up, you don't see a person's feet anyway":* Graham, "Shoe Rationing Causing Confusion Among Stars," p. A7.

51 *"I will design my dresses to the shoes owned by the star":* Ibid.

51 *delivered a solemn speech to his peers:* As printed in the *Coast Shoe Reporter*, April 1944 issue, "Washington Is Seat of Shoe Industry," p. 30.

51 *"ration tickets were turned in right and left":* Fitzpatrick, "Flood of Sales Follows Thaw of Shoe Freeze," p. 2.

52 *New jobs automatically meant a new style of dress:* Emily Yellin's *Our Mothers' War: American Women at Home and at the Front During War World II* (Free Press, 2004) provided excellent information about women and work during that time.

52 *"when styling the hair of an actress":* "Lana Turner Tries V-Style Haircut," p. 10.

53 *"only 30 percent of husbands gave unqualified support":* Yellin, *Our Mothers' War*, p. 45.

4: THE FEMME FATALE AND THE ORIGINAL POWER PUMP (1944–1948)

56 *But despite director Billy Wilder's own explanation:* Cameron Crowe, *Conversations with Wilder* (Knopf Borzoi Books, 1999), pp. 48, 53.

57 *"the first true film noir"*: *Double Indemnity*, directed by Billy Wilder
 (Paramount, 1944), two-disc special edition, Universal Studios,
 2006.

58 *publicly dubbed Lana "the vamp of today"*: "Lana Is Called 'Vamp' of To-
 day," *Atlanta Constitution*, April 18, 1943, p. 13B.

58 *the Hartford Courant reported*: Hubbard Keavy, "Star in Ascendant,"
 Hartford Courant, April 13, 1941, p. SM3.

59 *The Sweater Girl was all grown up*: Ibid.

60 *"Paul wanted to jitterbug"*: Shelley Winters, *Shelley, Also Known as Shirley*
 (William Morrow, 1980), p. 117. I was put on the trail of this reference
 by Cox's *Vintage Shoes*, p. 84.

61 *"The pinup is the only feminine companion"*: As quoted in Semmelhack,
 Heights of Fashion, p. 48.

62 *"the men started to come home"*: Phone interview with Barbara D'Agrosa,
 January 25, 2010.

64 *"We are saved"*: As quoted in Valerie Steele's *Fifty Years of Fashion: New
 Look to Now* (Yale University Press, 1997), p. 11.

64 *"In Georgia, a group of outraged men"*: "Fashion: Counter-Revolution,"
 Time, September 15, 1947.

65 *were also working as de facto shoe designers*: Semmelhack, *Heights of Fash-
 ion*, p. 44.

5: THE STILETTO (1950-1954)

69 *In one account of the origin of foot binding*: Louisa Lim, "Footbinding:
 From Status to Subjugation," NPR.com, March 19, 2007.

70 *"But Madame, you walked in these shoes"*: Caroline Cox, *Stiletto* (Harper
 Design, 2004), p. 32.

6: THE FEMININE BALANCING ACT (1953-1959)

73 *It was just past 1:00 a.m. on Fifty-second and Lexington*: This reconstruc-
 tion is sourced from Sarah Churchwell's terrific *The Many Lives of Mari-
 lyn Monroe* (Picador, 2004), pp. 230–233; Crowe, *Conversations with*

Wilder, p. 163; and *Backstory: The Seven Year Itch*, Prometheus Entertainment, original air date August 26, 2000, from 20th Century-Fox DVD of *The Seven Year Itch*, directed by Billy Wilder (1955), released in 2001.

74 *slipped a second pair of underwear*: *Backstory: The Seven Year Itch*.

76 *Cinderellas, Venuses, and Aristocrats*: Ferragamo describes his unique classification system in *Shoemaker of Dreams*, p. 199.

77 *She told him she was a secretary*: Ibid., p. 198.

77 *that would lead to more than forty pairs*: Cox, *Stiletto*, p. 70.

78 *The noir* Niagara *premiered in 1953*: Churchwell, *The Many Lives of Marilyn Monroe*, p. 55.

78 *intentionally had shoes made with one heel higher*: Ibid.

80 *his desire for a refined yet docile housewife*: Again, sourced from Churchwell, *The Many Lives of Marilyn Monroe*, pp. 230–233; Crowe's *Conversations with Wilder*, p. 163; and *Backstory: The Seven Year Itch*.

80 *"For the past three years"*: William J. Ahern's editorial, *Coast Shoe Reporter*, August 1955, p. 27.

80 *one ad for Carmelletes shoes*: *Footwear News*, May 20, 1955, p. 23.

81 *a physical extension of her womanhood*: Informed by a phone interview with my stepgrandmother Mary Rovetto on January 30, 2010. In her words: "I always worked and I always dressed [up], because that's the way I felt—not even comfortable—[but] I wanted to present that kind of look [to the world] . . . and when you dress, it's automatic, you put on high heels." Despite shifting styles and attitudes over the years, Rovetto's conviction that ladylike shoes complete an outfit is so firm, that when she woke up from her first hip replacement surgery in 2005, she asked the doctor how soon she'd be allowed to wear her high heels again.

82 *"The first principle of wife-dressing"*: Anne Fogarty, *Wife Dressing* (Glitterati, 2007), p. 10; *Women's Wear Daily* writer Rosemary Feitelberg encouraged a reissue of this 1959 text.

82 *"Old Garbo movies may make you cry"*: Ibid., pp. 14–15.

7: FLATS, OR SOME LIKE IT NOT (1957–1959)

85 *"Excessively high heels will always be a source of danger"*: As quoted by Cox, *Stiletto*, p. 82.

86 *A 1955 ad for Esquire Lanol-White shoe polish:* Coast Shoe Reporter.

87 *In fact, Seventeen's readers alone spend:* Footwear News, May 20, 1955, p. 23.

89 *"in perfect proportion to her height":* Ferragamo, *Shoemaker of Dreams,* p. 204.

90 *"You were right about the socks":* Cox, *Vintage Shoes,* p. 111.

91 *"designed for very young women":* As quoted by Steele, *Fifty Years of Fashion,* p. 52.

8: FROM DOLLY BIRDS TO BIRKENSTOCKS (1961–1966)

95 *"People are talking about":* As quoted by Steele, *Fifty Years of Fashion,* p. 49.

96 *"I have always wanted young people":* From Quant's autobiography *Quant by Quant,* as quoted by Steele, *Fifty Years of Fashion,* p. 51.

97 *"through whole winters with [their] legs frozen":* As quoted in Cox, *Vintage Shoes,* p. 132.

98 *Natural rubber–soled shoes:* Tom Vanderbilt, *The Sneaker Book: Anatomy of an Industry and an Icon* (The New Press, 1998), p. 8.

100 *By May 1962, sneaker sales had jumped:* Ibid., p. 13.

100 *"They're like hot dogs, part of America":* Ibid., p. 14.

100 *"The buying of things drains away those needs":* Betty Friedan, *The Feminine Mystique* (Dell Publishing, 1984), p. 225.

102 *one shoe store proprietor rejected them as "hideous":* Coeli Carr, "Thank You for Insulting Our Sandals," *New York Times,* March 12, 2006.

103 *In 1961, on their way back from a nightclub tour:* Tony Bramwell, *Magical Mystery Tours: My Life with the Beatles* (St. Martin's Press, 2006), p. 34.

9: THESE BOOTS ARE MADE FOR THE VALKYRIE (1965–1969)

105 *What was Lee Hazlewood going to do about Nancy Sinatra?:* The following scene is reconstructed from the following articles (in chronological order of publication): Andrew Perry, "I Made Sinatra's Daughter Sound Like a Tough Broad," *Telegraph,* June 14, 2004; Sia Michel, "One Last Walk for the Man Behind 'These Boots,'" *New York Times,* January 28, 2007; Lee Hazlewood's obituary, *Telegraph,* August 6, 2007; Andrea Seabrook, host:

"Lee Hazlewood: Writer Gave Music Biz the 'Boots,'" NPR, *All Things Considered*, August 6, 2007; Steve Horowitz, "You Only Live Once: An Interview with Nancy Sinatra," Popmatters, October 15, 2009.

 I also made good use of Thomas Levy's documentary of Hazlewood, *He Moves Around*, unreleased at the time of this book's printing but made available in excerpts by the documentarian on YouTube: www .youtube.com/user/presbytere.

108 *"He played me a bunch of songs"*: CBS *Sunday Morning*, Elizabeth Kaledin's interview with Nancy Sinatra, segment produced by Jason Sacca. Available at http://www.youtube.com/watch?v=1Bden6Rp-JM.

108 *"It doesn't mean that in New Jersey!"*: Ibid.

109 *"It was always about the music"*: Phone interview with Nancy Sinatra, April 8, 2010.

109 *"so I look gorgeous in the morning"*: Natalie Gittelson, "Sinatra Is Her Name," *Harper's Bazaar*, October 1966, p. 268.

110 *"I went to London when my first [Lee Hazlewood] record came out"*: NS to RB, April 8, 2010.

111 *"Some of the boots" [came from Levine]*: Ibid.

112 *as Jonathan Walford explains*: Walford, *The Seductive Shoe*, p. 46.

113 *"Robert Kanigher—the writer who'd succeeded Marston in the late 1940s"*: JW to RB, March 6, 2010.

115 *"The Diana Prince experiment ended"*: Ibid.

116 *"There I was, a young woman who hated her body"*: Jane Fonda, *My Life So Far* (Random House, 2005), p. 180.

117 *"To Jane, a nude scene in a movie"*: Thomas Thompson, "Up and Away with Jane Fonda: A Place in the Sun All Her Own," *Life*, March 29, 1968, p. 68.

117 *"For the first time in modern history"*: Gittelson, "The Erotic Life of the American Wife," *Harper's Bazaar*, July 1969, p. 76.

118 *"Scientists suggested that the extreme unpredictability of the female body"*: Lisa Parks, "Bringing *Barbarella* Down to Earth: The Astronaut and Feminine Sexuality in the 1960s," in Hilary Radner and Moya Luckett, eds., *Swinging Single: Representing Sexuality in the 1960s* (Minnesota University Press, 1999), p. 253.

119 *Fonda herself "took decades"*: Fonda, *My Life So Far*, p. 180.

10: PROPS, PLATFORMS, AND PORNO (1970–1974)

A note on the illustration (p. 121): This drawing reflects a real shoe designed by Biba, circa 1972–1973, done in green, gold, and silver zig-zagging metallics.

121 *After antitrust suits and increasing television sales left the film studios all but
 dissolved:* For his explication of Kent Warner's role in the MGM auction
 and the subsequent ruby slippers trade, I relied on Thomas's *The Ruby
 Slippers of Oz.* David Elkouby, who owns a pair of authentic ruby slippers
 and described his own history of prop collecting to me in a phone call
 on August 21, 2009, reinforced many of Thomas's assertions.

124 *"the end of the sixties": Life* has reprinted the original January 1, 1969, photo
 spread on its Web site: www.life.com/gallery/30702/image/3438618
 /manson-murders-the-end-of-the-60s#index/0.

125 *Nora Ephron, in her* Esquire *magazine "Women" column: Esquire,* February
 1973, p. 14.

125 *In 1973, the American Psychiatric Association declassified homosexuality:*
 Robert Hofler, *Party Animals: A Hollywood Tale of Sex, Drugs, and Rock 'N'
 Roll* (Da Capo Press, 2010), p. 23.

127 *Her experiment, which sold 1.6 million copies:* Jess Cagle, "Reynolds Un-
 wrapped," *Entertainment Weekly,* March 27, 1992.

127 *as Donna Pescow, who played Tony's number one groupie Annette in the film,
 remembers:* "Platforms & Polyester," special features, *Saturday Night Fe-
 ver,* directed by John Badham (1977), thirtieth anniversary special col-
 lector's edition, Paramount Pictures, 2007.

128 *"The young men who are clumping into the jazzy shoe stores":* Angela Taylor,
 "The 4-inch Heel Returns, But This Time It's for Men," *New York Times,*
 February 19, 1972.

128 *"people of modest means imitated this eccentric fashion":* Marie-Josephe
 Bossan, *The Art of the Shoe* (Parkstone Press, 2004), p. 25.

129 *The shoe's phallic shape also interested:* Footnotes to William Rossi's *The Sex
 Life of the Foot and Shoe* pertain to the Krieger Publishing Company's 1993
 reprint of his original 1976 book published by the Saturday Review Press.

129 *Later, in the palace of Louis XIV:* Bossan, *The Art of the Shoe,* p. 43.

130 *"The American general public . . . is a pretty sophisticated audience by now":*
 Nancy Erlich, "Bowie, Bolan, Heron—Superstars?" *New York Times,* July
 11, 1971.

130 *"I was talking [to Iggy Pop] about Iggy and the Stooges in the early 1970s"*:
Interview with John Varvatos, New York, July 28, 2010.

132 *The shoes were designed by Terry de Havilland*: Cox, *Vintage Shoes*,
pp. 159–160.

132 *"It can be read as an allegory of a drug trip"*: Dominic Wells, "Richard
O'Brien: Rocky Horror? It Was All About My Mother." *Times Online*,
August 18, 2009.

133 *inspired by the cherry red 1460 Doc Martens popular with London youth at the
time*: Via the Northampton Borough Council Web site: www.northamp
ton.gov.uk/site/scripts/documents_info.php?documentID=369&page
Number=13.

134 *"To watch a bike movie"*: Joan Didion, "Notes Toward a Dreampolitik,"
The White Album (Farrar, Straus and Giroux, 1990), p. 101.

11: THE LORD OF THE GENDER-BENDING DANCE (1977–1979)

138 *Australian entrepreneur Robert Stigwood*: Biographical material about John
Travolta is sourced from a March 1996 Playboy interview with the star;
VH1's *Behind the Music*, season 4, episode 23 devoted to *Saturday Night Fe-
ver* (original air date April 1, 2001; Wensley Clarkson's *John Travolta, King
of Cool* (John Blake, 2005); and the special features from *Saturday Night
Fever*, thirtieth anniversary special collector's edition, 2007.

138 *Nik Cohn's "Inside the Tribal Rites of the New Saturday Night"*: Published in
New York on June 7, 1976.

140 *the junk-food junkie lost twenty pounds to do the film*: Behind the Music,
season 4, episode 23, VH1, original air date April 1, 2001.

140 *"too sophisticated [and] too rich"*: Interview with Patrizia von Branden-
stein, July 15, 2010.

141 *"John was a superb dancer always"*: PvB to RB, July 15, 2010.

141 *"There were a few shoe stores on Thirty-fourth and a few on Forty-second
Street"*: Ibid.

141 *After* Saturday Night Fever's *Grauman's Chinese Theatre premiere*: "Mak-
ing Soundtrack History," special features, *Saturday Night Fever*, thirti-
eth anniversary special collector's edition, 2007.

142 *"before the film was announced"*: "Catching the Fever," special features,

Saturday Night Fever, thirtieth anniversary special collector's edition, 2007.

143 *"it just wasn't the same"*: PvB to RB, July 15, 2010.

143 *The actor himself told VH1: Behind the Music*, VH1, season 4, episode 23, original air date April 1, 2001.

146 *To prepare the dingy disco for filming*: " 'Saturday Night Fever' Floor on the Auction Block," *All Things Considered*, NPR, March 11, 2005.

147 *John had lost his beloved girlfriend*: "Playboy Interview: John Travolta," Judson Klinger, pp. 47–58, 146–47. March 1996.

147 *In her largely glowing December 1977 New Yorker review*: Pauline Kael, December 26, 1977, pp. 59–60.

148 *the New York Times ran an article called "Doctors Predict a Broken Foot"*: Mary Ann Crenshaw, "Doctors Predict a Broken Foot," *New York Times*, August 23, 1972, p. 36.

12: MANOLO, MOLLOY, AND THE NEW POWER SHOES (1975–1982)

151 *Before Manolo Blahnik was a household name*: Biographical details about Blahnik are from the following sources: Tamsin Blanchard's "High on Heels," *Observer* (London), January 12, 2003, p. G13; Lauren Goldstein's "The Discipline of Manolo Blahnik," *Time*, March 10, 2003; as well as Cox's *Vintage Shoes*, and *Manolo Blahnik Drawings* (Thames and Hudson, 2003).

152 *Blahnik listened and found a job designing footwear for a London boutique*: Ossie Clark details via Cox, *Vintage Shoes*, pp. 168–69.

153 *From 1972 to 1985*: Stats via George Guilder, "Women in the Workforce," *Atlantic*, September 1986.

153 *As "America's first wardrobe engineer"*: John T. Molloy, *Dress for Success* (Warner Books, 1975), p. 14.

154 *"When wearing a black raincoat"*: Ibid., p. 17.

154 *"one-third of the master of business administration graduates"*: John T. Molloy, *The Woman's Dress for Success Book* (Warner Books, 1977), p. 19.

154 *After scheduling an appointment with three executives*: Ibid., pp. 34–35.

155 *"the most preposterous thing manufactured for a woman"*: Ibid., p. 80.

155 *One group of corporate women took his advice so seriously*: Ibid., p. 48.

155 *"I am doing this so that women may have as effective a work uniform"*: Ibid.,
 p. 48.

157 *Adidas and Puma were founded by rival brothers*: Details by way of Jennifer
 Barrett, "A Tale of Two Sneakers," The Daily Beast, April 13, 2008.

158 *In 1980, at the start of the decade*: Details about the transit strike from
 Time's coverage of the event in "Nation: Get a Horse . . . or an Elephant,"
 April 14, 1980.

13: THE WORKOUT IS NOT A SPECTATOR SPORT (1982–1988)

For background on the Workout, I conducted phone interviews with two for-
mer instructors: Lesley Mallgrave, on June 25, 2010, and Doreen Rivera, on
July 5, 2010. I relied on Jane Fonda's own recollections in *My Life So Far* and
collected more information about the Workout and the general aerobics trend
from the following articles (in chronological order of publication): Jean Cox
Penn, "Fonda and the Fatty Issue," *Los Angeles Times*, February 27, 1981, p. K2;
Robert Lindsey, "Jane Fonda's Exercise Salon Aiding Her Husband's Candi-
dacy," *New York Times*, May 2, 1982, p. 24; "The Aerobics Way," *Los Angeles Times*,
September 18, 1983, p. Z62; Vicki Sanders, "Right Moves—Aerobics Gets in
Step with Its Own Sole," *Chicago Tribune*, November 16, 1983, p. NW_B11C;
William Scobie, "Fonda—Aerobics and a Political Flutter," *Observer* (London),
February 26, 1984, p. 33.

163 *"Money,"* Jane said: David Crook, "Fonda Goes Video with Exercises,"
 Los Angeles Times, March 18, 1982, p. J8.

164 *"She must never look in the mirror anymore"*: Fonda, *My Life So Far*,
 p. 234.

165 *"If you can teach me how to dance, you're hired"*: DR to RB, July 5, 2010.

165 *"it was almost like a woman who's been told she makes really good pasta
 sauce"*: LM to RB, June 25, 2010.

166 *"People would come up to me after class"*: DR to RB, July 5, 2010.

166 *"[The Workout] wasn't a scene"*: LM to RB, June 25, 2010.

167 *"I associate Tom Hayden with Karl Marx"*: Lindsey, "Jane Fonda's Exercise
 Salon Aiding Her Husband's Candidacy," p. 24.

167 *"it was a big novelty, these shoes that were meant for exercise"*: LM to RB,
 June 25, 2010.

168 *the books and videos, which sold for $18.95 and $59.95, respectively*: "On
 Golden Fonda," *Time*, August 30, 1982.
168 *"you started seeing people around Los Angeles wearing exercise outfits"*: LM
 to RB, June 25, 2010.

The following articles about Nike versus Reebok proved useful (in chronological
order of publication): Andrew Pollack, "Nike Struggles to Hit Its Stride Again,"
New York Times, May 19, 1985, p. F17; Rhonda L. Rundle, "Reebok's Shares Could
Decline If the Public Tires of Aerobic Exercise, Some Investors Say," *Wall Street
Journal*, February 11, 1986, p. 63; Martha Groves, "Reebok Sprinting to the Lead,"
Los Angeles Times, August 3, 1986, p. OC_C1; Dan Dorfman, "Reebok's Race with
the Shorts," *New York*, August 11, 1986, p. 12; Linda M. Watkins, "Reebok: Keep-
ing a Name Hot Requires More Than Aerobics," *Wall Street Journal*, August 21,
1986, p. 25; Linda M. Watkins, "Reeboks Sales and Profit Rose Sharply Last Year,
Chief Executive Officer Says," *Wall Street Journal*, January 27, 1987, p. 12; Adam
Paul Weisman, "If the Shoe Fits, the Manufacturers Stand to Profit," *Washington
Post*, March 24, 1987, p. 15; Alex Brummer, "Reebok Faces Some Sole Searching,"
Guardian, August 29, 1987, p. 18; Bernice Kanner, "On Madison Avenue: Reebok
on the Rebound," *New York*, October 16, 1989, p. 26.

169 *"Orwell was right: 1984 was a tough year"*: Andrew Pollack, "Nike Strug-
 gles to Hit Its Stride Again," *New York Times*, May 19, 1985, p. F17.
169 *"mid-sole cushioning and lateral stability"*: "The Aerobics Way," *Los Ange-
 les Times*, September 18, 1983, p. 262.
169 *Podiatrists quoted in a* Chicago Tribune *article*: Vicki Sanders, "Right
 Moves—Aerobics Gets in Step with Its Own Sole," *Chicago Tribune*, No-
 vember 16, 1983, p. NW_B11C.
170 *By 1987, the* Guardian *was reporting*: Brummer, "Reebok Faces Some Sole
 Searching."
171 *"you can wear them with an outfit"*: Groves, "Reebok Sprinting to the
 Lead."
171 *As she told* People *magazine in 2009*: "What My Mother Taught Me,"
 People, December 2, 2009.
171 *"Nike all over again"*: Rundle, "Reebok's Shares Could Decline If the
 Public Tires of Aerobic Exercise, Some Investors Say," p. 63.
172 *"While the walking motion is gentler"*: Weisman, "If the Shoe Fits, the Manu-
 facturers Stand to Profit."

173 *"like wood . . . you don't want to stroke her"*: "Sexes: On Golden Fonda,"
 Time, August 30, 1982.

14: THE COOL KID TRINITY (1982-1994)

178 *"Betty would hear about movies"*: Phone interview with Steve Van Doren,
 July 8, 2010.

178 *"My dad . . . I won't say he's cheap"*: SvD to RB, July 8, 2010.

180 *"100 cents on the dollar"*: Ibid.

180 *"skateboarders, surfers, BMX motocross people"*: Ibid.

182 *"I have a friend in Hollywood"*: JV to RB, July 28, 2010.

182 *"I don't think he's ever gone a day without wearing Converse"*: Ibid.

183 *In 1994, the* New York Times *profiled Converse executive Baysie Wightman*:
 Jennifer Steinhauer, "Feet First into the Clubs," *New York Times*, May
 22, 1994.

184 *"The week the war ended, everyone started looting"*: Martin Roach, *Dr. Mar-
 tens: The Story of an Icon* (Chrysalis, 2003), p. 20.

184 *They considered both "Dr. Funck" and "Dr. Maertens"*: Ibid., pp. 14–24.

185 *"as they needed no time to style their hair"*: Phone interview with Martin
 Roach, September 16, 2010.

185 *Skins used their shoelaces to communicate*: Some specifics provided by
 MR to RB, September 16, 2010.

186 *In the late 1960s, the steel-toed versions*: Roach, *Dr. Martens*, p. 56.

186 *"One of the most unique things about Dr. Martens"*: MR to RB, September
 16, 2010.

187 *When, for instance,* A Clockwork Orange *premiered*: Martin Roach, *Dr.
 Martens*, pp. 96–100.

187 *"right around 1985, 1986"*: MR to RB, September 16, 2010.

188 *"As quintessentially English and appealing as it is"*: Ibid.

189 *Ultimately, the school district caved*: "Boots Make a Statement: Is It Fash-
 ion or Politics?" *New York Times*, November 5, 1993.

189 *"If you're twelve [for instance]"*: MR to RB, September 16, 2010.

15: GIRL POWER AND MARY JANES (1994-1999)

191 *Unlike many rock stars in the early to mid-1990s:* Details about Gwen Stefani and No Doubt are via two *Rolling Stone* articles: Chris Heath's "Snap, Crackle, Pop!" May 1, 1997, and Jenny Eliscu's "Gwen Cuts Loose," January 27, 2005, as well as the VH1 *Behind the Music*, season 3, episode 28, devoted to the band, which first aired on April 9, 2000.

193 *"female rock stars like Gwen Stefani":* "Music Review: Tragic Kingdom, No Doubt," David Browne, *Entertainment Weekly*, August 2, 1996.

193 *"Gwen used to say that Eric":* Heath, "Snap, Crackle, Pop!" p. 37.

195 *the ratio of joy to tragedy in Courtney Love's life:* Background about Courtney Love is by way of the following *Rolling Stone* profiles: Mark Seliger's "Life After Death," December 15, 1994; Jason Cohen's "Hole Is a Band," August 24, 1995; and Katherine Dunn's interview with Courtney Love for the thirtieth anniversary "Women in Rock" issue, November 13, 1997. The VH1 *Behind the Music*, season 12, episode 4 (original air date June 21, 2010) proved helpful, as did Charles R. Cross's excellent rock-and-roll biography of Kurt Cobain, *Heavier Than Heaven* (Hyperion, 2001).

195 *walking around in the jacket Cobain died in:* Seliger, "Life After Death," p. 59.

196 *"I recall growing up with Leonard Cohen records":* Ibid, p. 67.

197 *"I just didn't photograph well and I didn't feel confident":* Behind the Music, season 12, episode 4, VH1, original air date June 21, 2010.

197 *"I would like to think—in my heart of hearts":* Seliger, "Life After Death," p. 67.

199 *"I think there's a huge connection between flappers and girl power":* ES to RB, August 30, 2010.

199 *Costume designer Mona May views the mid-1990s as "the breaking point":* Telephone interview with Mona May, September 30, 2010.

200 *"We wanted to counteract grunge":* Ibid.

200 *"In the fittings we tried different shoes":* Ibid.

201 *"So okay, I don't want to be a traitor to my generation and all":* Clueless, directed by Amy Heckerling (Paramount, 1995).

201 *"It was so cute to see girls everywhere":* MM to RB, September 30, 2010.

201 *gone were the days when a show like* My So-Called Life: Telephone interview with A. J. Langer, November 1, 2010.

16: SHOES AND THE SINGLE GIRL (1998–2008)

204 she "wear[s] no other shoes but his": Manolo Blahnik Drawings.

204 "There are thousands, maybe tens of thousands": Candace Bushnell, Sex
 and the City (Grand Central Publishing, 1996), p. 25.

207 "No one I know in New York watches Sex and the City": Rebecca Mead,
 "Wild About Carrie? Not in New York?" Guardian, June 5, 2001, p. A5.

207 "In New York where we don't have cars": Interview with Suttirat Larlarb,
 New York, December 30, 2009.

208 "I spent the afternoon with my shoe soul mate, Manolo Blahnik": "The Ago-
 ny and the Ex-tasy," Sex and the City, season 4, episode 1, HBO, original
 air date June 3, 2001.

208 "Give me your Blahniks": "What Goes Around Comes Around," Sex
 and the City, season 3, episode 17, HBO, original air date October 8,
 2000.

208 Blahnik, though he claimed not to watch the series: Celia Walden, "Manolo
 Blahnik: Men Say My Shoes Have Saved Marriages," Telegraph, Sep-
 tember 23, 2010.

209 "Sex and the City introduced shoe obsession": Telephone interview with a
 subject who wishes to remain anonymous, September 11, 2008.

209 "a little bit of Imelda Marcos in every woman": Steele, Shoes, p. 8.

210 an attitude that the series actually winked at in episode six, season five:
 "Critical Condition," Sex and the City, season 5, episode 6, HBO, origi-
 nal air date August 25, 2002.

210 Bushnell herself confessed that her writing addressed: Victoria Degtyar-
 eva, "Bushnell Speaks on Sex, City and Shoes," Stanford Daily, March 1,
 2005.

211 "It's almost like when an actor puts on a costume": Tamsin Blanchard,
 "High on Heels," Observer (London), January 12, 2003, p. G13.

211 Along with his American CEO George Malkemus: Neil Weilheimer, "Hall of
 Fame: George Malkemus," Footwear News, November 30, 2009.

211 Blahnik refers to his company: Walden, "Manolo Blahnik: Men Say My
 Shoes Have Saved Marriages."

211 "Dirty! . . . Blood sometimes!": Blanchard, "High on Heels," p. G13.

211 The designer is celibate: Sarah Lyall, "Taking the High-Heel Walk," New
 York Times, February. 8, 1998, p. ST1.

212 "If you want to know what sets fashionable women's hearts aflutter": Anne-

Marie Schiro, "The Imelda Factor in Every Stylish Woman's Heart," *New York Times*, December 8, 1998, p. B15.

212 *"as good as sex . . . and they last longer"*: Andrea Byrne, "Manolo Blahniks: 'As Good as Sex and They Last Longer,'" *Independent Woman*, December 14, 2008.

212 *In a 2007* Time *magazine article called "Who Needs a Husband?"*: "Who Needs a Husband," *Time*, July 5, 2007.

212 *that of the more than 40 percent of adult women who were technically single in 2007*: Ibid.

213 *writers acknowledged her questionable money management in season four*: "Ring a Ding Ding," *Sex and the City*, season 4, episode 16, HBO, original air date January 27, 2002.

213 *"Fifty-three percent of women [ages twenty-one to thirty-four] questioned"*: Julie Flaherty, "To Young Single Women, Thrift Is a Dowdy Virtue," *New York Times*, May 13, 2001.

214 *neither intrinsically "empowering nor disempowering"*: Interview with Valerie Steele, New York, November 12, 2010.

214 *"I was driving home from work once, [listening to the radio]"*: ES to RB, August 30, 2010.

214 *"What's interesting is that they didn't go for jewelry"*: VS to RB, November 12, 2010.

215 *Or, as humorist Patricia Marx put it in a* New Yorker *article*: Patricia Marx, "Sole Sisters," *New Yorker*, September 1, 2008.

215 *who claims those "stupid shoes"*: Brill Bundy, "'Sex and the City': Manolo Blahnik Bites the Hand That Feeds Him," Zap 2 News and Buzz from Inside the Box, September 8, 2009.

216 *Choo would supply her with a suitcase full of samples*: Phoebe Eaton, "Who Is Jimmy Choo?" *New York Times*, December. 1, 2002, p. E102.

216 *"had an obsession with shoes that was extraordinary"*: Evgenia Peretz, "The Lady and the Heel," *Vanity Fair*, August 2005.

217 *Tom Yeardye later joked*: Phoebe Eaton, "Who Is Jimmy Choo?" *New York Times Magazine*, December 1, 2002, p. E102.

218 *and eventually to diversify in the mold of megalabel Gucci*: Details sourced from Eaton's article "Who Is Jimmy Choo?" as well as Peretz's "The Lady and the Heel."

218 *"with many occasions to wear high heels"*: Evgenia Peretz, "The Lady and the Heel," *Vanity Fair*, August 2005.

219 *"as Choi points out, no one can see the Choos underneath the long gowns"*: Dana Thomas, *Deluxe: How Luxury Lost Its Luster* (Penguin Press, 2007), pp. 125–26.

17: THE SEARCH FOR RUBY SLIPPERS (2000–PRESENT)

222 *"Someone at the auction had said"*: Telephone interview with David Elkouby, August 21, 2009.

222 *"For whatever reason [at auctions]"*: DE to RB, August 21, 2009.

223 *"a rare jewel," that harks back to a different, more innocent time*: Telephone interview with Michael Siewart, August 29, 2009.

223 *"are one of the most recognizable symbols of film history"*: Telephone interview with Cathy Elkies, March 18, 2010.

225 *"There's nobody in the world like me"*: Giles Hattersley, "We'll Always Have Paris," *Sunday Times* (London), July 16, 2006.

225 *described Paris's inimitable quality as "the light"*: Elizabeth Currid, *Starstruck* (Faber & Faber, 2010), p. 25.

225 *"I desperately hate one thing about my body"*: Paris Hilton, Merle Ginsberg, and Jeff Vespa, "Confessions of an Heiress: A Tongue-in-Cheek Peek Behind the Pose," Fireside, September 2004.

226 *that didn't stop her from walking into Patricia Field's boutique in New York City*: Lola Ogunnaike, "Paris Inc.: Entrepreneurial Hilton Heir Means Business with New Ventures," *New York Times*, May 2, 2005.

226 *In 2008, trend forecaster Irma Zandl affirmed*: Interview with Irma Zandl, Brooklyn, NY, September 15, 2008.

226 *"after Slumdog, I got an e-mail from somebody"*: SL to RB, December 30, 2009.

227 *College friends Hilary Rosenman and Barry Budin*: Interview with Hilary Rosenman and Barry Budin, New York, September 18, 2008.

228 *"When I was on the set of Full House"*: Vanessa Grigoriadis, "The Godfather of Sole," *Vanity Fair*, May 2010, p. 124.

228 *"It was like an angel looked down on me"*: Ibid.

229 *"The red sole was absolutely genius"*: VS to RB, November 12, 2010.

229 *"Roman courtesans [who] sometimes had the soles of their sandals engraved"*: Steele, *Shoes*, p. 100.

229 *in the nineteenth century, Sioux*: Cathy Newman, "The Joy of Shoes," *National Geographic*, September 2006.

230 *The couple leaves without buying anything*: Steele, *Shoes*, p. 104.

230 *Louboutin spotted an assistant painting her nails with red polish*: Grigoria-dis, "The Godfather of Sole," p. 124.

230 *"Half of my women want a shoe to make them look a little tarty"*: Ibid.

230 *"If you don't see the magic"*: Jess Cartner-Morley, "Sexual Heeling," *Guardian*, January 10, 2003.

231 *"It's the height [of the shoes] that gives women that sexy rhythm"*: Walden, "Manolo Blahnik: Men Say My Shoes Have Saved Marriages."

231 *Melissa O'Shea, who founded the shoe club Hello Stiletto in 2004*: Telephone interview with Melissa O'Shea, September 2008.

233 *To Lisa Mayock, who is one half of the celebrated design duo behind Vena Cava*: Interview with Lisa Mayock, New York, June 17, 2010.

234 *"He's a trend forecaster—so he always would pick up a brand early"*: Interview with Ty McBride, Brooklyn, NY, January 13, 2011.

234 *"With a shoe collection it takes a minimum of six months"*: Ibid.

235 *"there were three things that coincided"*: Ibid.

236 *"because they could! Fashion always goes to the highest extreme"*: VS to RB, November 12, 2010.

236 *"Maybe it has to do with the fact"*: ES to RB, August 30, 2010.

236 *"Where does this girl want to be in her life"*: E-mail interview with Ce Ce Chin, March 2, 2011.

ILLUSTRATIONS

.

INDEX

.

ABOUT THE AUTHOR

• • • • • • • • • •

Rachelle Bergstein graduated from Vassar College in 2003, where she won awards for her academic writing. She works as an editorial consultant for a literary agency in New York City, and her writing has appeared in *Fresh Yarn*, *The Awl*, *Slice* magazine, and *The Dirty Durty Diary*. She lives in Brooklyn with her husband, her cat, and her shoes. This is her first book.